BUILDING A PRINT COLLECTION

BUILDING A PRINT COLLECTION

A GUIDE TO BUYING ORIGINAL PRINTS AND PHOTOGRAPHS

GLEN WARNER

Van Nostrand Reinhold Ltd., Toronto
New York, Cincinnati, London, Melbourne

Published simultaneously in the United States of America by Van Nostrand Reinhold Company, New York

Library of Congress Catalogue Number 80-71117

CANADIAN CATALOGUING IN PUBLICATION DATA

Warner, Glen, 1947-
 Building a print collection

Includes index.
ISBN 0-442-29662-2

1. Prints — Collectors and collecting.
2. Photographs — Collectors and collecting.
I. Title

NE885.W37 760'.75 C81-094199-6

PHOTO CREDITS
(Numbers refer to figure numbers)
Jim Chambers, 14, 44
T. E. Moore, 23, 37
National Gallery of Canada, 26, 27, 46
Eric Pollitzer, 8, 24, 30, 43, 48
David Tyrer, 32, 49a
Glen Warner, 1-7, 9-13, 15-19, 21-22, 25, 28, 31, 40-41, 49b, 49c, 55

COVER CREDITS
Top Left: *The Steerage,* photogravure by Alfred Stieglitz (Courtesy Yarlow/Salzman Gallery, Toronto); top right: *December's Pool,* serigraph by Toni Onley (Courtesy Gallery Pascal Graphics, Toronto); middle left: *Whimbrel Moving West on Lake Ontario,* woodcut by Eric Nasmith (Courtesy The Wildlife Gallery, Toronto); middle right: *Northern Stone Number 1,* lithograph by Claude Breeze (Courtesy Sword Street Gallery, Toronto; frame courtesy Framecrest Mouldings, Toronto); bottom left: *At the Edge of the Pines,* serigraph by Ken Danby (Courtesy Gallery Moos, Toronto); bottom right: *Sedan,* photograph by Donald Dunsmore (Courtesy Déjà Vue Gallery, Toronto). Furniture courtesy of De Boer's.

DESIGN: Brant Cowie/Artplus Ltd.
COVER PHOTOGRAPH: Paterson Photographic Works
TYPESETTING: Compeer Typographic Services Limited
PRINTING AND BINDING: Metropole Litho Inc.
Printed and bound in Canada

81 82 83 84 85 86 87 7 6 5 4 3 2 1

CONTENTS

PREFACE

BUILDING A PRINT COLLECTION is written for people who are interested in assembling a collection of modern and contemporary graphic art, as well as those who would merely like to buy one or two fine prints by favorite artists to decorate their homes or offices.

The book developed out of my own experiences as a print collector and journalist. I became interested in modern (1900-1945) and contemporary (1945-present) prints several years ago when my wife and I decided to purchase several pieces of original art for our apartment. We were attracted to limited edition prints for a number of reasons.

First, there is the aesthetic appeal of original graphic art. Many contemporary artists have created some of their finest images using the printmaker's media; their prints are often prized as much as their paintings, drawings, or sculpture by collectors and museum curators. Then, too, original prints are available in styles of art representing most of the important trends, "schools," and art movements of this century.

The second reason is a monetary one. Prints, which are original art objects created in multiple, are usually much less costly than an artist's unique works. Like most people, we couldn't afford to collect original oils by important modern or contemporary master artists, but original limited edition prints were within financial reach. We also became interested in the investment value of original graphic art. Although prints are comparatively inexpensive to buy, many have become excellent investments — some prints by major artists have increased in value by as much as 1,000 percent in the past decade alone.

The third reason for collecting prints is their availability. Because prints are created in multiple on paper, they are easy to acquire, transport, and display.

It is not surprising, then, that in recent years original prints by modern and contemporary artists have been created, collected, traded, and shown in public art galleries and museums to an extent never seen before.

As we expanded and upgraded our collection, my growing interest in prints led me to write numerous magazine and newspaper articles on

print collecting and related subjects. While researching these articles, I was surprised to discover that in spite of the tremendous popularity of twentieth-century original prints, few books are available which give useful advice to occasional art buyers and collectors of modern and contemporary graphics. This book essentially grew out of my series of articles, and was written to fill this need.

BUILDING A PRINT COLLECTION guides collectors through the steps of authenticating, buying, and selling original prints. It provides the reader with practical information on printmaking techniques; limited editions; forgeries and misrepresented prints; print dealers and auction firms; buying prints for profit; and the care, framing, and conservation of works of art on paper. Also, I have included an overview of the photography market, a fascinating and relatively new field of collecting which is capturing the interest of more and more print collectors. In short, this book is intended to provide the reader with the information he or she will need to make informed judgments on the quality, condition, and value of almost any type of modern or contemporary print.

I haven't tried to influence readers' tastes; the examples given in the text, and the prints and photographs which illustrate it, were selected solely for their instructional value and with little regard for personal tastes or preferences. I have, moreover, avoided delving too deeply into the aesthetics of twentieth-century graphic art and the history of prints and printmaking techniques, since there are already many excellent books available to collectors on these subjects. Instead, I have concentrated on the key issues and problem areas which concern anyone who is interested in building a first-rate collection of modern and contemporary prints and photographs.

I wish to thank the following people, many of whom gave me hours of their time and provided helpful insights, advice, and assistance in preparing this book: Loretta Yarlow and Greg Salzman, Yarlow/Salzman Gallery, Toronto; Marianne Friedland, Marianne Friedland Gallery, Toronto; Marc Rosen, Sotheby Parke Bernet Inc., New York; Ken Danby, Guelph; Geraldine Davis and Don Phillips, Sword Street Press Ltd., Toronto; Brooke Alexander, Brooke Alexander, Inc., New York; Douglas Druick, National Gallery of Canada, Ottawa; Chris Yaneff, Yaneff Gallery, Toronto; Gayle Richardson, Toronto; Geoffrey Joyner, Sotheby Parke Bernet (Canada) Inc., Toronto; Aaron Milrad, Milrad & Agnew, Toronto; Terry Legault, Toronto; Jane Corkin, Jane Corkin Gallery, Toronto; Marcia Reid and Saundray Ball, Déjà Vue Gallery, Toronto; Maureen Crocker, Gallery Moos, Toronto.

I would also like to thank my wife Diane, for her enthusiasm, encouragement, and assistance in typing the manuscript; and my good friend and editor, Laurie Coulter, for her perceptive comments and suggestions.

In addition, grateful acknowledgment is made to the Canada Council, which provided an Explorations Grant for this project.

COLLECTING
ORIGINAL PRINTS

WE BEGIN WITH the story of two novice print buyers: one who spends a relatively small amount of money for prints, which give her years of enjoyment and unexpected financial rewards, and another who plunges deeply into the market and comes out less well off in the end.

Our first buyer became interested in contemporary graphic art after attending an exhibition of prints at a museum. Shortly afterward, she began visiting local commercial galleries and was delighted to discover that identical prints to many of those she had admired at the museum were offered for sale at prices she could afford. After reading several books about prints and print collecting, talking to dealers, and looking at a large number of prints, she decided to specialize in collecting the work of up-and-coming local artists. She purchased her prints from several dealers, who offered to let her take two or three impressions home "on approval." Our buyer made her final selection after living with the prints for a few days, and paid between $200 and $300 for each print she decided to keep.

By making a few careful purchases each year, this print collector has assembled an outstanding collection of modern and contemporary graphic art. Although she would never consider selling her prints, she has been told that many of them have increased in value over the years as the demand for the artists' work increased and their early prints have become scarce.

Our second buyer was drawn into the print market by an article he read in a business magazine, which described the spectacular profits investors could make by speculating in original prints by famous artists. The article explained how art prices have skyrocketed in recent years. It outlined price histories for prints by artists such as Pablo Picasso, Marc Chagall, Joan Miró, and many others, which sold for a few hundred dollars each in the 1950s and are worth tens of thousands of dollars today.

Several weeks later our would-be collector wandered into a print gallery that was hung with dozens of brightly colored graphics. Out of curiosity he asked the clerk if he had anything by the artists whose works were touted as great investments in the magazine article. "Ah yes," replied the clerk, who led him to the back of the store and proceeded to expound the virtues of investing in prints by the artists mentioned. The unsuspecting customer was shown a large selection of colorful prints in fancy frames. They were described as original, limited edition lithographs and etchings. The clerk was quick to point out that each print was signed by the artist, which he said gave collectors a personal guarantee of quality and authenticity. The customer was pleasantly surprised by the prices; most of the prints cost between $350 and $900, not thousands of dollars as indicated in the magazine article.

The next day he returned to the store with his wife and purchased four prints, which they thought would go particularly well with their living room decor.

With cash to spare and wall space to fill, our collector later added more prints to his collection. He obtained them at seemingly bargain prices from a mail-order company that ran advertisements in popular magazines offering "investment-quality prints by international master artists."

Two years later, our collector found himself in financial difficulty and decided to raise some cash by selling his print collection. He made an appointment with the print expert at a respected auction firm and took his entire collection of nine framed prints in for an appraisal. After a cursory examination of each print, the expert shook his head and pronounced them unsuitable for inclusion in the company's print sales.

"What do you mean, unsuitable?" asked our somewhat indignant collector. "Your company often sells prints by these artists."

"Yes," replied the print expert, "but not *those* prints."

After some coaxing from our collector, the print expert reluctantly proceeded to describe the humble origins of each print: "This one is a reproduction of a famous Chagall painting; the signature is probably a phony. This one is also a copy of a painting; the original Renoir hangs in the Jeu de Paume Museum in Paris. Your three Picassos are 'restrikes'; they were made after the artist's death by someone who got hold of the original printing plates and ran off thousands of copies. The 'Miró' is a handmade copy of a painting that was used as a poster to advertise a show of Miró's oils. The rest are reproductions as well, and it's anyone's guess as to where the signatures came from."

"What are they worth?" asked the dismayed collector.

"Well, the frames are nice; maybe $50 to $100 each," replied the

print expert. "If you paid much more than that for them, I'd suggest you have a word with the person who sold them to you."

The next day our collector tried to contact his print dealer and found he had gone out of business. His letters to the mail-order company that had sold him the other prints came back marked "Address Unknown." The prints are still hanging in the collector's home, but neither he nor his wife get much pleasure out of looking at them.

As these two stories illustrate, print collecting can be a satisfying, challenging, and profitable hobby for those who take the time and effort to find out about prints, printmakers, and the print market. But at the same time, collecting modern and contemporary graphic art can be risky for people who make indiscriminate purchases without investigating what they are buying.

As our first collector discovered, buying prints wisely takes time, effort, and personal interest, and often a surprisingly small amount of money. The end result can be a carefully selected collection of art, which gives its owner years of enjoyment. As an added bonus, quality original art normally appreciates in value and can be an excellent hedge against inflation.

Fortunately, the problem areas in the print market that our second collector encountered are easily avoided by reading books about prints, looking at different types of graphic art in galleries and museums, and talking to dealers, museum curators, and other print experts. For most print enthusiasts, these tasks are extremely enjoyable, highly educational, and personally rewarding. Learning about a printmaker's working methods; researching a print's history of ownership or provenance; and authenticating a print by carefully examining it, obtaining expert opinions on it, and checking published sources of information on the artist's work, are all part of the fun and challenge of building a print collection.

There are basically three broad issues, then, which concern the novice print collector: (1) how to learn about prints; (2) what types of prints to collect, and where to buy them; and (3) how to distinguish original prints from art reproductions. As our second print buyer discovered, this issue is undoubtedly the most troublesome one facing collectors of modern and contemporary prints.

HOW TO LEARN ABOUT PRINTS AND PRINTMAKERS: As indicated above, the best way to learn about prints, the print market, and the work of artists who are of special interest is by reading, visiting dealers and museums, and talking to experts.

In addition to this book and others on collecting prints, there are many excellent texts available on the history of printmaking, aesthetics, techniques, and the work of individual printmakers. Some of the more informative books for beginning collectors are listed in the Bibliography. Periodicals, such as *The Print Collector's Newsletter*, and art magazines that regularly feature articles on prints and printmakers also help collectors keep up to date on new trends and developments in the market.

Although reading about prints gives you much of the basic information you will need, it is also essential to look at a variety of prints "in the flesh." No amount of reading can make up for first-hand experience gained by looking at, touching, and studying prints. By visiting local commercial galleries and print dealers, you can examine a large number of impressions, make comparisons, and find out about prices.

Public galleries also provide collectors with many opportunities to look at prints. In addition to staging print exhibitions, some museums (and a few public reference libraries) have "print rooms" where collectors may arrange to examine impressions from the institution's collection, and perhaps meet with the resident print curator as well.

It is often a good idea to concentrate on learning as much as possible about a certain style or "school" of art or even the work of just one or two printmakers before making your initial purchases. Specialization enables you to become knowledgeable about a narrow segment of the market within a short period of time.

WHAT TYPES OF PRINTS TO COLLECT AND WHERE TO BUY THEM: As you make the rounds of galleries and museums to look at the various types of prints that are available, you will no doubt find certain styles of art are more visually appealing to you than others. Obviously, you should only buy prints that you like and can live with. It is also important to make sure you can afford to buy the very best examples of whatever type of prints you decide to collect. In general, collectors on a limited budget are wise to purchase first-rate prints by lesser-known artists rather than poor-quality impressions by the big names. Excellent original graphic art is available for under $100 for prints by unknowns to well over $100,000 for important or rare impressions by major artists such as Pablo Picasso or Henri de Toulouse-Lautrec. The print market offers collectors a wealth of first-rate material to choose from at prices to suit every budget.

In addition to helping you determine the types of prints you like, your visits to commercial galleries will give you some idea of the level of expertise available from local dealers. As our unfortunate collector discovered, it is unwise to purchase several prints from one dealer until

you have done some comparison shopping, or at least checked out a dealer's reputation in the art community. (More on where and how to buy prints in Chapter 6.)

HOW TO DISTINGUISH ORIGINAL PRINTS FROM ART REPRODUC-TIONS: The most common deceptive practice in the print market is unquestionably the misrepresentation of art reproductions as original prints. Novice collectors of modern and contemporary graphic art often unwittingly pay enormous sums for what they think are rare original prints, only to discover later that they have acquired worthless reproductions with hundreds, or even thousands, of identical copies in existence. It is crucial, therefore, for collectors to understand the fundamental difference between original prints and reproductions in order to fully appreciate why one printed image can be worth thousands of dollars, while a copy of the same image is comparatively valueless.

Art reproductions are made by commercial printers, who take a photograph of a painting or a drawing and run off thousands of copies of it on a printing press, employing the same technology that is used to reproduce pictures in books and magazines. The printed images that result are sometimes incorrectly referred to as "prints." However, they are not originals; they are merely copies of an image that an artist created in some other form.

Original prints, on the other hand, are made from images an artist has created directly on a printing plate. A small number of prints are made by the artist, or by a printer following the artist's instructions, usually on a hand-operated printing press. The finished prints are collectively called an *edition.* The artist will normally sign and number each print and indicate the size of the edition in pencil on the face of the impression below the image area. After the edition is printed, the image the artist created on the printing plate is usually defaced to prevent more prints from being made; thus the edition is said to be *limited.* (Detailed descriptions of the various printmaking processes and procedures follow in Chapters 2 and 3.)

The essential differences to keep in mind between reproductions and original prints are: a reproduction is a *copy* made by a printer from a photograph of a painting or a drawing, whereas an original print is a multiply-produced art object made by an artist, and the image he creates for it does not exist in another form. When an artist makes an edition of original prints, there is no single original from which copies are made. The printing surface or *plate* the artist uses to print the images cannot be considered the original, because it only holds the components or features that will produce the image when sheets of paper

are pressed against it. Moreover, it is impossible to appreciate the artist's creative intention by looking at the surface of the plate. As duplicate originals produced in multiple, the prints themselves are the only originals.

Collectors must learn how to examine prints they are interested in purchasing to determine if they were made by the hand of the artist or if they are art reproductions. In addition, buyers should know how many impressions of a print were made, and whether the plate was canceled to prevent further prints from being printed. This information is usually documented in published catalogs, which are available from most reputable dealers or from the library.

Clearly, there is more to buying original prints than merely walking into a gallery and choosing aesthetically pleasing images. Before spending a large sum of money on a print, it is not only important to investigate what you are buying, but also who you are buying it from, just as you would when making any other major purchase.

Most print dealers are honest, responsible merchants who are eager to steer new collectors in the right direction by providing them with helpful information and advice. However, in recent years a number of fast-buck operators have cashed in on the enormous popularity of prints by peddling overpriced, second-rate merchandise to unsuspecting buyers.

Caveat emptor, or "buyer beware," has always been the first rule of the art world, and this maxim certainly applies to prints. The best protection against the rip-off artists in the print market is simply awareness of the problem areas and avoidance of dealers who sell junk. It is essential, then, for collectors to become knowledgeable about prints and to understand how the market works before making their initial purchase.

HOW ORIGINAL PRINTS ARE MADE

AT THE OUTSET, it is important for collectors to become familiar with the various types of prints that are available and to learn how to identify them by the unique visual characteristics of each printmaking technique. Also, knowledge of how a print is supposed to look is helpful when judging the quality of an impression you are considering purchasing.

All prints are made by pressing an inked *matrix*, a printing surface made of metal, wood, stone, or other material, against sheets of paper. There are four basic printmaking methods, and each one requires a different type of matrix: lithography, silkscreen (also called serigraphy), intaglio, and relief printing. Within the categories of intaglio and relief printing there are several variations of the basic techniques, and many artists also combine processes to produce what are known as "mixed media" prints.

LITHOGRAPHY

Lithography was invented in 1798 by a German named Aloys Senefelder and has remained the most popular printmaking process to this day. Many of the great artists of this century, including Pablo Picasso, Henri Matisse, Joan Miró, Marc Chagall and Georges Braque, have created some of their finest work in the lithographic medium.

Lithography is a *planographic* process, which means the image is printed off a flat surface. (Other printing methods require the image to be cut into the surface plane or to be raised above it.) In the lithographic process, a chemical reaction that takes place on the surface of the matrix enables the image to be inked and printed.

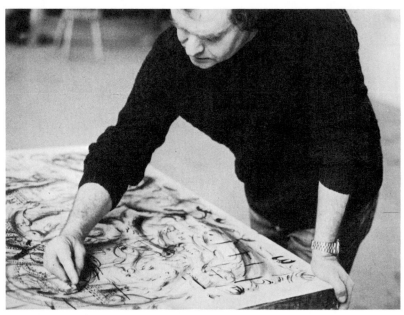

FIGURE 1
To create a lithograph, an artist draws directly on the surface of a limestone slab using a grease crayon or a greasy liquid called tusche.

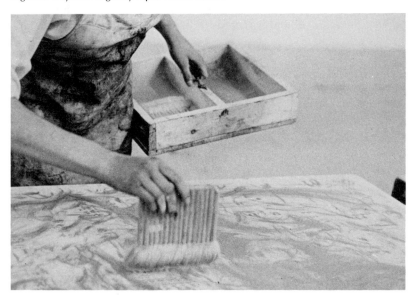

FIGURE 2
The drawing is then stabilized or fixed onto the surface of the stone with rosin, acid, and gum arabic.

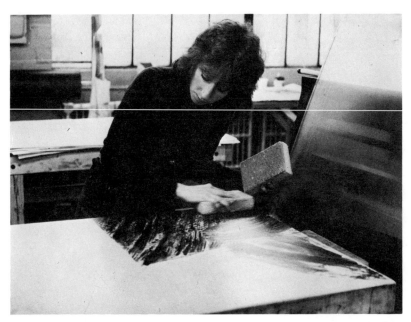

FIGURE 3
Water is sponged over the stone's surface to repel the ink in the non-image areas.

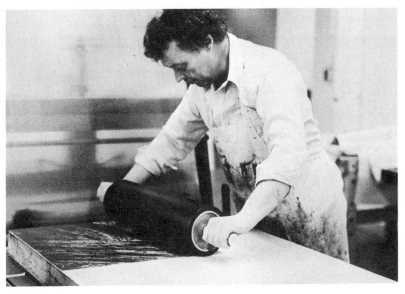

FIGURE 4
Greasy lithographic ink is then rolled onto the stone's surface. The ink adheres to the image, but is repelled in the moist non-image areas.

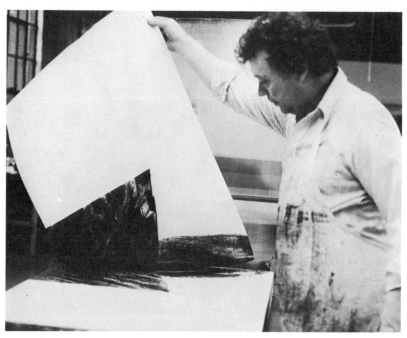

FIGURE 5
The image is transferred to sheets of paper under pressure exerted by the printing press. The process of dampening, inking, and printing the image must be repeated to add each color to every print in the edition.

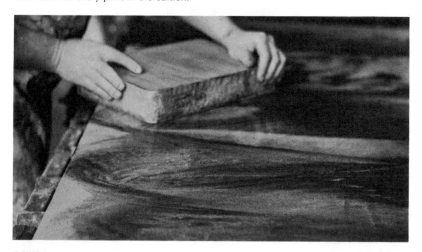

FIGURE 6
After the complete edition is printed, the images on the lithographic stones are ground off with a carborundum abrasive and another block of limestone. The stones are now ready for a new set of images to be drawn on them.

Lithography works on the principle that grease and water do not mix. Using a grease crayon or a greasy ink called *tusche*, the artist makes his drawing directly on the surface of a block of limestone or on a thin zinc or aluminum plate. The stone is then *etched*, or stabilized, with a dilute mixture of acid and gum arabic. Although not strong enough to eat into the stone, this mixture chemically "fixes" the image onto the stone's surface and also makes the non-image areas more receptive to water. A thin film of water is then sponged over the stone's surface, and greasy lithographic ink is applied with a roller. The greasy ink adheres to the drawn areas but is repelled by the dampened non-image areas.

To create an edition of prints, sheets of paper are laid on the inked stone, one at a time, and the stone and paper are then pulled through a hand-operated lithographic printing press under great pressure. The pressure forces the transfer of ink from the stone to the paper. After each sheet of paper is printed, the stone is dampened and inked again so that another print can be pulled.

Multicolored lithographs are made by drawing images on several stones, one for each color of ink. Each stone is placed in turn in the printing press and positioned so that, when printed, the color it holds will be perfectly lined up or *in register* with the colors already printed. If a color is *off register* (not properly aligned), it will overlap the outline and the other colors in the image creating an undesirable blurred effect. Colors are printed one at a time; the sheets of paper must be fed through the printing press one time for each color stone the artist prepares.

Because the crayons and inks the artist works with produce only black lines, the artist must imagine how each drawing will appear when printed in color. This is simple enough when only two or three areas of solid ink colors are added, but the process can become complicated if the artist decides to "mix" additional colors by printing them on top of one another. For example, to achieve a brown hue, the artist would shade the areas to be colored brown on each of the three stones he has designated for red, yellow, and blue inks. When the shaded areas on the three stones are printed on top of one another, the colors combine to produce brown. Each stone must be shaded with a different intensity to achieve the desired color, and the artist must position all the shaded areas on each of the stones in exact alignment.

As the artist works on the stones, several proofs may be pulled for his inspection. When one finally meets with his approval as the finished image, he marks it *bon à tirer* ("good to be pulled" or "good to be printed") and leaves it for a master printer to use as a guide when printing the edition.

Although the artist's drawings on the stones are capable of printing a

thousand or more impressions, only a small number of original lithographs are normally produced, usually 200 or less. After an edition of prints has been pulled, the images on the surface of the stones are ground off in preparation for a new set of images to be drawn on them. If zinc or aluminum plates were used, they are destroyed or defaced to prevent unauthorized prints from being made.

Lithographs are often similar in appearance to crayon drawings. A good impression reveals velvety blacks, soft grays, and rich, luminous colors. Many artists experiment and obtain fine wash effects with soft gradations of tone, which give their prints the appearance of watercolor paintings. Lithographers will often make use of the stone's texture and irregular grain to create unusual tonal effects. Lithographs can be vivid or subtle in color; the creative possibilities for the printmaker are endless.

TRANSFER LITHOGRAPHY: The size and weight of lithographic stones make it next to impossible for most artists to transport them back and forth from their studios to a printer's workshop. Artists who prefer to work in the solitude of their private studios and who do not like the quality of the impressions made off thin metal plates (many artists prefer the texture produced by the lithographic stone on a print's surface) often do their drawings on lithographic transfer paper, which can be easily transported to the printer's workshop for printing.

Transfer paper is treated on one side with a greasy substance that transfers the image the artist draws on the sheet to a lithographic stone for printing. By placing the transfer paper on a prepared lithographic stone and running them both through a printing press, the printer can transfer the image onto the surface of the stone and create prints off it in the normal way.

The transfer method is also used when a large quantity of prints is required. Transfers are made to the second and subsequent stones simply by printing a drawing that has been done on a lithographic stone directly onto sheets of transfer paper. Skilled printers can transfer the drawings from stone to stone, although much of the detail and tonal qualities in the original drawing is lost. This method of "mass-producing" lithographs is often used by European artists to create a large number of posters to advertise an upcoming exhibition of their work. The artist will create an edition of two or three hundred prints, which he will sign and number in the normal way. Then several transfers of the image will be made to other lithographic stones to facilitate a press run of thousands of copies, printed with the gallery name and date of the show below the image.

Some artists use a photographic process to transfer drawings they have created on sheets of paper onto lithographic stones. Although some purists feel that the use of photography disqualifies the prints from being classed as "originals," it is a transfer method that is becoming increasingly popular with many printmakers.

PHOTO-OFFSET LITHOGRAPHY: Many contemporary artists such as James Rosenquist, Andy Warhol, Robert Rauschenberg, and Jasper Johns make use of the photo-offset method, which until the 1960s was only used for inexpensive commercial printing. Since then, the use of the photo-offset process has become a highly controversial issue in the print world, because it employs the same printing method used to make inexpensive art reproductions.

To make an original photo-offset lithograph, an artist first creates a design or assembles the elements of his composition in the way he wants them photographed. The composition is then photographed through a special screen, which translates the tonal values into tiny dots. (These *halftone dot patterns* are normally clearly visible on the finished prints. See Figure 7.) A negative image is then transferred onto a metal plate coated with a light-sensitive, water-soluble solution. This solution

FIGURE 7
An enlargement of a halftone screen showing the dot pattern.

hardens when it is exposed to light. When the negative and plate are exposed to a special high-intensity lamp, the light penetrates the gray and light areas on the negative, causing the coating to harden on the plate where it becomes the image that will be inked and printed. The dark areas on the negative (the non-image areas) do not allow light to penetrate and harden the coating. Because the coating is water-soluble, these areas will be washed out later. The thin metal plate is then attached to a roller and placed in an offset printing press, which inks the image and transfers or "offsets" it onto a rubber roller. This roller rotates and prints the image on sheets of paper.

Although most prints made by the photo-offset process do not qualify as original prints (since the process is more often used to make exact copies of paintings and designs that were originally created in other art media), some artists have found photo-offset lithography well suited to creating certain visual effects, which they are unable to duplicate with other printmaking processes. If the artist starts out with an idea he wants to express as a print, and if he decides photo-offset lithography is the best medium through which to translate his idea onto paper, then there is no reason why collectors should not accept the resulting edition of prints as originals. Collectors must, however, be careful to distinguish between printmakers who employ photography creatively, and those who use it for purely reproductive purposes.

The degree to which the artist manipulates the image to adapt it for photoreproduction is helpful in determining whether it was his intention to create an original work, or merely to allow a printer to inexpensively reproduce exact copies of an image he created in another medium. For example, if an artist assembles a collage of photographs, sketches, or designs to be reproduced by photo-offset (See Figure 8), he may legitimately claim his prints are originals, since the image was created for the purpose of making original prints and with the aesthetic qualities of the photo-offset lithographic medium in mind.

Obviously, it may be difficult for collectors of contemporary graphics to determine why an artist chose to use photo-offset lithography to make his prints, or if an "original" image exists in another medium. It is therefore important to become familiar with the working habits of artists you are interested in, through books, art magazines, catalogs of their work, and discussions with knowledgeable dealers. Before accepting a photo-offset lithograph as an original print, collectors should first learn something about an artist's approach to creating art in other media. Try to find out if the artist works in the traditional manner of painting and drawing images on canvas or paper, or if his art is based on a modern concept which may legitimately be executed by means of

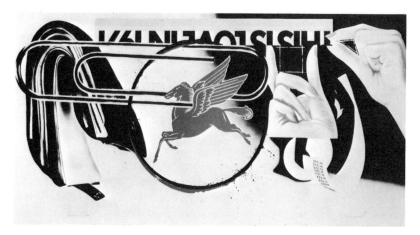

FIGURE 8
JAMES ROSENQUIST (b. 1933), *Paper Clip*, 1974.
Photo-offset lithograph, 36 x 69 in. (91.4 x 175.3 cm).
© James Rosenquist 1981. (Courtesy Brooke Alexander, Inc.,
New York)

some mechanical technique, such as photography. If the artist's work normally involves painting and drawing, in other words, if it is largely a product of his hand, it would seem logical that his original prints would require images to be hand-drawn on the matrix as well.

SILKSCREEN (SERIGRAPHY)

The technique of silkscreen printing (usually called serigraphy or "serigraph prints" when referring to fine art prints) evolved out of Chinese and Japanese stencil printing methods. In recent years it has become a popular printmaking technique for artists such as Victor Vasarely, Roy Lichtenstein, and Toni Onley, as well as many Canadian Indian artists, who have found serigraphy ideal for their bold, hard-edged images in flat colors.

Silkscreen printing is essentially a stencil technique using an open-mesh fabric stretched on a wooden frame to hold the stencil design. (Although the term *silkscreen* is still used, the screens are now made of synthetic fabrics, which are stronger and have more uniformly spaced mesh holes.)

In its simplest form, the artist draws on the screen with a brush and liquid tusche. After the drawing is completed, a glue is painted around the image. The glue hardens and fills the screen holes in the areas not to

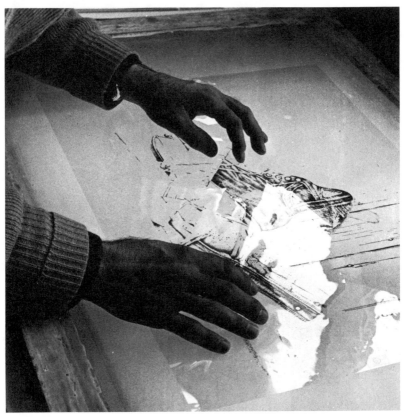

FIGURE 9
Canadian realist painter and printmaker, Ken Danby, demonstrates his technique for making serigraph prints. First, an ink drawing is made on a sheet of clear acetate. The completed drawing is then positioned on a screen, which is treated with a light-sensitive coating.

be printed. The tusche image is then washed out with turpentine, leaving the tiny holes in the mesh open in the image area. Serigraph prints are made by squeezing ink through the mesh in the open parts of the screen to transfer the artist's drawing directly onto sheets of paper.

Multicolor prints require the artist to prepare a separate screen for each color. To make a full-color print, it is not unusual for an artist to use twenty or thirty different screens.

Serigraphs are usually easy to identify by their large areas of solid color and their hard edges. Until recently, it was almost impossible for an artist to obtain soft gradations of color on serigraph prints. However, innovative screen printers have incorporated new technical advances

FIGURE 10

The drawing and screen are pressed together on a vacuum table and exposed to a bright arc lamp. The light causes the coating on the screen to harden in the non-image areas, while the areas protected behind the drawing remain soft. The screen is then washed to loosen the soft coating and open the holes in the image areas. The holes in the non-image areas remain plugged.

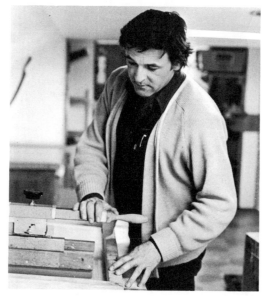

FIGURE 11

Ink is forced through the open mesh holes in the image area with a rubber squeegee, transferring the image onto each sheet of paper.

FIGURE 12
A separate drawing and screen must be prepared for each color. Danby is able to keep the colors in perfect alignment by drawing the image for each screen on an acetate sheet, which is placed on top of a proof of the colors that have already been printed. After each drawing is prepared, the entire printing process must be repeated to add the new color to each impression.

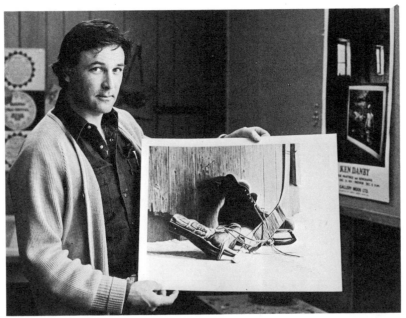

FIGURE 13
A proof of the finished print, a twenty-two-color serigraph entitled *The Skates.*

FIGURE 14
KEN DANBY (b. 1940), *At the Edge of the Pines*,
1979. Serigraph, 18 x 24 in. (45.7 x 61.0 cm).
(Courtesy Gallery Moos, Toronto)

into the making of their stencils, enabling them to achieve a much broader range of effects.

To create a multicolor serigraph such as *At the Edge of the Pines*, (Figure 14), Canadian artist Ken Danby first makes a drawing in black ink on a sheet of clear acetate. The acetate sheet with the completed ink drawing is taped into position on a stretched screen that has been treated with a light-sensitive coating or emulsion. The screen and drawing are placed on a glass-topped vacuum table, which sandwiches the drawing tightly between the screen and the glass when the air is removed. In the next step, the drawing and the screen are exposed to a bright arc lamp for several minutes. The light rays evenly strike the surface of the light-sensitive coating except in those areas protected behind the opaque drawing. When exposed to light, the coating hardens while the areas hidden by the drawing remain soft. The acetate sheet is then removed and the screen is washed to loosen the soft areas of the coating and to open the mesh in the image.

Prints are made by forcing ink through the mesh openings onto sheets of paper with a rubber squeegee. After each pull, the screen is raised, and the print is removed and replaced with another sheet. The procedure is repeated until all of the sheets are printed.

Following the completion of this first printing, a clean acetate sheet is placed over one of the proofs, and Danby begins to draw the second color, visualizing where it will appear and how it will alter the image and color beneath it. When this drawing has been completed, the whole printing process is repeated with another screen. A separate drawing and screen must be prepared for each color.

When the edition is completed, the acetate drawings are destroyed, and the screens are cleaned for future use by dissolving the emulsion with a powerful solvent.

Some artists create serigraphs by exposing a photographic image onto a screen coated with a special emulsion. Others create collage effects by photographing several images and printing them on top of one another in different colors. But all of these modern techniques are simply refinements of the basic stencil printing process invented hundreds of years ago.

INTAGLIO PRINTING METHODS

Intaglio (pronounced in-tal-yo) is a term used to describe any printing process in which the image to be printed is incised or etched into the surface of a matrix. Terms such as etching, drypoint, aquatint, engraving, and mezzotint merely refer to different methods of putting lines and texture into a plate. In each case the printing process remains the same — the transfer of ink to paper takes place below the surface of the plate, and the printed lines stand in relief above the surface of the paper.

ETCHING: Etching techniques were developed in Germany early in the sixteenth century (the earliest known dated etching was made in 1513 by an artist named Urs Graf) and perfected in the middle of the seventeenth century by Rembrandt, who raised the medium to artistic heights as yet unsurpassed by any other artist.

To make an etching, an artist coats the surface of a metal plate with a waxy, acid-resistant substance called *ground*. The artist draws on the plate with a pointed tool, scratching lines through the ground to expose

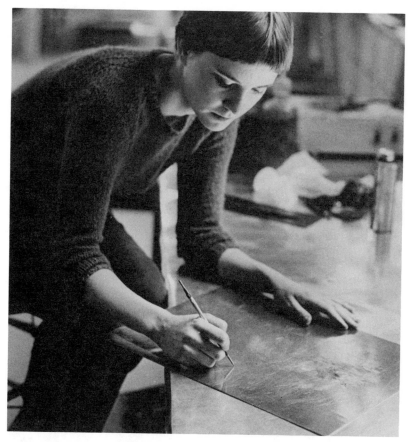

FIGURE 15
To make an etching, an artist uses a sharp tool to draw an image on the surface of
a copper plate, coated with a waxy, acid-resistant ground. The sharp tool scratches
through the ground to expose the metal underneath.

the metal surface beneath. The plate is then placed in an acid solution,
the *mordant*, which etches or "bites" the lines into the exposed surfaces
of the plate. The acid-resistant ground protects the areas of the plate left
blank by the artist.

The ground is then removed, and the entire surface of the plate is
covered with an even layer of ink. The plate is wiped clean with a cloth,
leaving undisturbed the ink that has settled into the lines in the plate,
but removing the ink from the flat, unetched surface.

Dampened paper is then placed over the inked plate. Both are run
through an etching press under sufficient pressure to force the surface
of the paper into the inked lines, where the ink is lifted from the

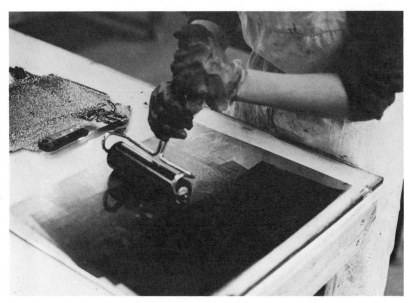

FIGURE 16
After the plate is placed in an acid solution that "bites" the scratched lines into the surface of the metal, the ground is removed and a coating of ink is rolled onto the plate.

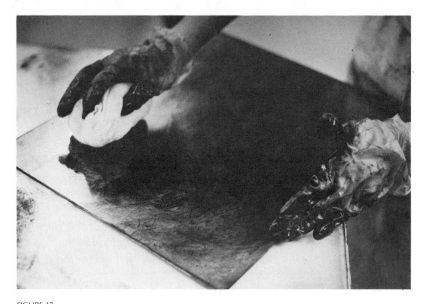

FIGURE 17
The surface of the plate is then carefully wiped clean with a cloth, without disturbing the ink which has settled into the scratched lines.

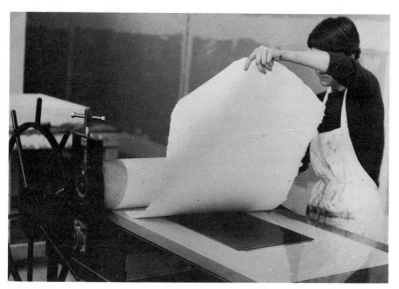

FIGURE 18
The plate is placed in an etching press and a sheet of damp paper is laid over it.

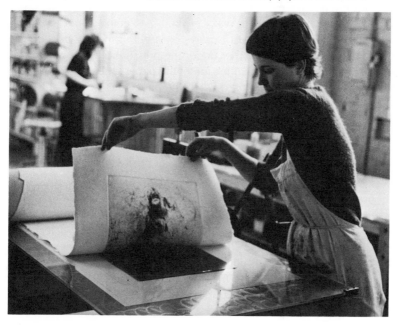

FIGURE 19
The paper and printing plate are run through the press under sufficient pressure to force the surface of the paper into the lines on the plate. The ink is picked up from the grooves and adheres to the paper.

grooves onto the paper. The plate must be reinked and wiped after each impression is pulled.

Artists may achieve a wide range of tonal effects at various stages in the etching process. Light lines and tones are made by shallow etches, which contain a small amount of ink. Heavy lines and solid colors are produced by etching deep lines into the plate, which hold more ink and produce darker impressions on the paper. By immersing the plate in the acid bath several times, darker or lighter effects may be achieved. If, after a trial proof has been pulled, the artist decides that certain areas need to be darkened, he can apply a second coat of ground or a special acid-resistant varnish to protect the areas he is satisfied with and immerse the plate in the acid bath again to eat away more metal in the unprotected areas. This process of darkening some areas while holding back others is called *stopping out*, and it may be repeated several times.

SOFT-GROUND ETCHING: Etchings made by the process described above often look like pen-and-ink drawings. If the artist wishes to make coarse, uneven lines to give prints the appearance of a crayon drawing, he may choose to make a soft-ground etching.

As the name suggests, a soft-ground etching is made by coating a copper plate with a very soft, waxy ground. A sheet of paper is laid on top of the ground, and the artist draws on it with a pen or pencil. The soft ground adheres to the paper under the pressure of the tool and lifts off the plate, sticking to the underside of the paper where the lines were drawn. The metal is left exposed when the paper is removed. The plate is then immersed in acid to etch the image into the metal, and the texture of the paper and the pencil lines are transferred to the plate. Prints are made by inking and wiping the plate and pressing sheets of paper against the image in an etching press.

DRYPOINT: The drypoint technique of making intaglio prints involves the use of a sharp, needle-like instrument to scratch and gouge a drawing directly into the surface of a metal plate. Under pressure, the sharp instrument produces a groove which will hold ink. The metal displaced from the groove is pushed up on both sides of the incision. These two rough ridges of metal are called the *burr*. When the plate is later inked, this burr fills with ink and produces rich, velvety tones on the prints. Unfortunately, the burr wears down quickly, and its soft effects are seldom visible after about twenty prints are pulled.

Since the drypoint technique can be worked quickly and directly on the plate without a ground or other chemical preparation, it is frequently used in combination with other intaglio processes. If an artist uses

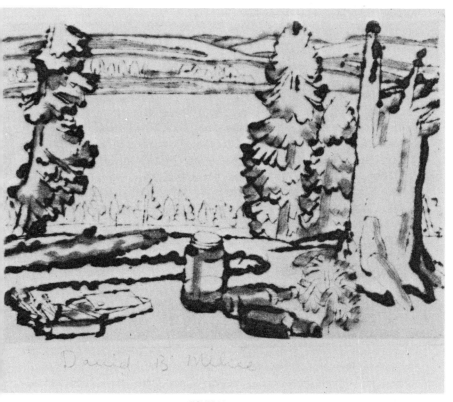

FIGURE 20
DAVID MILNE (1882-1953), *Painting Place*, 1929.
(Published in 1931 as *Hilltop* in *The Colophon* Part V.)
Drypoint etching, $4^7/_8$ x $6^7/_8$ in. (12.3 x 17.5 cm).
Note the drypoint burr (the fuzzy black lines), which
is particularly noticeable on the objects in the fore-
ground.

drypoint tools to accent or touch up etching plates, his prints will then
be described as "etching and drypoint," which simply means the plate
was etched in the normal way and then reworked in some areas with a
drypoint tool.

Print buyers should carefully examine prints with drypoint work in the
image to determine the quality of the burr. If the impression was one of
the first fifteen or twenty printed, the drypoint areas will have a soft, rich
appearance as in Figure 20. Impressions made after the burr was worn
down will be lighter in tone in the drypoint areas. Of course, prints with
an unspoiled burr are worth much more than impressions made after the
thin curl of metal had worn away.

AQUATINT: Aquatint is essentially a tonal process. Invented in the eighteenth century, it is often used by artists to achieve wash effects on etchings.

To shade certain areas of an image with aquatint, the artist dusts the plate with asphalt grain or rosin powder. The plate is then heated, which causes the tiny particles to melt and stick to it, forming a porous ground of acid-resistant dots. The plate is then "bitten" in an acid bath. The acid attacks the metal between the particles and pits the plates with an ink-retaining "grain." The longer the plate is allowed to bite, the darker the image on the prints. It is possible for an artist to achieve a tonal gradation from white to black by interrupting the etching process and stopping out areas which he decides are sufficiently darkened.

Aquatint is often combined with other intaglio processes, particularly etching and drypoint, to make mixed media prints. The printmaker simply stops out with varnish or ground the areas of the drawing not to be shaded with aquatint and applies etching or other intaglio techniques to these areas of the plate.

ENGRAVING: The engraving process was first used for printmaking in the fifteenth century. While the method was well suited to Albrecht Dürer, Andrea Mantegna, and other great draftsmen of the time, it became less and less popular due to the tedious and exacting work of incising an image onto the engraving plate. Apart from a few artists such as Stanley William Hayter and Alberto Giacometti, who experimented with engraving techniques in the 1930s, very few modern or contemporary printmakers have shown much interest in the technique.

To make an engraving, an artist draws on a metal plate with a sharp tool called a *burin* or *graver*, which is forced into the metal to produce deep grooves. Light and dark tones and shading are achieved by variations in the spacing and hatching of the lines. As in the drypoint technique, a small metal burr is formed as the lines are cut. However, the engraver polishes all traces of it away. The lines in an engraving are usually so close together that a burr on one of them would print solid black areas on the paper and cover the delicate lines and hatching — the most notable characteristics of the technique. Engraving plates are usually inked and printed in a press, although small editions may be printed by hand.

MEZZOTINT: The mezzotint process, invented in the seventeenth century, is essentially a method of engraving in tone. It was popular in the eighteenth and nineteenth centuries when it was mostly used for printing book illustrations. The technique experienced a minor revival in

contemporary printmaking in the 1950s and 1960s when Italian artist Mario Avati and Japanese artist Yōzō Hamaguchi created numerous superb images using the mezzotint process.

Mezzotints are made by roughening the surface of a copper plate with a spiked tool called a *rocker*. The rows of tiny indentations are placed close together and cover the entire surface. If the plate were inked at this stage, it would produce a solid black image. The artist creates his design by scraping and gouging out the pitted areas to produce white areas and light tones, and by lightly scratching and polishing the plate to produce darker shades of gray.

RELIEF PRINTING METHODS

The intaglio processes print images from a design that is made below the surface of the plate. Relief prints are also made by cutting into a matrix, but in this process unwanted areas are gouged out of the plate, leaving raised portions on the surface which form the image to be inked and printed. A rubber stamp makes a relief impression.

WOODCUT: The woodcut, an ancient Japanese printmaking process, is the oldest known printing method. It became popular in the West in the fifteenth and sixteenth centuries, when German artists such as Albrecht Dürer combined their artistic talents with the skills of master woodcutters to produce some of the most exquisite prints ever made in the medium. The woodcut process did not appeal to many artists after the sixteenth century, until it was revived by artists such as Paul Gauguin and Edvard Munch in the 1890s.

To make a woodcut, an artist creates a drawing on the surface of a smooth block of wood. The surface on both sides of the lines in the drawing are then cut away, leaving the drawing in relief. When the carving is finished, the surface of the wood block is inked and placed in a small printing press, which forces sheets of paper against the inked image under pressure. Because the press must exert a considerable amount of pressure on the wood block to make clean, rich impressions, the thin lines in the carved image may crack, break, or show signs of wear if a large number of prints are made. Collectors should examine woodcuts and wood engravings (the distinction is only that wood engravings are made on the end grain of a wood block, while woodcuts are made on the side) for broken or missing lines in the image.

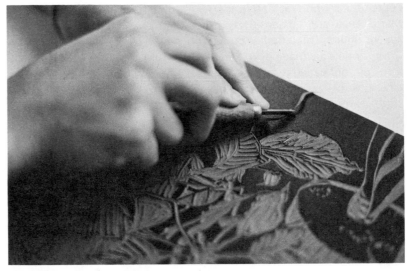

FIGURE 21
Woodcuts and linocuts are made by gouging and cutting the non-image areas out of
a matrix. Here, a design is being cut into a block of linoleum. The raised portions
remaining on the surface of the matrix form the image and the gouged-out areas
remain blank when the matrix is inked and printed.

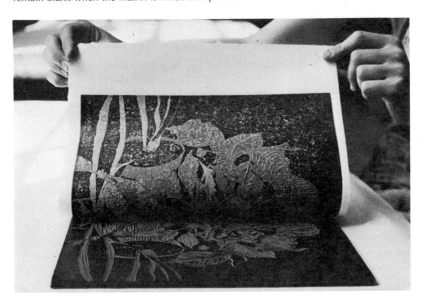

FIGURE 22
Prints are made by pressing sheets of paper against the inked image on the matrix.
The paper and matrix may be run through a printing press, or the back of the paper
may be rubbed with a spoon to press the image onto the paper.

LINOCUT: Linoleum cuts, or linocuts as they are usually called, are a twentieth-century refinement of the woodcut process; the matrix is carved out of a sheet of linoleum instead of wood. Linoleum is much easier to cut than wood and is especially well suited for artists who want to create large prints with broad areas of solid color.

In the printmaking methods described above, each print created is an original work of art, produced in multiple. Since the artist must draw a separate image on a separate matrix for each color he uses, each matrix holds only part of the final image and cannot be considered as "the original." Only the finished prints reveal the beauty and invention in the artist's conception; as multiple originals, they alone represent the embodiment of his creative concept.

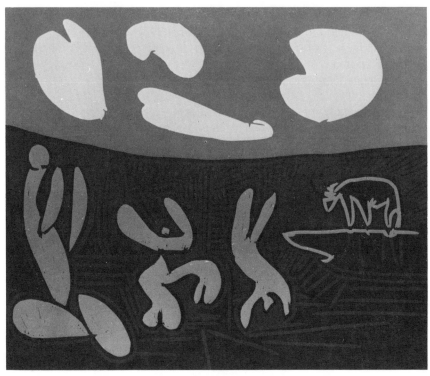

FIGURE 23
PABLO PICASSO (1881-1973), *Bacchanale au taureau,
(Bacchanal of the Bull)*, 1959. Linoleum cut,
20³/₄ x 25 in. (52.7 x 63.5 cm).
© SPADEM, Paris/VAGA, New York, 1981. (Courtesy Albert White
Gallery, Toronto)

LIMITED EDITIONS, NUMBERING AND SIGNING

THE NUMBER OF IMPRESSIONS that are made of a print is normally determined by three factors: (1) the quantity of impressions which can be pulled before the matrix shows signs of wear; (2) the demand in the marketplace for the artist's work; and (3) the amount of time and money the artist or his printer is willing to spend printing the same image over and over.

In the past, the print medium itself determined the maximum number of impressions that could be made. However, the artist's skill in creating the design on the matrix and the printer's ability to obtain as many uniformly good-quality impressions as possible before the printing surface began to deteriorate were important factors as well.

In 1821 a German printmaker and cataloger named Adam von Bartsch estimated the number of impressions that could be produced by the various printmaking methods. According to Bartsch, an engraved copper plate could yield 500 quality prints and several hundred weaker ones; a mezzotint, about 300 to 400, although the quality began to suffer after the first 150; an aquatint made on a copper plate, less than 200; and a drypoint, less than 150 impressions. Bartsch also observed that the fragile burr, which produces the highly desirable rich blacks on a drypoint, was often worn away after as few as fifteen or twenty impressions were made. It should be noted that copper plates were probably more durable in the nineteenth century because the metal was beaten flat rather than rolled into sheets as it is today. Contemporary printmakers probably could not produce quality impressions in the quantities outlined above.

According to Bartsch, a wood block could produce up to 10,000 impressions, depending on how it was cut.

Although lithography had been around for twenty-three years at the time Bartsch published these observations, he failed to include the new medium in his estimates. However, lithographs have often been issued

in editions of several thousand or more. Original lithograph posters by Henri de Toulouse-Lautrec, for example, were often printed in editions of up to 2,000 copies in the 1890s.

LIMITED EDITIONS

Nineteenth- and twentieth-century technological developments make it possible for artists to produce an almost unlimited number of impressions of identical quality. Today, the number of images that are printed off a matrix has little to do with limitations imposed by the various printmaking methods.

A process called *steelfacing*, invented in the mid-eighteenth century, greatly reduces the wear and tear on the printmaker's copper plates. A fine coating of steel (today nickel is sometimes used) is put on the image. It prolongs the life of the plate and enables the printer to make several thousand prints, although in the process some detail and contrast is usually lost in the image. Steelfacing also reinforces the delicate metal curl which produces the burr on a drypoint print. Traces of burr may still be noticeable after several hundred impressions are made off a coated copper plate.

Contemporary printmakers are capable of printing a thousand or more impressions off lithographic stones (the image quality of the later impressions depends on how it has been chemically "fixed" onto the stone), and almost limitless numbers of lithographs can be made by the transfer process described in Chapter 2. Modern photo-offset lithographic processes permit artists to print an unlimited number of impressions, as do silkscreen or serigraphic printmaking methods.

So why then, at a time when most printmaking media have the potential to produce thousands of impressions, do artists continue to make prints in small, limited editions? Clearly, the practical considerations — the market demand for the artist's work and his willingness to spend time and money cranking out thousands of impressions of the same image — are the most important factors influencing the modern practice of limiting editions. Moreover, since nineteenth-century artists such as Camille Pissarro, Paul Gauguin, James A. McNeil Whistler, and Edgar Degas first began to consider printmaking as a serious art form capable of producing unique effects and imagery, and not simply a means to reproduce images, there has been a general desire on the part of artists, print dealers, and collectors to retain a degree of rarity in the production of prints. Today most printmakers follow the practice of limiting their

print editions to whatever number they feel the market will absorb in a relatively short period of time.

Some artists, however, such as the late American printmaker Ben Shahn, are philosophically opposed to the practice of limiting editions, claiming that artificial limitation defeats one of the most attractive aspects of printmaking — the ability to reach large numbers of art buyers with relatively inexpensive works. Limiting editions, they say, only results in higher prices for prints and a reduction in the artist's potential income. In fact, some artists advocate a return to the old practice of making prints on demand. As long as their wood blocks or plates are usable, they see no reason not to print them. (In the early days of printmaking, prints were issued in unlimited editions; wood blocks and metal plates were printed and reprinted until they were worn out.)

Today, edition sizes typically range from 50 to 150 prints, although some artists prefer to make very small editions — anywhere from one to twenty-five impressions — while others create extremely large editions. A few European artists frequently produce editions of 200 to 300 or more prints.

NUMBERED AND UNNUMBERED EDITIONS

Artists began to number their prints toward the end of the nineteenth century, shortly after the practice of issuing original prints in small editions became popular. Since then, most artists have manually numbered their prints in pencil below the image area in the lower margin. The number appears in the form of a fraction, which reveals the size of the total edition and the individual number assigned to each print by the artist. Thus, a "19/25" or "XIX/XXV" notation on a print tells the viewer that it is part of a total edition of twenty-five, and the artist designated this particular impression as number nineteen.

It should be noted that the top number only identifies the order in which the artist numbered the prints. It does not signify the artist's judgment of print quality or the order in which the prints came off the press, since the printing sequence is typically lost as prints are handled, stacked, or hung to dry. When more than one ink color is used, the printing sequence usually varies from color to color. The sequence is also lost if the artist decides to discard inferior impressions.

The printing order would only have significance if later impressions tended to be of poorer quality than the first ones off the press, but as

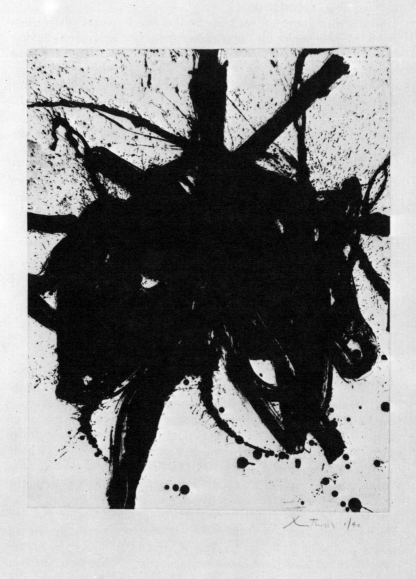

FIGURE 24
ROBERT MOTHERWELL (b. 1915), Untitled, 1979.
Aquatint, 32 x 26 in. (81.3 x 66.0 cm).
©Robert Motherwell, 1981. (Courtesy Brooke Alexander, Inc.,
New York)

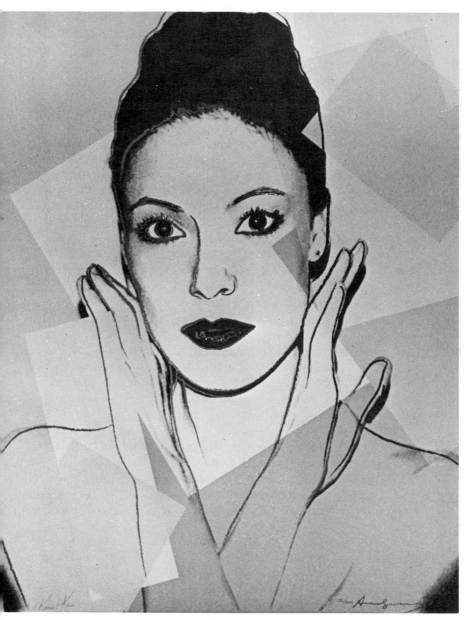

FIGURE 25
ANDY WARHOL (b. 1930), *Karen Kain*, 1980.
Photolithograph and silkscreen, 40 x 32 in.
(101.6 x 81.3 cm).
© Andy Warhol, 1981. (Courtesy Frame Master Gallery, Toronto)

previously indicated, most modern printing processes are capable of printing hundreds of nearly identical impressions. (The exception, of course, is the drypoint method, in which the characteristic rich blacks only appear on the early impressions made before the burr wears away. However, most modern and contemporary printmakers usually make a practice of limiting their editions to whatever number of satisfactory impressions they can obtain off the drypoint plate.) Clearly, a low-numbered impression — 3/25, for instance — is not more desirable or valuable than a print with a high number from the same edition.

The practice of numbering prints, like the practice of issuing graphics in editions, is a marketing device intended to lend an appearance of uniqueness and individuality to art objects produced in multiple. The original idea behind numbering and editioning prints was to give an air of rarity to each impression and, in effect, to provide the buyer with a written guarantee of the total number of identical prints in existence. However, a few unscrupulous European artists and print marketers have devised numerous ways of abusing the system by putting a great many more prints on the market than the numbers indicate. The most popular ways of misrepresenting the size of a print run include: issuing prints in several editions; issuing "deluxe" or additional editions on special paper such as Japan paper; placing notations such as "A.P." for "Artist's Proof" (see below) on hundreds of prints; and numbering extra editions of prints with Roman numerals, or selling them with no numbers at all. The various methods employed by artists and print publishers to extend editions, while maintaining an illusion of rarity, are discussed in Chapter 4.

ARTIST'S PROOFS: It is common practice for artists to retain a number of prints for their personal use. Printers will typically "overrun" the prescribed number of prints for an edition by at least 10 to 20 percent to ensure that the artist will be left with several proofs for himself after he has weeded out and discarded any inferior-quality impressions. When the artist is signing and numbering the regular editions, he also signs his personal allotment of proofs and distinguishes them from the others with an "A.P.," "Artist's Proof," marginal notation in place of the numbering. (Prints made in France are marked "E.A." for "Epreuve d'Artiste" or "H.C." for "Hors de Commerce," meaning "out of trade" or "not for sale.")

Artist's proofs are usually retained by the artist or given as gifts to the printer or other people involved in the creation of the print edition. However, sometimes artist's proofs do end up "in commerce," where they are sold along with prints from the regular edition. Misinformed or

dishonest print dealers often misrepresent them as being more desirable to own than numbered prints from the edition. They reason that since the artist's proofs were once the property of the artist, and since the artist would only retain choice impressions for himself, the artist's proofs are better quality, a greater rarity, and hence more valuable. But there is no reason to believe the proofs are in any way superior to the other prints: they are printed with the rest of the edition or are taken from the printer's overrun. Nor are they necessarily a greater rarity than prints from the regular edition.

While it is customary for artists to designate about 10 percent of the prints in an edition as artist's proofs, some artists have been known to write "Artist's Proof" on dozens of impressions to capitalize on the mistaken popular belief that proofs are more desirable than numbered prints. On the other hand, many artists honestly number their artist's proofs (A.P. 1/10, A.P. 2/10 and so on) and retain them for their own use.

TRIAL OR STATE PROOFS: The creation of an image on a matrix is frequently a process of trial and error. Because it is difficult for an artist to visualize how his markings on the stone, screen, or metal plate will look on paper, several trial proofs are often made as the work progresses. The first proof the artist makes is called the *first state.* If, after inspecting this proof, the artist goes back to his matrix and makes changes to the image and it is proved again, this impression is called the *second state.* This procedure may be repeated several more times until the artist obtains an impression he is satisfied with. The final proof is the one the artist designates as the *bon à tirer* (B.A.T.) and leaves with his printer to follow as a guide for printing the edition.

State proofs are usually retained by the artist or his printer for future reference or as documentation of how a certain print was made. However, these proofs have been known to find their way into the art market along with artist's proofs. But state proofs, unlike artist's proofs, are highly prized by collectors, because they are often unique impressions revealing the stages through which the artist developed his image. (See Figure 26.)

CANCELED PLATES: It has been common practice since the latter half of the nineteenth century for artists to limit the number of prints that can be made of an image by destroying or in some way *canceling* the plates, stones, or screens used to make an edition of prints. The purpose is to prevent unauthorized editions of prints from being made, and to substantiate the artist's claim that the edition will always be limited to

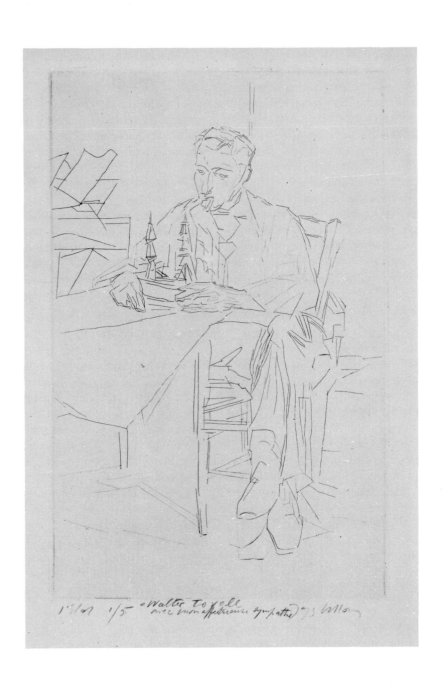

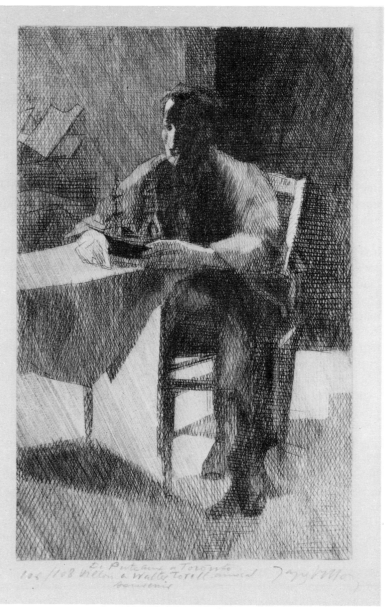

FIGURE 26
JACQUES VILLON (Gaston Duchamp) (1875-1963),
L'aventure, (The Adventure), 1935. Etching,
12^{19}/$_{32}$ x 8^{3}/$_8$ in. (32.0 x 21.2 cm). Left: first state.
Right: fourth and final state.
© ADAGP, Paris 1981. (Courtesy National Gallery of Canada,
Ottawa)

the number of prints and proofs he has specified on the face of each impression.

Matrixes are usually canceled in one of three ways. Images are removed from lithographic stones by grinding the surface with an abrasive material in order that the limestone blocks may be reused. Serigraph images are washed out of silkscreens with a powerful detergent, and they, too, may be used over and over. Copper plates, wood blocks, and linoleum blocks are usually canceled by scoring a large X or a crisscross pattern of lines through the image.

The procedure of canceling the matrix is often witnessed and certified on a document, which is retained by the printer or publisher. Sometimes one or more prints are made off a canceled metal plate as further proof that the plate was indeed destroyed, and if offered for sale, these impressions are prized as collector's items.

RESTRIKES: Although most artists are careful to cancel their plates, stones, and screens to prevent the possibility of someone publishing unauthorized editions of their prints, some artists keep their matrixes intact to give themselves the option of issuing additional impressions of images that prove to be popular with the art-buying public. Reprints that are made, with or without the artist's permission, from the original matrix some time after the first or original edition is printed are called restrikes or late impressions.

Some artists even sell their uncanceled matrixes and allow the new owner to make restrikes from them. (There has always been a market for reusable metal plates and wood blocks; however, lithographic stones are seldom offered for sale, presumably due to their size and weight.) Of course, numerous editions of prints may be produced when a matrix falls into the hands of a dealer or print publisher. For example, in 1913 Picasso sold his etching plate for a print he made in 1904 entitled Le repas frugal (The Frugal Repast). (See Figure 27.) He had already made thirty impressions off the plate before he sold it. The new owner, a Paris publisher and art dealer named Ambroise Vollard, had the plate steelfaced and reprinted an edition of either twenty-seven or twenty-nine impressions (no one is sure of the exact number). Vollard sold the unsigned prints as part of a collection of Picasso etchings called Les saltimbanques (The Acrobats). He later printed an edition of 250 impressions of Le repas frugal, which in its three editions ultimately became the most famous and valuable of all Picasso's prints.

Restrikes are clearly not reproductions, because they are made directly off the surface of the artist's matrix. However, they are usually of inferior quality to the artist's original edition, since they are often made off a

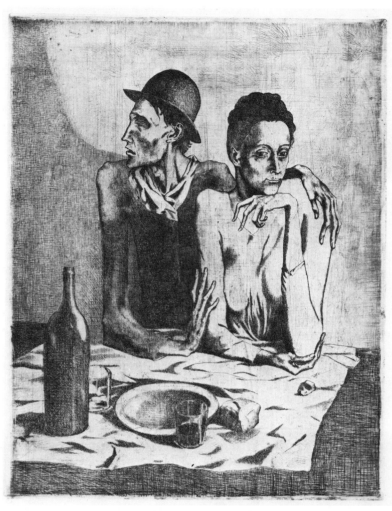

FIGURE 27

PABLO PICASSO (1881-1973), *Le repas frugal, (The Frugal Repast)*, 1904. Etching, $18^{7}/_{32}$ x $14^{25}/_{32}$ in. (46.2 x 37.6 cm). This impression is from the edition of 250 printed by Vollard in 1913.

© SPADEM, Paris/VAGA, New York, 1981. (Courtesy National Gallery of Canada, Ottawa)

worn, reworked, or steelfaced plate. And because they are usually unauthorized, unapproved, and consequently unsigned by the artist, restrikes are typically worth less than prints from the original edition. In the case of Le repas frugal, a signed impression from Picasso's first edition of thirty prints sold at auction in 1973 for $144,000, a world record at that time for a Picasso print. That same year several unsigned impressions from Vollard's edition of 250 restrikes sold for about $25,000 each.

Most restrikes, however, typically sell for less than $100. Reprint divisions of major art galleries and museums, such as the Chalcographie du Louvre in Paris, the Calcografia Nazionale in Rome, and the Chalcographia de Madrid own thousands of etching and engraving plates. They each publish inexpensive restrikes, which are sold to the public in museum-operated retail outlets.

The quality of a restrike depends to a large extent upon the condition of the printing plate. The last impressions made off Rembrandt's etching plates, for example, were struck from plates that survived thousands of reprints and numerous reworkings over the centuries. (Reworking simply means someone has attempted to reinforce worn lines to make them print more darkly.) The images these plates produce are often just pale reminders of the impressions made by Rembrandt himself, and are therefore only worth the small prices the museums charge.

At the same time, many restrikes are not noticeably inferior to the first impressions made under the artist's direction. Some of Gauguin's wood blocks, for example, still produce good-quality impressions, as do many of Picasso's etching plates.

The sale of restrikes is a legitimate practice so long as the price charged for them reflects the quality of the individual impression and the quantity in circulation. Restrikes enable the print collector on a tight budget to inexpensively obtain works by some of the world's most famous artists and printmakers. Although the museum offerings are mostly made from seventeenth- and eighteenth-century plates, some late nineteenth- and early twentieth-century material is available. The Chalcographie du Louvre, for example, sells restrikes by artists such as Raoul Dufy, Henri Matisse and Jacques Villon.

Fraud enters into the sale of restrikes when the quality and rarity of a print is misrepresented. Some merchants buy restrikes cheaply in large quantities, cut off the museum's identification stamp, forge numbering notations and artists' signatures on each print, and sell them for hundreds of dollars each, representing them as part of a rare limited edition. More enterprising print merchants have even tried, with some success, to "uncancel" canceled etching and engraving plates by removing the

scored lines and printing new impressions, which are priced and sold as if they were from the original limited edition.

It is often difficult for the untrained eye of the average print collector to identify a restrike, unless an early impression of the image is available for comparison. Fortunately, the work of most important artists has been thoroughly documented and cataloged, including information on the existence of uncanceled matrixes and restrike editions. Research of published material and contact with museum print curators, dealers, and other experts before making a purchase are the best protection against fraud and misrepresentation.

CATALOGUE RAISONNÉ: A catalogue raisonné is a chronological listing in book form of the complete oeuvre (works) of an artist. It usually includes every print he has created during a certain period in his career. All available information on each print is ordinarily listed including: the title; medium; date of the work and date of the edition (when actually printed); the name of the publisher and printer; measurements of the image or of the entire sheet; number of known states; size of the edition; the number of artist's proofs and the number of prints (if any) that were issued in a "deluxe" or separate edition; the kind of paper that was used to print the edition; a description of watermarks in the paper (a name or a design impressed into the paper during manufacture to identify the paper manufacturer, the artist, his printer, or his publisher); whether or not any or all of the prints were signed; the existence of posthumous or restrike editions; whether the matrix exists intact or has been canceled; and a description of any photomechanically made copies (such as posters) that are known to exist. Separate catalogues are published for the paintings, sculpture, and graphic works of major artists.

Catalogues raisonnés are usually compiled by art historians, scholars, or museum print curators, who often work closely with the artist to ensure that the listings are complete and accurate. Some catalogues raisonnés are considered such reliable sources of information that the artist's prints are referred to by the number the catalogue compiler assigned to each one in his book. For example, Picasso's prints are usually identified in books and auction catalogs by their "Bloch numbers," the numbers assigned to them in the catalogue raisonné, Picasso: Catalogue of the Printed Graphic Work, published in 1971 by Georges Bloch. Catalogues raisonnés are sometimes confused with catalogues illustrés, the difference being that the latter are books containing reproductions of prints. They seldom include complete information on states, editions, restrikes, et cetera.

As a rule, an authoritative catalogue raisonné can be trusted as the best source of information on an artist's work, although it must be remembered that new editions of prints, restrikes, and reproductions of prints may be released by an artist or his heirs after the publication of a definitive catalogue.

Catalogues raisonnés can be found in reference libraries and art museum libraries. They may not be available for relatively unknown artists or artists who have not produced a substantial number of prints in their careers. However, well-researched exhibition catalogs prepared by museum curators, and numerous other books and catalogs that may give sufficient information to evaluate or authenticate an impression are often available in reference libraries.

SIGNATURES ON PRINTS

Prints were seldom manually signed prior to the 1880s, when the invention of photographic techniques for reproducing pictures finally relieved printmakers of the reproductive commercial function of their craft. The introduction of the artist's pencil signature on each impression gave prints an air of respectability at a time when artists were striving to distinguish their innovative "originals" from mechanically made reproductive prints. The signature gradually became accepted as a guarantee of authenticity; individually signed prints gave the art buyer assurance that the work was indeed made by the hand of the artist, and that he had inspected the final product, was satisfied with it, and approved it.

A printmaker named Sir Seymour Haden, who was a brother-in-law of the famous American artist James McNeil Whistler, is generally credited with introducing the practice of hand signing to printmaking. Haden and Whistler began signing their prints in pencil in the early 1880s, and their signed impressions quickly became more desirable to own and hence more valuable than their earlier unsigned prints. In fact, Whistler and Haden were largely responsible for promoting the idea that signed prints are worth a premium, a concept that remains popular to the present day. In 1887 Whistler began charging twice as much for his signed prints as he did for unsigned impressions of the same images. At about the same time, Haden made it his policy to sign for the fee of one guinea any of his early prints that were brought to him by dealers

and collectors. By the late 1890s, the practice of signing prints manually had generally caught on with European and North American artists.

Today, signed prints are always considered to be more valuable than unsigned impressions of the same image, and many artists have cashed in on this knowledge in much the way Seymour Haden did back in the late nineteenth century.

For example, between 1950 and 1969 Picasso sold signatures to a Paris art dealer who owned the entire set of 30,300 impressions that make up Picasso's famous series of 100 prints known as the *Vollard Suite*. Picasso had only managed to sign about 150 of the impressions when they were printed in 1939, and the dealer realized that the remaining hoard would be much more valuable if he could coax Picasso into hand signing each print. Over a period of nineteen years, and for an undisclosed fee, Picasso affixed his signature to approximately 15,000 prints! Whatever price the dealer had to pay for the signatures probably proved to be a bargain when he finally sold the prints. Since Picasso's death in 1973, most signed impressions from the *Vollard Suite* have sold for about double the price of the unsigned prints.

HANDWRITTEN SIGNATURES VERSUS "SIGNED IN THE PLATE": It is important to note the difference between hand-signed prints and those labeled "signed in the plate," or "signed in the stone," or just plain "signed."

Hand-signed prints are signed individually by the artist; each impression bears the artist's signature in pencil, ink, or crayon, usually outside the image area in the lower margin.

When a print is "signed in the plate," the artist has simply drawn his signature in the plate or stone as part of the image; it is printed along with the rest of the design and adds nothing to the market value of the print. Unfortunately, terms such as "signed in the plate" or "in the stone" are often used to deceive art buyers into thinking that a print bearing a signature in the plate is worth a great deal more than one with no signature at all. In 1975 New York State passed legislation which makes it an offence to describe a print as being "signed" unless it in fact has been hand signed by the artist.

The value of a manually affixed signature becomes apparent when unsigned or signed in the plate impressions of an image are sold along with a pencil-signed edition of the same image. The signed in the stone lithograph titled *Nature morte à la bouteille* (*Still Life with a Bottle*) by French artist Bernard Buffet (Figure 28) is one of eleven original prints included in the Buffet catalogue raisonné, *Bernard Buffet, Lithographs, 1952-1966*. It is indistinguishable in quality from the wide-margined,

FIGURE 28
BERNARD BUFFET (b. 1928), *Nature morte à la bouteille, (Still Life with a Bottle),*1967. Lithograph, 12¹/₄ x 9³/₈ in. (31.1 x 23.8 cm). Signed in the plate edition.
(Courtesy Maurice Garnier, Paris)

pencil-signed, and numbered impressions of the same image released in 1967 in an edition of 150. Signed in the stone impressions removed from the book sell in Paris print galleries for about $40, while the individually signed prints typically sell for between $450 and $500. Clearly, in this instance, buyers of the signed in the stone impression receive the best value for their money — so long as they are only interested in the quality of the image they are buying, and are unconcerned as to whether their print bears the artist's penciled autograph. But the fact remains that in today's art market the presence of the artist's manually affixed signature on a print will always make it more valuable and more salable than any unsigned versions of the same image. Most print buyers are willing to pay huge sums for the privilege of owning an artist's autograph, even though hand-signed prints typically cost anywhere from two to four times more than unsigned impressions of the same image.

SIGNATURES ON POSTERS AND REPRODUCTIONS: The artist's handwritten signature on a print is generally assumed to be a guarantee that the impression is an original, created by the artist, and personally inspected and approved by him.

Unfortunately, many modern and contemporary artists are extremely cavalier with their signatures, and for this reason collectors cannot always accept an artist's autograph on a print as certification of authenticity. Some artists sign posters and other reproductions of their work with the intention of merely certifying that they have inspected the copies and approve of their quality. These signed reproductions frequently turn up in galleries where they are misrepresented as originals and priced accordingly.

For example, the late Canadian painter, William Kurelek, once signed a large number of photoreproductions of his best-known paintings in the hope that his signature would make the copies more enticing to a large number of people who admired his work but could not afford his originals. Kurelek's signed reproductions were never meant to be sold as original prints; it was his intention to make them available for not much more than the price of unsigned high-quality art reproductions. But after his death in 1977, a number of dishonest print dealers began to misrepresent the signed copies as "original Kureleks," pricing them anywhere from $750 to $1,500 each.

ESTATE SIGNATURES AND STAMPS: Often someone other than the artist will authorize and sign editions of prints. Posthumous editions of restrikes and reproductions are periodically released and signed by the

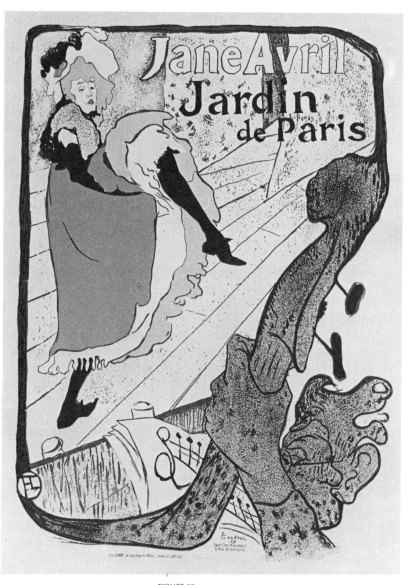

FIGURE 29
HENRI DE TOULOUSE-LAUTREC (1864-1901), *Jane Avril*,
1893. Lithograph, 51 x 37 in. (129.5 x 94.0 cm).
Poster for Jane Avril's appearance at the Jardin de
Paris in 1893.
(Courtesy Yaneff Gallery, Toronto)

FIGURE 30
RICHARD ESTES (b. 1936), *The Restaurant*, 1979.
Serigraph, 27^1/$_2$ x 19^1/$_2$ in. (69.9 x 49.5 cm). From
Urban Landscapes Number Two, a portfolio of
eight prints.
(Courtesy Brooke Alexander, Inc. and Parasol Press, S.A., New York)

artist's next of kin, or rubber stamped with a facsimile of the artist's signature or with an estate stamp. Typically, the heirs of an artist's estate are more concerned with the money to be realized from the sale of a print than its aesthetic value, and poor-quality prints or out-and-out fakes (see Chapter 4) are released onto the market by heirs eager to cash in on a famous relative's name.

The signature of the artist's widow, son, daughter, or grandchild, or the appearance of an estate stamp on a print, has come to mean that the work has been endorsed and authenticated by someone close to the artist — a direct descendant or perhaps an outside expert on his work. The inference is that whoever signed or stamped the print is qualified to make aesthetic judgments on the artist's behalf. Since it is impossible to know if the artist would agree with the decisions made by his heirs, the presence of an estate signature or stamp on a print adds little to its value. A facsimile signature, an estate stamp, or the manual signature of a relative of the artist on a print should therefore only be interpreted as a loose guarantee that the impression is authentic.

A catalogue raisonné of an artist's graphic work can usually provide a good deal of information on his signature. It can tell you if a print should be signed and how the signature should appear. (The catalogues often include reproductions of the artist's signature for comparison.) An authoritative catalogue will also document whether unsigned prints are known to exist in addition to the signed impressions.

Be wary of any print that is supposed to be signed but is not. It may be a valuable trial or state proof, or it could be a late impression or restrike, perhaps made several years after the artist's death. Be equally cautious when considering the purchase of a signed print that the catalogue raisonné lists as being part of an unsigned edition. While there is always the possibility that the print could be a rare, one-of-a-kind, signed impression, there is a much greater chance that the signature or the print itself is a forgery.

FAKES, FORGERIES, AND MISREPRESENTED PRINTS

THE PRINT MARKET has experienced more than its share of misrepresentations, fraudulent practices, and swindles in recent years. The business of faking, forging, and misrepresenting prints is flourishing due to an unprecedented demand for prints by popular artists and certain styles of art.

This great demand has also pushed the prices for quality prints out of reach of many print buyers and opened the door for sellers of what is generally referred to as "schlock" merchandise — poor-quality impressions, restrikes, reproductions, and manually drawn "afters" created by copyists in the style of a famous artist's work.

When authentic signed and numbered prints from small editions by Picasso, Chagall, Miró, and many other well-known artists typically sell at prices ranging anywhere from $2,000 up to well over $100,000, a $500 to $1,000 price tag on a print bearing one of these artist's signatures may seem to be an incredible bargain to novice print buyers. Similarly, when Inuit prints often sell for between $5,000 and $15,000 at auction, uninformed buyers may think they are getting the bargain of the century when "original Eskimo prints" are offered to them for less than $100.

But in the art market you seldom get more than what you pay for; bargain-priced "Picassos," "Chagalls," and "Mirós," or "Neimans," "Rockwells," and "Calders" often turn out to be photoreproductions or hand-copied translations of the artist's work in another medium, and many of the cheap "original" Inuit prints sold in some Canadian galleries are in fact manufactured in Hong Kong factories.

ART REPRODUCTIONS MISREPRESENTED AS ORIGINALS

The most obvious and commonplace fraudulent practice in print selling is the misrepresentation of art reproductions as original prints. Usually, print promoters make photoreproductions of paintings or drawings by well-known, deceased artists, enabling them to trade on famous names without having the artists around to interfere with the scam. There are many examples of this type of fraud.

Photoreproductions of a Picasso crayon drawing entitled *Young Spanish Peasant* were falsely advertised after the artist's death as "the last known work of Pablo Picasso." The mail-order ads claimed that the prints were "original limited edition lithographs" and were "hand pulled under Picasso's direct supervision." However, it is known that Picasso was not involved in any way in the execution of the reproductions, which were made in Paris by a printer named Michel Casse. Today, some merchants are honest enough to acknowledge that the copies were made in an extraordinarily large edition of 2,500, but few charge less than the going rate of $125 to $150 for the reproductions.

Another fraudulent mail-order print promotion in the early 1970s offered "original" prints by the French painter Pierre-Auguste Renoir. A publisher named Jean-Paul Loup ran advertisements in several American magazines to sell poor-quality reproductions of six Renoir paintings, describing them as "authentic Renoir lithographs." (The originals are well-known paintings, which hang in the Jeu de Paume Museum in Paris.) The prints sold for between $225 and $450 each or $2,250 for the set of six and were accompanied by a "Certificate of Authenticity" signed by Renoir's grandson, Paul Renoir. They were also numbered and estate stamped with a facsimile of Pierre-Auguste Renoir's signature. The ads claimed that the endorsement by a member of the Renoir family "guaranteed authenticity," although it was somewhat ambiguously worded: "This lithograph *represents* an authentic work of my grandfather Pierre-August Renoir" [italics mine].

Art experts in both Europe and the United States denounced the fraud, and other members of the Renoir family openly denied that the official Renoir estate stamp had been used to authenticate the six prints. (However, Paul Renoir did in fact sign the certificates of authenticity.) In December 1975, fraud charges were brought against Loup in New York. He agreed to an out-of-court settlement and was ordered to notify each

of his 397 customers that the Renoirs were not originals, and to offer them a full refund. The settlement also prevented him from selling more Renoir prints unless his promotional literature clearly stated that they were reproductions.

Sometimes living artists innocently lend their names and signatures to legitimate art reproduction creations. These end up being promoted and sold through ambiguously worded advertisements as originals. For example, a Toronto mail-order company recently offered signed, full-color, photo-offset lithographic reproductions of paintings by the famous Canadian "Group of Seven" painter, A. J. Casson. Casson personally hand signed and numbered each of the reproductions, he says, "to certify that I approved of the quality of the reproductions, and to guarantee buyers that only 200 copies were made." (In a telephone interview, Casson assured the author that while he had occasionally signed reproductions of his paintings in the past, he recently decided to discontinue the practice, "because you just can't be sure what some promoters will do with them.") Indeed. The prints sold for $275 each, unframed, a price which in itself suggests they are something more than art reproductions. The advertising copy in the company's sales literature variously described the prints as "an original limited edition of signed and numbered lithographs," "fine art lithographs," and "limited edition fine art portfolios." Only in a carefully worded statement by Casson himself (presumably written for him by an advertising copywriter) were the prints described as "reproductions"; however, the crucial word is qualified and lost in the linguistic sleight of hand accompanying it: "These fine art signed and numbered lithographic reproductions were very carefully created with my personal involvement at every phase." The copy also included the following statement, which further misleads the reader into thinking there is little difference between original prints and reproductions: "Whether a print is created exclusively for the print medium or was originally conceived in another medium, we believe, does not affect its artistic integrity." Apparently, when all you have to sell is a signature, the blending of an artistic conception with an appropriate print medium is unimportant.

The edition size of the Casson prints was "guaranteed" with an empty promise that "the plates have been destroyed." However, the only way an edition of photoreproductions could be truly limited would be if the offset plates were destroyed, along with the printer's color separation negatives, the photographer's transparencies or prints and negatives, and the painting itself — so that it could never be photographed again.

These three examples highlight the type of print merchandise that collectors should avoid at all costs — photographically made reproduc-

tions of paintings or drawings sold at prices which do not reflect the market value of art reproductions or the value, if any, of an artist's autograph. (It is important to remember, however, that there is nothing wrong with the sale and purchase of art reproductions so long as they are represented as *copies* of art and are priced accordingly.)

Reproductions of paintings and drawings are usually easy to identify by their flat, dull appearance. An examination of the prints will reveal a halftone screen dot pattern, which indicates the image was printed on photo-offset equipment. (More about authenticating prints in Chapter 5.) A much greater identification problem can occur, however, when reproductions are made of authentic original prints. The images are often indistinguishable from impressions that were printed as part of the original limited edition, because they are often printed by a similar process. Also, unlike photo-offset reproductions of paintings and drawings, the images will be found in the catalogue raisonné of the artist's graphic work.

The most common forgeries of this type are made from lithographed or silkscreened posters, which are often printed to advertise a gallery showing of prints. (The posters are usually printed by transferring an image from the stones or silkscreens the artist used to make an original print onto matrixes which are used by a commercial printer to run off thousands of copies on cheap paper, preprinted with the gallery name, address, and date of the show.) Forgers need only remove the lettering from this type of poster and add a forged signature and numbering notation, and they have created a print which may be difficult to distinguish from the original impressions when placed behind glass in a fancy frame. Often, however, the shiny paper that is used to print large quantities of posters will betray the forgery.

Fraudulent editions of prints are also made by photographically reproducing an impression from an authentic edition of originals. For example, in 1973 an ex-policeman from San Francisco named Roger Gheno was charged and convicted of fraud for creating unauthorized editions of Matisse reproductions and misrepresenting them as originals. Posing as an art dealer, Gheno borrowed several authentic prints by Henri Matisse on consignment from legitimate art dealers. He then photographed and reproduced the images on expensive handmade paper. Several of Gheno's creations were sold as originals in European auction houses, but the scam ended soon after one of the prints was consigned for sale to Sotheby Parke Bernet in New York. Experts there determined it was a fake.

Some editions of reproductions sold as originals are made by artists who have little interest in printmaking as a serious artistic pursuit; but

who want to cash in on the demand for signed "original" prints. Several Canadian Indian artists, for example, have chosen to make their serigraph prints by simply preparing an acrylic painting for a printer to reproduce on silkscreens. The printer will either photographically transfer the image onto the screens or cut stencils for each color and mix his inks to match the colors in the painting. Some artists even destroy their original paintings after the prints are made in an attempt to legitimize the claim that "no single original exists." They feel justified in calling their prints originals, since the image then only exists in the form of an edition of prints. But whether the original painting has been destroyed or not, the prints are only reproductions of images that were originally created in another medium.

FORGED SIGNATURES

Original prints may remain unsigned after an edition is printed for a number of reasons. Some impressions may not have met with the artist's approval, others may have been part of an unlimited edition or may have been originally bound into a book. And restrikes and reproductions are seldom signed by artists.

Any unsigned original print presents an inviting opportunity for a forger. By adding a signature, he can double or triple the print's value. Phony signatures have turned up on many of the unsigned impressions from Picasso's *Vollard Suite*, for instance. Also, many inexpensive restrikes from the Chalcographie du Louvre have been altered to look like expensive originals. Forgers simply trim off the museum's identification stamp in the margin and add a penciled signature and numbering. Unsigned original prints by Chagall, Miró, Calder, Rauschenberg, and numerous other artists were printed in huge editions and bound into art magazines such as *Art in America, Derrière le Miroir*, and *Verve*. These are also inviting sources of merchandise for would-be art forgers. The fold-out prints are frequently removed, pressed flat, given phony signatures, and sold as signed originals; however, they are usually easy to identify by the poor-quality paper, staple holes, and large creases across the image.

Art reproductions provide forgers with another unlimited source of prints for conversion to expensive "originals." An extreme case of this type of forgery was reported in Canadian newspapers in 1980. A Hamilton, Ontario, art dealer was charged with twenty counts of fraud,

including the forging of A. J. Casson's signature on fifty prints, which he sold to a leasing company for $15,000.

Facsimile signatures are sometimes added to prints by photographically copying an artist's autograph and either printing it in the margin along with the image while an edition of restrikes or reproductions is being run off, or stamping each impression with a rubber stamp made from the copied signature. Several years ago, a London, England, art dealer had a stamp made of Chagall's signature and used it to "sign" dozens of original Chagall prints that were bound into copies of the French art magazine *Verve*. Numerous prints by Renoir, Dufy, Picasso, and several other artists also have stamped or printed signatures, which may pass as being authentic if not examined closely.

Facsimile signatures are usually much easier to detect than forged pencil signatures. If the signature and image were reproduced by photo-offset, a close inspection may reveal the halftone screen dot pattern. All printed and stamped signatures have a flat, uniform appearance, and do not shine as most authentic pencil signatures do when examined at eye level under a reflected light.

Forged signatures handwritten in pencil may often be identified by consulting an authoritative catalogue raisonné. It will usually illustrate the artist's signature at various stages in his career, allowing you to make a direct comparison with an authentic specimen of his handwriting.

It is important to remember, however, that not every signature on reproductions, restrikes, and posters is necessarily a phony. Artists have been known to autograph unsigned prints and reproductions on request, for the benefit of a charity, or for a fee.

"AFTERS" — THE WORK OF COPYISTS MISREPRESENTED AS ORIGINALS

Many print collectors think they are buying an original print by Picasso, Chagall, Miró, Dali, Rockwell, Calder, Matisse, Dufy, and numerous other famous artists, when in fact they are being sold a copy of one of the artist's paintings re-created as a print by a craftsman or "copyist."

These artists, and several others, have from time to time allowed skilled copyists to manually copy their oil paintings, watercolors, or drawings onto lithographic stones or plates for the purpose of making an

FIGURE 31

HENRI DESCHAMPS (after Picasso), *Côte d'Azur*.
Original lithograph poster created by copyist
Henri Deschamps after a painting by Picasso.
(Courtesy Posters Saint Germain, Toronto)

edition of prints. There are varying degrees of participation by the artist in the creation of these editions. Some artists may actually collaborate in the adaptation of their paintings into the print medium by working on the plates or stones, or by approving the *bon à tirer* proof before the edition is printed. But most simply sign and number the finished prints, which are entirely the work of copyist craftsmen.

Salvador Dali, for example, will frequently sell a print publisher a *gouache* (a type of watercolor painting) for a copyist to reproduce on a matrix. Dali's price (reportedly in the $30,000 to $40,000 range) includes several hundred sheets of paper with his pencil signature positioned on each one just below the area where the image will be printed. He simply hands over his painting and the signed sheets of paper, and allows the copyist to interpret the image as a print. The finished prints are sold as signed and numbered "original Dalis," even though Dali himself may have had nothing to do with their creation. It is possible that he may never have even seen some of the copyists' interpretations of his paintings. Yet each print bears a pencil signature, which suggests the image was made or at least approved by the artist.

It is also known that the late American illustrator, Norman Rockwell, allowed copyists to make his prints for him. (Rockwell only made one experimental original print in his life.) Several years before his death, Rockwell agreed to allow many of his *Saturday Evening Post* cover illustrations to be "translated" into the lithographic medium. Rockwell's involvement in the creation of these prints consisted of numerous inspections of trial proofs to verify their approximation to his original paintings, and the signing and numbering of the editions. The rest of the work was carried out by anonymous craftsmen and printers. The dozens of high-priced, signed and numbered "Rockwell" prints that are available today in hundreds of galleries are either manually copied facsimiles of Rockwell paintings or photographically made reproductions of them.

Today, it is not uncommon for print sellers to misrepresent copyists' prints, or *afters* as they are sometimes called (since they are created "after" or in the style of pre-existing works), as original prints created by the artist himself. Although afters are created by means of the traditional printmaker's method of drawing directly on a printing plate or stone, they are not originals in the true sense of the word, because in most cases the artist had little or nothing to do with the execution of the image as it appears in the edition of prints.

The fact that an artist lends his name and signature to a print does not mean that the work is equal in terms of monetary or aesthetic value to works originating from his own hand. An artist may choose to sign afters to show his approval of the copyist's translation of his artistic concep-

tion into a graphic medium. Or he may decide to sign certain editions of afters because he admires them as works of art which stand on their own merit. And unfortunately, some artists have been known to sign editions of afters simply because someone offered them a large sum of money for a few hundred signatures.

In the past twenty years, the tremendous popularity of original prints by the superstars of modern and contemporary art, combined with the demand for signed impressions by "name" artists, has caused the practice of marketing the work of copyists under an artist's name to become big business. Most art buyers expect that all manually signed prints by a certain artist must be products of his own hand. To capitalize on this misconception the involvement of copyists in the creation of a print is normally concealed from the public, a practice that enables print sellers to misrepresent afters as original prints.

Few copyists today identify themselves on the face of the prints they create as the copyists, engravers, printers, and publishers did in the past. Pre-twentieth-century afters are easily identified by their inscriptions, which usually appear inside the image or just below it in the lower margin of the print. The various craftsmen who were involved in the creation of the print were identified, as well as the artist who created the image or original painting that was copied. (In the seventeenth and eighteenth centuries, prints were made primarily for the purpose of reproducing paintings. Engravers often hand copied paintings onto an engraving plate and made large editions of prints. These were sold as cheap souvenirs of the important art of the day.)

A typical seventeenth-century etching by Wenzel Hollar, for example, bears the inscription "Hans Holbein 1532" and "Hollar fecit 1647," stating that Holbein painted the original, and Hollar copied it (*fecit* means "executed it"). No one could possibly confuse the reproduction of Holbein's painting with an "original Holbein," since it is clearly identified as the work of Hollar *after* a painting by Holbein.

Similarly, when an artist designed an image and executed it as a print, he would often indicate in the margin that he performed both functions himself. For example, a seventeenth-century etching by Jacques Callot entitled *Les grandes misères de la guerre* (*Miseries of War*) bears the inscription "Callot inv. et fec." ("Callot designed it and executed it").

Most afters or *gravures d'interprétation* made between the seventeenth century and mid-nineteenth century identify the artists and craftsmen who designed, executed, and printed the image by name and give a description of each person's function. Printmakers discontinued this practice during the second half of the nineteenth century when photographic techniques of reproducing images made the traditional repro-

ductive functions of printmaking obsolete.

The modern-day practice of artists allowing copyists to make their prints for them originated in France in the 1950s when a number of highly skilled craftsmen were trained in printmaking workshops or *ateliers* to adapt paintings by famous artists into the various printmaker's media. These copyists or *chromistes* assisted artists in the creation of their original prints. By working closely with artists over many years, several copyists became extremely skilled in duplicating their styles in the print medium. The copyists' prints were originally made for the purpose of illustrating artists' paintings in deluxe art books or reproducing paintings on posters, which were printed to advertise an exhibition of an artist's work. Some afters were also published in signed limited editions to meet the growing demand for prints by popular artists.

Today, thousands of afters circulate on the print market with no markings on them whatsoever to identify their true creators. The signed pseudo Rockwells, Calders, and various works by the School of Paris artists mentioned above are often either deliberately or innocently priced by many print dealers on a par with legitimate prints by these artists.

While some afters are quite skilfully done, many others are, at best, poorly drawn, uninspired interpretations of an artist's imagery. Under close examination, handmade copies generally have a rather crude appearance; individual lines lack the graceful, fluid quality of those created by the artist himself. The spontaneity and sensitivity of an artist's original works are usually lost in the translation from paintings to prints. Collectors who are familiar with the artist whose work is being represented will usually have little difficulty distinguishing afters from prints that were created from designs made directly on a matrix by the artist's hand. However, there are a number of other, more conclusive ways of determining if a print was executed by the artist himself or by a copyist.

First, look for a copyist's identification inscription, which may be found on or near the lower margin of the image. Although most contemporary copyists do not indicate their involvement in the creation of a print that is supposedly by a famous artist, a few do identify themselves on the faces of their prints. They follow the traditional practice of placing a tiny typographical notation, which identifies them by name and indicates the function they performed, within the image near the lower margin. For example, some prints made by the French copyist Charles Sorlier after paintings by Dufy, Chagall, and several other artists, bear a tiny typographical inscription near the margin, "CH. SORLIER. GRAV. LITH." Similarly, a close examination of prints in the style of Georges Braque may reveal the name of another Parisian copyist, Aldo Crommelynck, who identifies his work with the inscription "ALDO CROMMELYNCK GRAV."

Other names which may turn up in the form of a copyist's inscription include: Deschamps, Durasiers, Guillard, and Mourlot. Fernand Mourlot is the owner of the famous Paris *atelier*, Mourlot Imprimeurs, in which most contemporary copyists learned their trade.

It is important to look for an inscription bearing one of these names when purchasing prints (particularly lithographs) by Picasso, Chagall, Miró, Matisse, Dufy, and other popular European artists. The absence of an inscription, of course, is no guarantee that the print was made by the artist himself. As indicated above, copyists of modern and contemporary art normally do not identify themselves on the faces of the prints they create, presumably in order not to jeopardize the sale of their images as original works by the artist being copied. Prints by Dali and Rockwell, for example, will seldom, if ever, bear a copyist's inscription line.

Next, check authoritative catalogues raisonnés of both the artist's graphic works and unique works. If the print in question is the work of a copyist, it will *not* appear in the catalogue of graphic works. However, if a similar image is found in the catalogue of the artist's paintings, it would most certainly indicate that the print was copied after the painting.

While afters are not normally listed in the catalogue raisonné of an artist's original prints, it is important to look at the reproductions in the catalogue of graphic work for vaguely similar images to the print in question. Often, a catalogue raisonné of graphics will give clues to the origins of certain afters that were made "after" genuine original prints. In Europe, copyists are sometimes employed to make transfer lithographs off the artist's stones for the purpose of producing a large edition of posters. The image may be reworked or slightly altered in the process, and a description of it may be found in the catalogue raisonné under the listing for the artist's original image.

For example, in the fourth volume of the catalogue raisonné of Marc Chagall's lithographs, under the illustration and description of an original print entitled *Le Magicien de Paris I (The Magician of Paris I)*, the following statement is given: "This lithograph was reproduced as an exhibition poster. 10,000 copies were printed. The inscription CH. SOR-LIER GRAV. LITH. appears at the bottom right of the illustration, which must on no account be considered as an original [print]."

Finally, always comparison shop. After visiting a number of dealers and closely examining several prints by an artist, you will probably be able to distinguish the uninspired creations of copyists from the works showing evidence of the artist's personal touch. (Chapter 5 describes various other ways to authenticate prints.)

MISREPRESENTED EDITION SIZES

Not all misrepresentations in the print market can be blamed on dishonest mail-order merchants, art dealers, forgers, and copyists. In many cases, the artists themselves are responsible for some of the deceptive practices, due to laziness, greed, or a simple desire for fame and fortune through widespread distribution of their imagery. For example, the edition size noted in the margin of many prints made in Europe often does not reveal the total number of impressions that were made. The traditional practice of limiting the number of artist's proofs to about 10 percent of the edition size is often ignored. Some artists who enjoy a worldwide demand for their work extend their editions by simply writing "A.P." or "E.A." (artist's proof) on hundreds of impressions, which are outside the regular edition. These prints are released onto the market without any numerical notation to inform prospective buyers of the actual number of impressions that were printed.

Other artists expand the size of their editions by signing and numbering a deluxe edition on a special paper such as *Japon nacré*. For instance, the Spanish printmaker, Alvar, usually issues each of his prints in a standard edition of 225 images on ordinary paper, such as Arches Vellum, and an additional 75 "deluxe" images on Japan paper, plus another 25 artist's proofs for each edition and 5 or more *hors de commerce* impressions on both types of paper.

Some artists misrepresent the true size of their editions by numbering prints in such a way as to create an illusion of rarity when in fact hundreds, or even thousands, of identical impressions are printed. The total press run will be broken down into several sets or editions, which bear more acceptable edition sizes. For example, a press run of 500 prints may be numbered as follows: one set numbered in the normal way as an edition of 200 prints; a second set of 200 will also be numbered, but perhaps using Roman numerals to distinguish it from the first batch and to prevent two prints from having the same number; and finally, the remaining 100 prints may be designated as artist's proofs.

When an artist and his publisher are confident that thousands of prints of a certain image will sell worldwide, the edition will often be broken down into several sets. Each set is designated for a certain market, and the intended destination is usually indicated on the face of the print next to the numbering. Some editions of Salvador Dali's prints, for example,

bear numbers such as "A 1/300" ("A" for "America") and "E 1/300" ("E" for "Europe"), and so on, and presumably a sizable number of artist's proofs accompany each edition as well.

Although buyers of prints bearing Arabic numbers often have no way of knowing of the existence of a second edition (unless an authoritative catalogue raisonné or some other documentation is available), they should be wary of any print with a capital letter designation preceding the number notation, and of prints from an edition numbered with Roman numerals. However, some artists number their artist's proofs with Roman numerals, for example, "A.P. XXI/XXV," to further differentiate them from their regular edition of prints. (This designation on a print is not to be confused with the practice of numbering hundreds of prints with Roman numerals to disguise the true edition size.)

Some European artists produce unsigned and unnumbered editions of prints, which are technically original, but are printed in extraordinarily large editions. Often a small signed and numbered "limited edition" is issued of the same image, and these prints sell for much more than they would if buyers were aware of a parallel unlimited edition. For example, several years ago the French magazine *Verve* published sixteen color lithographs by Marc Chagall and bound them into issues of the magazine, which then had a press run of 6,500 copies. Shortly thereafter, the same sixteen lithographs were published in separate signed and numbered editions of seventy-five prints with wide margins. Both editions were printed from Chagall's original zinc plates. Since a print's market value is based at least partly on rarity, buyers of prints from the much more expensive signed and numbered limited edition would certainly be dismayed if they discovered their print exists as one of 6,575 impressions, not 75 as stated in the marginal notation.

Because the number of existing prints of an image often determines to some extent the market value of each impression, buyers of modern and contemporary European prints must be extremely cautious. They should do some research on a print before paying the outrageous prices that many prints from large editions command. Moreover, many of the prints from Europe that are offered in several editions are in fact afters, created with little or no involvement by the artists themselves. Also, it is anyone's guess as to the authenticity of the pencil signatures appearing on prints from extraordinarily large editions. If an artist is not interested in taking an active part in the creation of his prints, it would seem logical that he would also be unwilling to spend hours signing hundreds or even thousands of finished impressions; probably this task is often delegated to copyists as well.

FIGURE 32
MARC CHAGALL (b. 1889), *Moses and his People*,
1973. Lithograph, 12⁴/₅ x 9⁴/₅ in. (32.5. x 25.0 cm).
This lithograph was originally published in an
edition of 50 wide-margin, manually signed and
numbered prints.The same image (with trimmed
margins) was also used as the frontispiece of the
book, *The Biblical Message*; 10,000 copies of the
book were printed.
© ADAGP, Paris 1981. (Courtesy Phillips Ward-Price Ltd.,
Toronto)

HOW TO AVOID BEING DUPED

It is important to know that the practice of issuing prints in several editions is a modern-day European custom. Very few North American printmakers and publishers are known to make a regular practice of misrepresenting edition sizes. In fact, most American and Canadian publishers and printmaking workshops keep precise records of the exact number of prints, artist's proofs, and state proofs that are in existence. A few even issue certificates signed by both the artist and publisher, which disclose the exact size of the edition, as well as the total number of proofs that were made, and declare that the matrix was destroyed or canceled in some way after the edition was completed.

Only three states (and none of the Canadian provinces) have passed laws requiring print dealers to make similar disclosures to their customers.

California passed legislation in 1971, which applies to all original prints sold in the state for over $25 unframed and $40 framed. Print sellers must provide their customers with information such as the name of the artist; the year the image was printed and the name of the printer or workshop where it was made; the total number of signed and unsigned impressions, including all proofs authorized or in existence; whether or not the print is a restrike, and if so, the degree to which the matrix was reworked or altered before reprinting; and finally, the total number of prints in all editions in existence.

If a print buyer in California discovers within one year of purchase that a print was misrepresented, he may receive a full refund of his money plus interest. If it can be proven that the print dealer knowingly sold a print in violation of the law, the seller may be forced to pay the buyer three times the purchase price plus interest.

The State of Illinois passed similar legislation in 1972. It also requires dealers to disclose the medium and methods employed to make a print, in addition to providing the information specified under the California law.

The disclosure requirements of both states apply only to print editions issued after July 1, 1971, in California, and July 1, 1972, in Illinois. Both state laws specify that a dealer may issue a categoric disclaimer professing his ignorance about a print's origins, in lieu of giving his customers a full disclosure or the specified information.

New York State and New York City are the only other two jurisdictions that have passed legislation governing the sale of original prints. New York State passed a law in 1975 making it an offence to label or describe a print as "signed" unless it has been manually signed by the artist. The New York law also makes it illegal to alter a print in any way, such as adding a numerical notation to give a print the appearance of being part of a limited edition or cutting the lettering off a poster, without disclosing the alterations to the buyer. If a buyer discovers that a print was sold to him in violation of the law, he is entitled to a full refund. In New York City it is also against the law to describe a print as being part of a limited edition if the edition size was not predetermined by the publisher, or in the case of mail-order offerings, by the actual quantity purchased within a short period of time.

Clearly, with so few laws in force to protect them from deceptive advertising, labeling, and marketing practices, print collectors must come to rely on their own instincts, research, and knowledge when making a purchase. The laws described above in fact offer little protection to print buyers. Dealers can easily skirt around them with a written disclaimer and an explanation that they could not possibly know how many impressions were made of every print they sell, particularly those from some far-off atelier. Also, none of the laws regarding the sale of prints require print publishers and dealers to disclose information about the participation of the artist in the actual creation of the image, information which would be very helpful in determining if certain reproductive prints or afters are worth the price dealers ask for them.

To avoid getting stuck with a fake, a forgery, or a misrepresented print, choose your print dealer or auction house with care. Generally, signed reproductions, afters, and prints from unlimited editions are found in print galleries which offer art-as-investment gimmicks. Questionable merchandise also turns up in mail-order print offerings, charity auctions, bookstores, picture frame shops, some public gallery or museum shops, and print sales by small auction companies, particularly those which operate one-shot sales in hotels.

Regardless of how honest a dealer may seem, or how impeccable his reputation may be, it is important to obtain a bill of sale for each print you purchase. It should clearly state the following:

- the title of the work, name of the artist, and particulars such as the image's catalogue raisonné number and the date or year the print was made

- the printing process employed and whether the print is an original

- the size of the edition, the edition number on the print, and whether the image exists in other editions

- whether the print was hand signed *by the artist*, unsigned, or signed in the plate

- whether the print is a restrike or an art reproduction

- the price charged, and any exchange and refund privileges.

While this may sound like a lot of information to request on a single bill of sale, a brief description such as *"Trois femmes (Three Women)* original etching by Pablo Picasso, 1938 (Bloch number 303) signed in pencil by the artist and numbered 47/50 from a total edition of 50. . . . $5,200" will usually be sufficient protection should the authenticity of the print or its signature ever be in doubt.

Apart from choosing a print dealer with care, and only buying impressions that are documented in an authoritative catalogue raisonné, the best protection against fraud and misrepresentation is research, knowledge, a trained eye, and the specialized expertise that print collectors refer to as "connoisseurship." Chapter 5 describes the skills print experts must develop and gives tips on becoming a print connoisseur.

BECOMING A
PRINT CONNOISSEUR

THE BEST PROTECTION against fraudulent practices is a thorough knowledge of an artist's work, combined with a trained eye able to recognize styles and techniques, the various printmaking processes, paper types, and watermarks.

Not everyone, however, has the time or the inclination to become a print expert, or the opportunity to examine a large number of quality impressions by major artists. But even occasional print buyers need to know how to examine prints in order to authenticate an impression they are considering purchasing, and how to inspect an authenticated print for defects to determine if it is worth the price asked. Although books on prints, catalogues raisonnés, and auction and dealer catalogs are helpful in checking a print's pedigree, no amount of reading and research can equal the knowledge gained from close examinations of many prints.

It is often possible to examine a large number of authentic prints in the print rooms of many public libraries and museums. Usually, libraries and public galleries make a practice of only purchasing superb quality impressions, and if such a collection is available locally and open to the public, it can be an excellent resource for research. Museum print curators frequently make themselves available to answer your questions and will sometimes offer an unofficial professional opinion on the authenticity of prints that collectors bring to them. Nevertheless, it is very useful to know how to examine prints yourself to determine if an impression is authentic and in good condition.

Prints cannot be examined properly if they are in frames, so it is important to ask the dealer or auction house to open the frame of a print to permit a close examination of both the face (recto) and back (verso) of the impression. If the dealer refuses to open the frame, make sure you get a written, unconditional money-back guarantee on the bill of sale allowing you to return the print should a later examination prove it to

be a fake. Most dealers in contemporary prints stock both framed and unframed impressions. Providing that they have been stored properly, the *unframed* ones are infinitely more desirable, since prints are easily damaged by the cheap or improper framing materials used by many dealers and by exposure to ultraviolet light while on display in the gallery.

Unframed impressions also enable the buyer to measure the full sheet, including the margins, and permit an unrestricted examination of the image with a magnifying glass. (Two invaluable pieces of equipment should be carried by all print collectors — a five- to ten-power magnifying glass and a tape measure with measurements in inches and feet on one side and centimeters and millimeters on the other.)

If a valuable print is purchased in a frame, it should be removed at home and inspected to authenticate it and to check the quality and condition of the impression.

AUTHENTICATING A PRINT

There are six basic examinations, which can be performed without any specialized equipment, to check the authenticity of a print. In most cases one or more of the following examinations will unmask forgeries of modern and contemporary prints:

1. *MEASURE THE IMAGE AND PAPER SIZE:* The first task in determining a print's authenticity is to measure the dimensions of the image and the overall size of the sheet of paper. Always check a print's measurements against the dimensions documented for the image in the catalogue raisonné of the artist's graphic work. Manufacturers of art reproductions often enlarge or reduce the size of their copied images (unless it is their intention to pass the work off as originals) and a discrepancy in image dimensions of more than 3/16 of an inch makes a print highly suspect. However, paper has a tendency to stretch and shrink when dampened for printing and when stored under certain atmospheric conditions, so slight variations in the image size should be no cause for alarm.

The overall size of the sheet gives few clues to the authenticity of the print, since it is a simple matter for forgers to trim paper to the size of the sheets the originals were printed on. Nevertheless, it is important to

FIGURE 33
JASPER JOHNS (b. 1930), *Land's End,* 1979.
Lithograph, 52 x 36$^1/_2$ in. (132.1 x 92.7 cm).
© Gemini G.E.L. Los Angeles, Calif. 1979. (Courtesy Gemini G.E.L., Los Angeles)

measure the sheet size to determine if the margins have been trimmed to fit a frame. Cut margins reduce a print's value.

2. *CHECK FOR EVIDENCE OF PHOTOMECHANICAL REPRODUCTION:* After measuring and confirming the image size with the dimensions specified in the catalogue raisonné, the next step in authenticating an impression is to identify the printing process that was used to print it. As indicated in Chapter 4, the most common fraud in the print market is the representation of reproductions as originals. Photomechanically made reproductions are usually easy to spot with a good magnifying glass. Magnification will reveal the halftone screen dot pattern used in this process to break down the gray tones and colors in a painting into tiny dots that produce similar tones and colors on printed reproductions.

Some types of reproductions, however, are made without the use of halftone dot screens and can be very difficult to detect even when inspected under a magnifying glass. Original etchings, engravings, woodcuts, and linoleum cuts, which are essentially line drawings printed in black ink with no gray tones in the image, may be reproduced photographically without the telltale dot patterns, or by photoengraving processes called *photogravure* and *heliogravure.*

The best method for detecting this type of reproduction is to examine the print at several distances and from various angles. Photoengraved lines tend to be heavy and blunt-ended when examined under a magnifying glass, whereas hand-drawn or incised lines on an original etching, drypoint, or engraving come to a gradual point. (See Figure 35.) From a distance, photoengraved reproductions usually appear flat and even. When viewed from various angles, the smooth, dull surface of the paper in the image area may also suggest that a print is a copy, since original impressions made by the intaglio and relief processes have a three-dimensional look and feel to them. Etchings and drypoints have embossed or raised surfaces in the inked areas where the paper was forced into the incised lines, while woodcuts and linocuts typically have raised areas on the verso of the print, where the image carved into the block was pressed into the surface of the paper.

Reproductions of intaglio prints made by the heliogravure method, however, will also have raised areas in the surface of the paper, because the matrix used in this process is similar to the artist's original. The photographically reproduced lines may even be reworked by hand to make a more convincing copy. However, the inked lines will often appear rough and grainy or crudely drawn when compared to an original print made by the artist's hand.

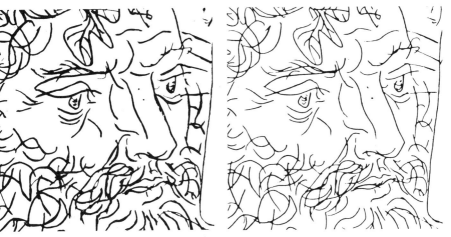

FIGURE 35
PABLO PICASSO (1881-1973), *Sculpteur, modèle accroupi et tête sculptée, (Sculptor, Crouching Model, and Sculpted Head)*, 1933. Etching, $10^5/_8$ x $7^5/_8$ in. (26.9 x 19.4 cm). Plate 39 from the *Vollard Suite*. Detail on left shows heliogravure reproduction of the image. Note thick coarse, blunt-ended lines, compared with the thin, tapered lines of the original shown on the right.
© SPADEM, Paris/VAGA New York 1981. (Private Collection)

Intaglio printing plates and lithographic stones usually leave what is known as a *plate mark* or indentation around the perimeter of the image, where the shape of the printing plate was pressed into the paper under the pressure of the printing press. However, the absence or existence of a plate mark gives few clues to the authenticity of a print since only slight traces of it may remain on some original lithographs, and phony plate marks can be easily pressed into paper around the image area of a reproduction.

Reproductions generally have a rather coarse surface texture, and the colors appear dull and flat, whereas the surfaces of most original prints have a rich, silky luster. The inks on a multicolored lithograph, for example, are built up in layers on the paper, and the surface appearance of the image will vary from shiny to dull where the colors overlap. By contrast, the inks on art reproductions usually appear to have been absorbed by the paper.

3. *IDENTIFY THE PAPER AND WATERMARKS:* The paper on which an impression is printed can offer several clues to the authenticity of the print. Paper can usually be identified by appearance, feel, or watermarks, and should be checked against the paper type specified for the impression in the artist's catalogue raisonné. If the paper of the print in question does not match the paper type that the catalogue identifies as being used to print the edition, the authenticity of the impression would certainly be in doubt. (However, trial proofs are often pulled on odd sheets of paper that the printer has on hand.)

Contemporary printmakers in Europe and North America generally print their editions on handmade paper or on special papers manufactured in France, such as Arches or Rives paper. Some artists print special editions of their prints on papers made in the Far East from rice hulls or mulberry bark, such as Japan, China, or India papers. Each type has a distinctive character and texture. An artist carefully selects the paper that is most appropriate for his image.

The papers artists use are usually one of two types, laid or wove. *Laid* paper is made on screens which produce horizontal and vertical lines across the surface. The closely spaced grid pattern may be visible when the paper is held up to a light. *Wove* paper has an even-textured surface with no lines. Both types of paper may be handmade or manufactured commercially; the former is preferred by most artists for printmaking. Some artists even have their paper custom-made for them by specialist craftsmen.

The identification of paper by the manufacturer's watermark is of the utmost importance in the detection of fakes and restrikes. Encyclopedias

of watermarks are available to assist in dating pre-nineteenth-century prints and papers, but unfortunately, no such directory exists to aid collectors of prints made in the nineteenth and twentieth centuries. However, enough information is usually provided in an authoritative catalogue raisonné to identify papers and authenticate a print with some degree of certainty. (Again, there are exceptions to the rule — watermarks have been faked in the past, and some modern print forgers are careful to print their fakes on the same type of paper that the originals were printed on. But not every faker is so meticulous about his work, and watermarks often provide important clues to the authenticity of a print.)

The absence of a specific watermark on a print as described in a catalogue raisonné or catalogue illustré is almost certain proof that the impression is a phony or a restrike. For example, the Thames and Hudson catalogue illustré of Picasso's *Vollard Suite* specifies that 250 copies of each image were printed on Montval paper measuring $13^3/_8 \times 17^5/_{16}$ inches and watermarked "Vollard" or "Picasso" (artists frequently have their own names or initials watermarked on custom-made paper). An additional fifty prints were made of each impression on Montval paper measuring $15^1/_8 \times 19^{11}/_{16}$ inches and watermarked "Papeterie Montgolfier à Montval." Any impression from the *Vollard Suite* bearing a different watermark would be a fake.

It is not uncommon for catalogues raisonnés to give similar detailed descriptions of the papers that were used to print an edition of prints. Often this information alone offers sufficient proof as to the authenticity of an impression.

4. *COMPARE THE IMAGE WITH AN AUTHENTICATED IMPRESSION OR FACSIMILE:* Forgers tend to reproduce an artist's most popular images, since they are the easiest to sell. Fortunately, the well-known prints that are in great demand are also the impressions that have received the most attention from scholars, and usually a great deal of information is available on them in the form of specifications of the originals and good-quality photographic reproductions in books and catalogs for comparison.

If possible, a print should also be viewed alongside an authentic impression by the same artist. A side-by-side comparison enables you to check the image and print quality against a known original, and will often reveal other obvious faults if the print in question is a phony.

5. *EXAMINE THE SIGNATURE:* Signatures on prints are somewhat easier to examine and may also provide important clues to the authen-

ticity of a print. First, check the catalogue raisonné to find out if and how the print in question is supposed to be signed. Some artists change their signatures and signing habits several times over their careers, and as mentioned in Chapter 3, certain editions of prints will often remain unsigned for a variety of reasons. The catalogue should describe how and where the artist's signature should appear and on which prints. It should also identify which prints bear estate stamps or facsimile signatures. A catalogue raisonné of Renoir's work, for example, indicates which impressions are known to have estate stamped signatures and which ones were signed by the artist.

A signature should be examined under a magnifying glass to determine if it was added by hand, or rubber stamped, or photographically reproduced and printed along with the image. Pencil signatures should leave a slight indentation in the paper's surface and should shine in reflected light. A rubber stamp signature will likely take on a flat, fuzzy appearance under magnification, and a photographically reproduced signature will be easily identified by the halftone screen dot pattern. Always compare signatures which appear to be hand signed with samples reproduced in the catalogue raisonné.

6. *IDENTIFY STAMPS, INSCRIPTIONS, OR OTHER SIGNATURES:* It is very important to examine a print for other identifying stamps, inscriptions, or signatures which may appear below the image or on the verso of the print.

In the past, an artist's printer would often hand sign prints along with the artist. Today many printmaking workshops print or emboss their own *blindstamp* or *chop mark* on every impression they print. The presence of such a signature or stamp may give some further assurance of authenticity.

Information on the previous owners of a print, the dealers and auction houses who may have sold it in the past, or an indication that a print was once displayed in a prestigious public gallery or museum may provide further clues to the authenticity of an impression. Although few collectors of modern and contemporary prints follow the traditional practice of placing their own distinctive collectors' marks or stamps on every print they own, the *provenance* or history of previous ownership may be established from inscriptions and other markings. Picasso, for example, gave many of the early impressions of his famous *Le repas frugal* etching to friends and acquaintances (there was virtually no market for them when Picasso was a relatively unknown artist). Some of the prints he gave away bear a personal, handwritten inscription to the recipient. After Picasso became famous and numerous other edi-

tions and reproductions of *Le repas frugal* were published, the early, signed impressions with inscriptions to Picasso's friends (many of whom had become famous themselves) became the most desirable to own, since they were the earliest prints made from an unsteelfaced plate, were signed, and had a provenance which could be traced directly back to the artist.

Stamps, signatures, and other notations that confirm a print was once in the possession of someone close to the artist give the collector further assurance that the impression in question is authentic. Any print bearing the stamp of an artist's official dealer or publisher will likely be authentic, unless of course the stamp has been faked. Many prints published in the 1920s and 1930s by Ambroise Vollard, for instance, have his personal watermark on each impression.

It must be remembered, however, that a provenance in the form of an unknown collector's mark, or even conclusive evidence that a print was part of a famous person's estate, may be of little relevance in determining its authenticity and value. The assurance that at some time in the past a certain person or institution owned a particular impression often proves nothing, unless the former owner happens to have a reputation for being a great print connoisseur.

Nevertheless, knowledge of a print's previous ownership, its appearance in books and auction catalogs, or its inclusion in a public exhibition can be somewhat helpful in determining authenticity and market value. And certainly the research of a print's provenance from whatever inscriptions or markings are found on it will make the impression a much more interesting conversation piece to own.

In addition to consulting an authoritative catalogue raisonné and thoroughly examining prints as outlined above, wary print collectors subscribe to publications such as *The Print Collector's Newsletter* and *Print Collector*, which report on fakes as they appear on the market. (Addresses for both publications are given in the Resource List at the back of this book.)

While the best protection against getting stuck with a forgery is knowledge and connoisseurship, the second-best protection is to only purchase prints from reputable dealers and auction houses that offer money-back guarantees which will allow you to confirm a print's authenticity within a reasonable period of time.

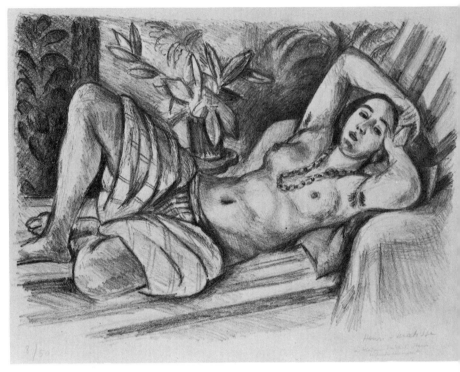

FIGURE 36
HENRI MATISSE (1869-1954), *Odalisque aux magnolias, (Odalisque with Magnolias)*, 1923. Lithograph, 11^1/$_5$ x 15^4/$_5$ in. (28.5 x 40.0 cm).
© SPADEM, Paris/VAGA, New York, 1981. (Courtesy Yarlow/Salzman Gallery, Toronto)

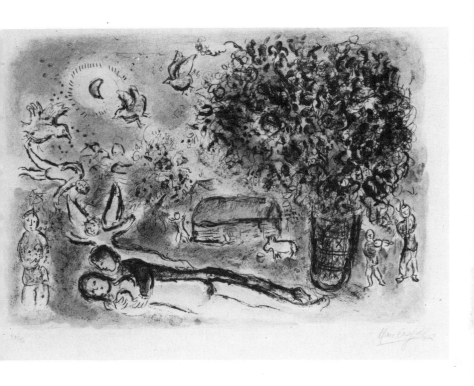

FIGURE 37
MARC CHAGALL (b. 1889), *Pastorale, (Pastoral),* 1977.
Lithograph, 15³/₄ x 23¹/₄ in. (40.0 x 59.1 cm).
© ADAGP, Paris 1981. (Courtesy Albert White Gallery, Toronto)

THE QUALITY OF
THE IMPRESSION

After a print is authenticated, the next concern is the overall quality of the impression — the image content, the selection of a suitable print medium for its execution, the artist's or printer's ability to exploit the inherent qualities of that medium for the best possible presentation of the image, the quality of the printing, and the condition of the matrix that was used to print the image. Each of these factors plays an important role in the determination of both the aesthetic and monetary value of a print.

IMAGE CONTENT: The quality of a work of art should, first and foremost, be judged in terms of image content — the artist's ability to express a visual concept and communicate the idea in an appropriate print medium. When making such judgments, it is important not to confuse *content* with *craftsmanship*. Many contemporary artists seem unable to get past the concerns of the technical craft of printmaking to concentrate on truly inventive imagery, and much of what is passed off as great printmaking today is, at best, visual gimmickry created on a printing press. More than ever before, printmakers seem to concentrate on the technical wonders which produce certain effects on the surface of a sheet of paper, rather than on image content and the aesthetic value of their work. At the same time, many collectors appear willing to appreciate prints solely on the level of craftsmanship.

True print connoisseurs, however, develop an ability to distinguish between mere technical wizardry on the printing press and the inventive and expressive qualities of a print made by an artist who is skilled in presenting visual concepts in a graphic medium. They purchase the work of printmakers who have a unique sense of vision — artists who have developed their own styles and present their artistic concerns from an unusual perspective. They look for strong content, as opposed to purely decorative images, and perceive technical craft as only being important for the best possible presentation of a given idea. This is not to say that connoisseurs underestimate the value of technical competence and print quality. They realize that brilliant conceptions can be ruined through sloppy printing, the selection of poor-quality or inappropriate paper, or the failure to match the visual concept with a suitable print medium. But the appreciation of technical skill is of secondary importance to the overall inventiveness and expression of an original concept.

IMAGE QUALITY: When judging the quality of an impression, it is also important to assess the suitability of the print medium chosen by the artist for the image. The most successful prints are those which reveal a perfect blending of the artistic concept with the print medium selected by the artist. Eric Nasmith's woodcut, *Whimbrel Moving West on Lake Ontario* (Figure 40), is an excellent example of how an artist can exploit the inherent qualities of his medium for maximum impact. The texture of the woodgrain in the matrix provides a suggestion of rough water, and the cuts of a circular saw blade enhance the sense of movement of the whimbrels across the image. It is doubtful that the same effect could have been achieved in any other medium.

The second assessment of image quality involves the paper the artist has chosen to print the edition on. This can be a particularly important consideration if the image is offered on two or more types of paper, since different paper textures and colors can significantly alter the appearance of an image. Many European artists, for instance, print a regular edition on a coarse-textured paper such as Arches and a separate "deluxe" edition on more expensive Japan paper. The so-called superior edition may be priced considerably higher than the regular edition, even though the image may be much better suited to the heavier French paper. If an image is available on more than one kind of paper, always try to make a side-by-side comparison. While some people may prefer the hard, crisp appearance of an image printed on European papers, others may be willing to pay extra for the subtle richness and softened colors that are characteristic of images printed on Oriental art papers.

The quality of the printing job itself should also be inspected. Colors should be in alignment or "register," and the image should be straight on the paper. Uneven inking or an exceedingly heavy inking of a printing plate often produces an image which is lacking in intermediate tones; details in the design may be missing in areas where the ink was applied too heavily or lightly. If a print appears to have several imperfections, you could try to compare several impressions of the same image, but the variation in print quality within contemporary editions is usually negligible.

Prints that are made in editions of a few hundred impressions from wood blocks, linoleum blocks, lithographic stones and plates, and silkscreens, should be of uniform quality. However, repeated inkings and passes through the printing press can quickly wear down the image on an intaglio plate, and the rich velvety blacks produced by a drypoint burr can show signs of wear after as few as fifteen or twenty prints are pulled. The etched lines of an unsteelfaced copper plate become thin

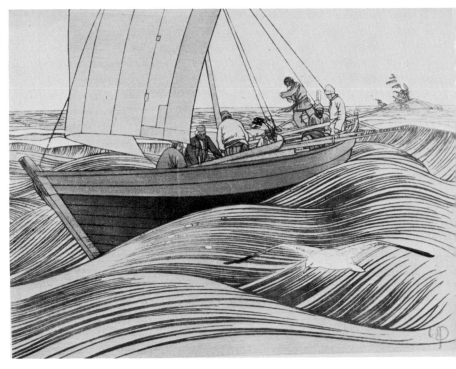

FIGURE 38
WALTER JOSEPH PHILLIPS (1884-1963), *York Boat on Lake Winnipeg*, 1930. Woodcut, $10^{1}/_{4}$ x $13^{3}/_{4}$ in. (26.0 x 34.9 cm).
Reproduced by permission of Gladys K. Phillips. (Courtesy Sotheby Parke Bernet (Canada) Inc., Toronto)

FIGURE 39
TONI ONLEY (b. 1928), *Silver Shore, Japan*, 1978.
Serigraph, 11 x 15 in. (27.9 x 38.1 cm).
(Courtesy Gallery Pascal Graphics, Toronto)

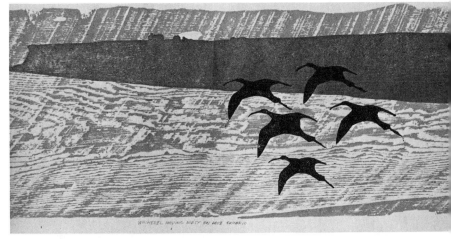

FIGURE 40
ERIC NASMITH (b. 1916), *Whimbrel Moving West on Lake Ontario*, (detail) 1976. Woodcut, 10 x 31 in. (25.4 x 78.7 cm).
(Courtesy The Wildlife Gallery, Toronto)

and hold less ink as the plate wears down under repeated printings. Obviously, early impressions off copper plates are the most desirable. They may be recognized by their rich, solid blacks, sharply defined unbroken lines, and the presence of drypoint burr if the artist worked on areas of the plate using that technique. Late impressions or restrikes of etchings, aquatints, and mezzotints may be identified by their light, broken lines and the overall "thinness" of the image. Aquatinted areas on a worn plate lose their even texture and become weak and mottled.

Worn intaglio plates are often reworked; thin lines may be brought back to life through re-etching or retracing with a burin or drypoint tool. Attempts to revitalize an image can usually be spotted without much difficulty, because the reworked lines often have a coarse, uneven appearance and stand out in sharp contrast to any undoctored lines.

Always try to compare an intaglio print with a reproduction in a book or catalogue raisonné, which will often show sufficient detail to judge the quality of the print in question.

THE CONDITION OF
THE PRINT

The physical condition of a print can seriously affect its market value. Stains, tears, marks, creases, abrasions, dirt, faded ink colors, and evidence of repair work will severely reduce the value of a print, particularly if a relatively large number of impressions are known to exist in superior condition, as is the case with most modern and contemporary prints. (Collectors of old master prints are often willing to overlook slight damage on a rare impression, since scarcity is usually the more important factor in determining market value.)

A magnifying glass will permit you to uncover many defects which are invisible to the naked eye. Examine the image, the margins, and the verso for repairs, stains, and discoloration (particularly around the perimeter of the image where the paper within the window area of the mat may be discolored due to overexposure to light). Tears, abrasions, erasures, and other defects may also diminish the print's value. Look for traces of *foxing* (brown spots caused by the interaction of acids in mold and impurities within paper); slight spotting may be detected by holding the print up to a bright light. Check along the top margin for signs of damage or stains left from framing materials — tape, glue, paper hinges, or evidence of the paper being "skinned" where old hinges were torn away.

A print that is glued or permanently mounted in some way on a sheet of cardboard or other material is worth less than one that is unmounted. Prints that are pasted or taped around the edges to their mounts are often described as *laid down* in auction catalogs, and generally should be avoided unless they can be purchased for a good deal less than their unmounted value. Collectors are usually reluctant to pay top prices for mounted prints because of concerns over possible defects on the verso, which may be hidden by the cardboard, or fears that the print may eventually become stained either by the glue that was used to mount the impression on the board or by acids and other impurities within the board itself.

In the print market, impressions in pristine condition are the ones collectors prize most. For this reason, a print with trimmed margins will also be worth less than a similar impression with intact or "full" margins. (Framers will often cut a print's margins down to fit a certain mat or frame size, and even though the width of the margins is usually hidden behind the mat, the value of a trimmed impression will be

considerably less than one with intact margins. Often, a poor-quality print with full margins will sell at auction for more than a superior impression of the same image with cut margins.)

The preference for wide margins probably originated in the late eighteenth century when collectors first began to take prints out of portfolios and frame them as decorations. Prints with wide margins looked better behind glass, and the practice of selling prints with untrimmed margins caught on and continued into the nineteenth century when some artists even began to decorate the margins of their prints with tiny sketches known as *remarques*. Although few twentieth-century artists place remarques next to their images, wide-margined prints continue to be prized by most collectors.

Clearly, there are many "rules" for buying prints that should be broken from time to time when common sense suggests that a certain impression is a good buy in itself even though it may not conform to whatever hallmarks of quality in printmaking happen to be in vogue. Unsigned impressions, prints with trimmed margins, late impressions or restrikes, and prints needing minor repairs should always be considered on their own merits, and providing the prices charged for them reflect their deficiencies, there is no reason why they should be categorically dismissed as unworthy merchandise.

At the same time, however, remember that a print that has certain undesirable qualities may be difficult to dispose of should you decide to trade it in or sell it. Dealers, auctioneers, and other collectors may not be as willing as you are to overlook a print's imperfections.

WHERE AND HOW TO BUY PRINTS

PRINTS MAY BE PURCHASED from a number of sources — retail galleries and specialist dealers, auctions, mail-order companies, museum shops and art lending services, print publishers, and other print collectors — to name just a few. There are advantages and disadvantages to buying from the various types of sellers, and varying levels of expertise available from each to guide you in your initial purchases.

RETAIL DEALERS

If you are a novice collector, the best places to buy prints from are a retail gallery that specializes in graphic art or a gallery that acts as a major dealer for an artist whose prints you are interested in collecting. Specialist dealers tend to be the most knowledgeable about prints and the print market in general, while staffs of galleries which represent one or more artists on some sort of exclusive basis are usually the best informed on the graphic works of their group or "stable" of artists.

It is very important to develop a good working relationship with one or two print dealers who demonstrate a willingness to share their knowledge and expertise in identifying and authenticating prints, in addition to giving an honest opinion of the quality, condition, and value of the art they sell. Most dealers are willing to spend time talking to novice collectors about prints and offering them friendly advice on their initial purchases, on the theory that well-informed customers will become better customers in the long run. Many dealers are frustrated collectors themselves and are eager to keep their clientele informed

of new acquisitions or new editions of prints published.

A good way to find specialist dealers is to check the Yellow Pages of your local telephone directory under "Art Galleries and Dealers," and to look through publications such as *The Print Collector's Newsletter, Art in America*, or *artmagazine* for dealer advertisements offering works that suit your taste and budget. Lists of dealers who belong to professional associations such as the Art Dealers Association of America and the Professional Art Dealers Association of Canada are also useful and may be obtained by writing directly to these organizations (addresses are given in the Resource List). To become a member of either group, a gallery must have been in business for at least five years and must have a reputation for high standards and honest, responsible dealings with the public, museums, artists, and other dealers.

Look over the magazine ads, the Yellow Pages, and association membership lists and select several dealers who sell the type of prints that you are interested in collecting. (Listed specialties in the association directories are often as specific as "prints by nineteenth- and twentieth-century masters," or "contemporary American prints.") After eliminating the dealers that are of little interest, visit or write the others and ask if they publish a stock list or print catalog. Many print dealers do a substantial part of their business by mail, and publish elaborate catalogs (for which there may be a small charge) listing their current offerings with descriptions and photographs of each print. Dealer catalogs enable collectors to shop for prints from dealers all over the world without ever leaving home. Many dealers will send prints out for a week or ten days "on approval" to customers they know or to anyone who can supply suitable references, while others require payment with orders and allow customers to return prints for a refund if unsatisfied. The catalogs are also a useful way to comparison shop and to get an overall picture of what is available in your area of interest. Always save these catalogs for future reference. They provide you with a useful guide to the graphic art that is currently being produced and a permanent record of prices on a certain date.

Novice collectors are well advised to visit several print dealers in person, if possible, before plunging in and making their first purchases. Gallery hopping not only enables you to compare prices, but more importantly, it provides you with an excellent opportunity to look at and check the quality and condition of large numbers of prints firsthand. Also, a brief chat with the various gallery owners will reveal which dealers are reputable, responsible, and true print connoisseurs themselves, and which ones are simply fast-buck promoters of what is generally referred to in the trade as "schlock" art.

Good print dealers — the only ones serious collectors should deal with — are generally easy to identify by their willingness and ability to intelligently discuss the prints they sell in terms of the artist's aesthetic concerns, the historical importance of his work, his printmaking technique, and the quality and condition of the impression. The best print dealers are those who display a genuine love for the art they sell. It must be remembered, however, that all dealers are in business to sell prints and make a profit, so a certain amount of sales hype is to be expected. But if a dealer cannot answer your questions and talk enthusiastically about an artist's work without turning every comment into a sales pitch, it may be wise to shop elsewhere.

A reputable dealer in contemporary prints should be able to provide you with answers to all your questions, either from printed literature on hand, or by calling the publisher of a print or the atelier that printed it. There should be no excuse for a dealer not knowing or not being able to obtain information on the origins of an expensive print, the size of the edition, the number of proofs, the existence of a deluxe edition and other pertinent data, particularly if the print is by a well-known artist. Most North American print publishers and workshops keep accurate documentation on file for each edition of prints they produce, and usually this information is made available to dealers and collectors. A good dealer won't hesitate to contact a publisher or atelier for more information or documentation.

The best dealers will offer unconditional refunds should a print's authenticity be questioned at some future date, and most will allow their clients to exchange or upgrade purchases within a prescribed period of time.

Another indication of a dealer's competence, expertise, and trustworthiness is the extent of his library of art books, auction catalogs, print market newsletters and catalogues raisonnés. Learned dealers usually maintain extensive libraries in their galleries to assist them in setting prices and verifying the authenticity of prints they acquire. No credible print dealer would purchase an expensive print before authenticating it with an authoritative catalogue raisonné. A good test of a dealer's expertise is to request appropriate documentation confirming a print's authenticity to see what evidence he presents as conclusive proof that an impression is genuine. Be wary of any dealer who cannot produce a catalogue raisonné (or a photocopy of a catalogue raisonné page describing the image in question) or some other authoritative document which testifies to a print's authenticity, such as a publisher's print documentation sheet or a certificate of authenticity signed by the artist.

It is also important to look for a dealer with tastes in art that are compatible with yours. Print dealers with good taste are easily recognized by the quality of the art they sell and their willingness to defend their selection in terms of aesthetic or historical value.

Dealers with no taste or standards are also easy to recognize by the type of art they handle and the manner in which they sell it. Their galleries are generally hung with dozens of undistinguished decorative graphics by artists who have reputations for not treating printmaking as a serious artistic pursuit. The same names and images appear with remarkable consistency in picture frame stores, print "emporiums," and hotel and shopping mall galleries. Typically you will see afters, restrikes, and signed and numbered photoreproductions of paintings by "name" artists who make prints (or have prints made for them) to cash in on the popularity of their work in other media. Prints of this order are schlock art, and no reputable dealer will sell them.

Merchants of schlock usually know, and care very little, about art, artists, aesthetics, print quality, and originality. They make up for their lack of knowledge with glib talk and sales pitches which praise the investment value of the overpriced afters, restrikes, and reproductions they sell. By trading heavily on the names of famous artists and the current barrage of publicity supporting the investment value of genuine art, schlock dealers coax gullible buyers into parting with hundreds, sometimes thousands, of dollars for third-rate print merchandise with little, if any, long-term investment potential.

Never buy prints from anyone who stresses an impression's investment value ahead of its aesthetic qualities or historical importance. It is a good idea to simply avoid all establishments that offer prints-for-investment gimmicks.

Once you have found a dealer or two whose tastes in art more or less coincide with yours and who specialize in the type of prints you are interested in collecting, ask them to put your name on their mailing lists and to advise you if certain prints of interest come onto the market. Often dealers will attempt to locate a particular impression for you by checking with other dealers, publishers, distributors, or collectors who may wish to sell their impression of the image you want.

At the buying stage, you will find that most dealers are willing to discuss the prices they charge and to justify them in terms of quality, condition, rarity, and historical importance. To some degree, dealer's prices for certain types of prints are set in relation to the current auction price history for an artist's work, and a dealer should be willing to further justify his prices by referring to recent auction literature.

Some dealers are willing to negotiate prices, whereas others make it

their policy to set a firm price for each print they carry. There is certainly no harm in asking for a discount, however, or requesting interest-free extended payments over several months. Few dealers will risk losing a sale for the sake of a 10 percent discount, or for a few dollars in lost interest on a diminishing monthly balance.

Another indirect approach to obtaining a discount is to ask a dealer to include the cost of framing in the purchase price of a print. Although some dealers will refuse to cut their prices, they may be receptive to framing a print for free or at dealer cost (generally about half of the retail price) in lieu of giving a flat discount. The savings from such an arrangement may be considerable; the cost of framing a print can range anywhere from $50 to $150 or more.

In the final analysis, however, a dealer's willingness to offer any sort of discount will depend on the demand for the particular impression, the length of time he has owned it, the amount of capital he has tied up in it (or if the print is held on consignment, the price he has promised to the owner), and the dealer's estimation of how valuable you are or could become to him as a customer.

It is also important to ask a dealer if he will allow you to take a print home "on approval." Some print dealers are willing to give their customers an opportunity to live with a print for awhile without making a commitment to purchase. Others simply offer full refund or exchange privileges if a print is returned within a reasonable period of time.

The opportunity to examine an impression away from the dealer's premises enables you to thoroughly and unhurriedly inspect the print out of its frame, compare it with catalogue raisonné descriptions, or perhaps get advice from experts such as museum curators or other collectors. Living with a print for a few days will also help you decide if you want to make it a permanent feature in your surroundings.

Be wary of any dealer who refuses to allow a no-risk inspection at home. And when taking a print on approval, always insist that the refund and exchange privileges are clearly spelled out on the bill of sale, along with the other information specified at the end of Chapter 4.

FIGURE 41
ALVAR (b. 1935), *Intérieurs — Suite Bleue, (Interiors — Blue Suite)*, 1980. Lithograph with embossing, 21 x 15³/₄ in. (53.3 x 40.4 cm).
(Courtesy Edmund Newman, Inc., New York)

DAVID BLACKWOOD (b. 1941), *Fire Down on the Labrador*, 1980. Etching, 31³/₄ x 19³/₄ in. (80.7 x 50.2 cm)
(Courtesy Gallery Pascal Graphics, Toronto)

BUYING PRINTS
AT AUCTION

Until recently, print auctions were the source of a great many bargains for collectors. Back in the days when the majority of people attending an auction were dealers, a knowledgeable collector could obtain prints at close to wholesale prices. Most of the bidding competition came from professionals who would only bid up to a price that would allow them to make a substantial profit when the print was sold in their galleries. But since the early 1960s, private collectors have been attending print auctions in ever-increasing numbers, and the presence of amateurs will often drive auction prices for some prints up to levels exceeding the going retail price for identical impressions. As a result, many dealers have found that they can no longer rely on auctions as an inexpensive source of inventory, and they simply stay away.

The shift in auction activity away from professional buyers to a predominantly amateur audience has caused a number of significant changes in the auction marketplace and in the operations of the auction houses themselves. Much-publicized dealer *rings* no longer exist to the extent they once did. (A *ring* is generally operated by a number of dealers who agree not to bid against one another on particular items, in the hope that they will be acquired by ring members at a lower price than would have been reached if each dealer bid independently. The dealers then hold a private or "knock out" auction among themselves to determine who keeps each object.) Since private collectors are often willing to bid prices up to retail levels, and since most items are consigned to auction houses with reserve or minimum price guarantees, dealer conspiracies have become less viable and are of little concern to the average collector.

Some of the changes auction firms have made in recent years to accommodate the influx of amateur buyers include simple improvements to auction catalogs and the implementation of elaborate money-back guarantee programs. Sotheby Parke Bernet, for example, now publishes a listing of estimated price ranges at the back of their catalogs as a guide for novice bidders. Until recently, few auction houses would guarantee the authenticity of items they sold. But in the past few years many of the major firms have begun to guarantee both authenticity and authorship of works they sell for periods ranging from a few days to several years. Sotheby Parke Bernet will usually give full refunds on works they have sold that are later proven to be fakes, forgeries, or otherwise

inadvertently misrepresented in their catalog, for a period of up to five years from the date of sale.

Unfortunately, some dealers have chosen to take advantage of the public's entry into the auction market and the willingness of many auction firms to guarantee the authenticity of their offerings, or *lots* as they are called, by using auctions as a dumping ground for poor-quality or damaged prints, which they would prefer not to sell in their galleries. (The auction company then assumes the responsibility for disclosing an impression's true condition and stakes their reputation on its authenticity, while the dealer remains anonymous.) Of course, the better auction firms employ a staff of experts in every field to assess the quality, authenticity, and condition of the items that are brought in to be sold, and forgeries will seldom get by them undetected.

Although auctions no longer present as many opportunities for bargains as they once did, the major auctions are still excellent sources for prints. Auction prices are usually somewhat lower than retail; however, for any number of reasons, the prices for certain impressions may exceed the current market value in galleries. There may be a sudden, inexplicable "run" on an artist's work; or several determined collectors may turn up at an auction for a particular impression, and bid the price up far beyond its retail value; or a number of people attending an auction may get caught up in what is known as "auction fever," and push all prices sky-high.

An auction, however, is definitely not the place to make your initial print purchases. Until you have developed an ability to distinguish the good-quality impressions from the bad, the authentic from the spurious, and the bargains from the overpriced junk, it is wise to buy prints from reputable dealers. It is a good idea, nevertheless, for novice collectors to attend one or two auctions and auction *previews* (items consigned for sale are *previewed* usually for two or three days immediately prior to an auction to allow potential buyers to examine lots). As indicated in Chapter 5, the best way to learn about print quality, condition, and relative values is to inspect and compare a large number of impressions. Print auction previews provide an excellent opportunity to unhurriedly examine many prints, to compare them with the descriptions given in the auction catalog, and to meet and talk with the auction firm's staff of experts, print dealers, and other collectors.

AUCTION CATALOGS: Auction catalogs, like dealer catalogs, are valuable sources of information for collectors and should be purchased whether you intend to bid on certain items or just attend the auction as an observer. Catalogs may be purchased in advance by mail, by annual

subscription, or over the counter at auction previews. Sale catalogs prepared by the major firms contain detailed information on each lot offered, including: the lot number, the title of the print, the name of the artist who made it, the catalogue raisonné reference number, the medium, the date it was executed, the edition size and number of the impression, signature information, type of paper the image is printed on, the dimensions, and a statement written by one of the auction company's print experts describing the importance, quality, and condition of the impression. Many prints are photographically reproduced in auction catalogs as well.

The quality and reliability of the information given in auction catalogs depends, of course, on the integrity of the company and the expertise of its staff. Most of the catalogs published by major print auction firms are well researched and quite accurate. Generally, the most valuable lots receive the greatest amount of attention by auction house personnel, and therefore catalog descriptions of expensive prints are usually more complete and accurate than those given for inexpensive offerings. Experienced collectors, however, only use the catalogs as a guide and rely heavily on first-hand inspections and their own independent research to authenticate and evaluate the prints which interest them.

It is an interesting exercise in connoisseurship to examine several prints on display at an auction preview and to compare your assessment of quality and condition with the catalog descriptions. Most auction houses will understate a print's defects, and typically only major damage is reported in the catalog. Whenever possible, the cataloger will have examined an impression outside of its frame (Sotheby print catalogs usually indicate the lots which have *not* been examined out of their frames with an asterisk after the description of a print's condition). Anyone contemplating bidding on a print should insist that the frame be opened for them at the auction preview to facilitate an independent inspection. If the company refuses, request to speak with the cataloger and ask him to justify his assessment — or simply pass up the print entirely.

Look for damage that may have been omitted from catalog listings. Also examine the reported imperfections. Descriptions such as "slight mat stains," "creases," and "restored" should always be checked out thoroughly to determine if the cataloger was prone to understatement.

Omissions of other details in catalog listings, such as a description of the signature on a print, are worth noting as well. Prints are seldom described as "unsigned" in auction catalogs, and if no reference is made to the presence of a signature, it is reasonable to assume the

impression was not manually signed by the artist.

It is also important to note the terminology used to describe signatures. For example, the Glossary of Terms included in every Sotheby print sale catalog outlines that company's policy on signature references as follows: "A print is described as 'signed,' only if it has, in our opinion, been individually signed by the artist. Signatures of doubtful authenticity may be indicated by a question mark or by such terms as 'bearing a pencil signature.' No mention is made of signatures in the plate." Clearly, there is a world of difference between "signed in pencil" and "bearing a pencil signature" in catalog jargon.

The estimated price ranges given in most print auction catalogs are generally accurate assessments of each impression's true market value. The cataloger can check the price history of other impressions of the same image by referring to recent auction catalogs, back issues of *The Print Collector's Newsletter* (which gives monthly listings of print prices at major auctions), auction price directories such as *International Auction Records* and *Gordon's Print Price Annual*, and by checking current retail prices with several dealers.

RESERVE PRICES: You can normally count on being able to acquire prints at auction for a price equal to or above the low estimate. It is seldom possible to purchase items for less than the low estimate because most lots are offered subject to a *reserve*, a minimum price agreed upon by the seller and the auction firm. The actual reserve price is not revealed to the buying public. (There is much criticism of the secret reserve system, particularly in the United States; but as yet, no laws have been passed to force auction firms to publish the exact reserve price.) In general, auction catalogs offer few clues as to how the price is set. Sotheby Parke Bernet's catalogs, for instance, simply state that they recommend "reserves be set at a percentage of the medium of the estimates, generally somewhat below the low estimate shown in the estimate sheet . . . In no case do we permit a reserve to exceed the high estimate shown in the estimate sheet."

Most auction firms ask sellers to set their reserve prices slightly below the low end of the estimate range the company's experts have established as an object's market value. Few, if any, auction houses would agree to sell an item for someone who insisted that the reserve price be set above the estimate range published in their catalog.

Virtually every lot offered in major print auctions will carry a reserve (Sotheby catalogs usually indicate lots subject to a reserve with a ■ immediately preceding the lot number). So even if you are the only

person bidding on a particular print, it will be impossible to acquire it for much less than the pre-sale estimate.

BUY-INS: The reserve system is designed to prevent lots from being sold for a small fraction of their market value. Without this protection, circumstances such as a poor turnout for a sale, or a general lack of interest in certain works on the part of a large number of buyers at a particular auction, would often result in huge losses for consignors of goods.

On the auction floor, the reserve is covered by an agent for the company or the auctioneer himself, who acts on the seller's behalf and bids up the price with fictitious bids "off the wall" until the necessary reserve is reached. Lots that are bid up to their reserve price by the auction house are said to be *bought in*. No one in the audience is usually aware that an item failed to reach its reserve from legitimate bidding. It would appear to them that the item was sold or *knocked down* in auction jargon to someone for an amount close to the estimated range printed in the catalog. Most auction houses, however, publish a list of the prices achieved at each of their sales and make it available to catalog purchasers a week or so after the auction. Lots which failed to reach their reserves are omitted from price lists, making it a simple matter to compare the price sheet with the catalog lot numbers to identify which prints were bought in. Some collectors frequently monitor the auction market in this manner to determine the price trend and popularity of work by a certain artist. If a number of prints by a particular artist are bought in at several auctions in a row, they reason, it may be an indication of a serious decline in the popularity of the artist's work.

MINIMUM PRICE GUARANTEE: Bought-in lots are returned to their owners, who usually must pay a small handling charge (the amount is often negotiable) to the auction house to cover their catalog and handling expenses.

Some auction firms, however, will guarantee a certain minimum price for an object, regardless of how poorly it does on the auction block. They do this by purchasing the item themselves if it fails to reach the minimum price agreed upon with the consignor. For the certainty of a guaranteed sale, the seller must pay a small surcharge over and above the standard commission the auction house charges to sellers.

The auction house disposes of prints it acquires in this manner by including them in future sales. Each print owned by the auction firm is designated in the catalog as their property to protect the company from

possible charges of conflict of interest. (They could be accused of promoting certain items in which they have a financial interest over others which are consigned for a relatively small commission.) The auction company sets a reserve price in the normal way on the lots they own, and an agent or the auctioneer himself would bid on them only to protect their reserve.

Auction firms typically have ownership interest in a very small number of items in a given sale. Some companies such as Phillips Ward-Price Ltd. (Phillips, Son & Neale Inc. in the United States) make it their policy not to own any of the lots they auction.

BIDDING: Once you have inspected an item that you wish to bid on at an auction preview, and checked it out with experts or with published documents such as a catalogue raisonné, the next step is to establish a firm bidding limit which you will not go over. When setting this price, it is important to remember that a *buyer's premium* (an extra commission charged by the auction house to buyers, usually 10 percent of the final selling price of each item) will be normally added to whatever amount you end up paying. Depending on where the auction is held, you may have to pay state or provincial sales taxes as well. The auction catalog should spell out the exact commission and sales tax percentages. Mark the maximum price you are prepared to pay in your catalog and promise yourself you will not exceed it.

In order to bid, you will need to register with the auction company by filling out a special form prior to a sale and obtaining a bidding number (the number you call out to the auctioneer if you are the successful bidder). If you require credit or if you wish to pay for your purchases by check and take them with you, most auction companies will request that you complete a credit reference form several days prior to an auction. Inquire about credit and payment policies well in advance of a sale.

Although there are many stories about people bidding by means of secret signals they have arranged with the auctioneer — a wink of an eye, a twitch of a shoulder, or some sort of hand signal — most people bid simply by raising their hand after the auctioneer calls out a price. (Secret signals are seldom used at print auctions; the comparatively low prices paid for most graphic art give buyers little reason to be concerned about concealing their ownership.)

ORDER BIDDING: One of the big advantages to buying prints at auction is that you can often acquire superb impressions from the major sales in New York and Europe without leaving home. By ordering print

auction catalogs well in advance of a sale (announcements of forth-coming auctions appear in the *The Print Collector's Newsletter* and in the better art magazines), you can bid on lots by completing and returning the order bid form or *bid sheet* in the back of each catalog. It is also possible to make bids by telephone; however, most auction firms require verbal bids to be confirmed by a letter or telegram, which must be received along with bank references before the sale. In any case, submit your bids promptly after receiving the catalog. If two or more people send in identical bids on a print, most auction firms accept the earliest one received and ignore the others.

To bid by mail, simply submit the top bid you would be prepared to make if you were attending the auction in person. An agent appointed by the auction house or the auctioneer himself will bid on your behalf against bids from the floor and other order bids, up to the maximum price you have authorized. However, the auction house will always attempt to secure the print for you at the lowest possible price. For example, supposing you have indicated on an order bid form that you are willing to pay a maximum of $800 for a particular lot. On the day of the auction, the auctioneer raises the bidding in $50 increments up to $650, when the bidding from the floor suddenly stops. He would then check for order bids (usually a colleague will submit them, but some-times the auctioneer will simply call them out from his notes). If none of the other mail-in bids exceed $650, the agent or the auctioneer would then tender your bid, but *not* for the full $800 you originally offered. Since the bidding was rising in increments of $50, the auctioneer would announce that he now has a bid for $700, and then try to extract a bid of $750 from the audience. If no one offers, the lot would be sold or *knocked down* to you for $700, a full $100 less than you actually bid.

Auction firms will not accept what are known as *buy bids*, which give them the authority to acquire a print at any price. You are always asked to set the maximum price you are willing to pay. You can, however, indicate on the order bid form that you will allow the firm to make one *discretionary bid* on your behalf, in case the bidding from the floor stops at the exact amount you specified as your maximum bid. The discre-tionary bid enables the auctioneer to break the deadlock and knock the print down to you.

Successful mail bidders are notified and invoiced within a few days of the sale, and items are shipped to them at their expense.

DEALER AGENTS: Print buyers who bid by mail must rely heavily on catalog descriptions when making decisions on which items to bid on and how much to offer. It is usually possible to phone or write the

auction firm and receive a detailed oral or written description of a print's condition, but such assurances are a poor substitute for a first-hand inspection. If you are unable to attend an auction and dislike the idea of buying prints out of a catalog, it may be possible to find a knowledgeable dealer who will be attending the sale, and to commission him to inspect certain lots for you and bid on your behalf. The fee a dealer will charge for this service may vary anywhere from 5 to 20 percent of the purchase price, depending on the value and number of lots you want him to examine and bid on. In return, the dealer offers you his expert opinion on the quality, condition, and value of each item you select and in effect gives you a personal guarantee as to the authenticity of the lots he purchases for you. Moreover, a dealer is less likely to get caught up in "auction fever" and overbid. (Nevertheless, you should specify the top price or price range you are willing to pay for each lot.) A dealer can also look after the payment and shipping arrangements, which can be particularly troublesome when items are acquired overseas. Finally, perhaps the best reason for hiring a dealer to bid on your behalf is to have an expert on your side to compete against the other experts in the room.

MAJOR AND MINOR AUCTIONS: Most of the major auction companies such as Sotheby Parke Bernet in New York, Los Angeles and London, England, and Christie's of New York and London, hold regular print auctions. Sotheby Parke Bernet sells Canadian prints in its Canadian art sales held in Toronto every spring and fall. A few firms such as Kornfeld & Company of Bern, Switzerland, specialize in print auctions. And there are several major German auction firms such as Karl & Faber and Hauswedell & Nolte that hold regular print auctions as well.

New York auction firms usually schedule their major sales within a few days of each other every spring and fall to enable out-of-town buyers to attend several sales on one trip. Exact dates and catalog information for upcoming auctions may be obtained by writing or telephoning each company, or by checking for announcements in the various art magazines.

Print auctions are also held by a number of small companies that specialize in handling charity auctions or estate sales. Typically, these firms do not publish catalogs or offer their customers any guarantees of authenticity. Nevertheless, they can be a good source for inexpensive decorative prints, since lots are usually offered without any reserves. Such establishments are definitely not the place to buy expensive prints by international master artists — more often than not their "consignments" in this field consist of the same overpriced afters and

photolithographed reproductions that are offered by the schlock dealers. Buying at auctions run by the smaller companies is infinitely more risky than buying from an auction firm that publishes an accurate catalog and is prepared to stand behind their descriptions with a guarantee. At the small auctions, the best advice is simply "buyer beware" -— especially when the bidding runs to $100 or more.

It is often possible to pick up bargains at auctions held in countries or localities where a particular artist's work or style of art is relatively unknown or unappreciated. Prints by some American artists, for example, often sell for less than their American market value when offered in European auction houses. When browsing through auction catalogs, always keep an eye open for prints that will be sold outside their natural geographic market.

After you have purchased one or two prints at auction, you will likely gain confidence in your ability to spot the bargains and bid for them. Experienced collectors find the major American and European auctions are the best sources of quality prints at relatively low prices.

OTHER SOURCES

Commercial retail galleries and print auctions run by the major auction firms are the best, but certainly not the only, sources of original graphic art. Here are some of the other types of organizations which sell prints, and the pros and cons of dealing with them.

PRINT PUBLISHERS: It is often possible for collectors to buy new prints directly from the companies which wholesale and distribute print editions to retail galleries. In most cases, print distributors are also publishers with a major financial stake in the editions they sell, and they are often agreeable to selling to collectors when pressed to recover their capital quickly.

Publishers of original prints operate not unlike publishers of books. They commission an artist to create a print edition for them, sometimes buying several images, which they package in a fancy box and sell in limited edition portfolios. (When the images are all created around one theme, the portfolio collection is often referred to as a *suite.*) The publisher usually assumes the full cost of printing the editions, and either pays the artist a flat fee for all the prints (except for a mutually

agreed upon number of artist's proofs and trial proofs which the artist keeps) or pays him an advance against future earnings from print sales, in the same way an author is paid an advance from a publisher for a book manuscript. In any case, the artist seldom receives more than about 10 to 15 percent of the retail selling price of his prints. The publisher sets the retail price for individual prints and portfolios. (Usually a complete set of prints will sell for less than the combined retail price of the individual impressions.) The publisher also establishes a trade discount off the retail prices of between 30 and 50 percent, which sets the wholesale price retailers must pay.

Print publishing is an extremely expensive, high-risk business. It can often take years for a publisher to sell enough impressions of an image to recover his investment in artist's fees and printing costs. Most publishers are more interested in raising cash to meet these expenses than they are concerned about protecting the retail market. Collectors with the cash in hand to purchase an image or a complete portfolio at wholesale prices may be welcomed with open arms by a publisher who is strapped for funds. Of course, a publisher's willingness to give trade discounts to private collectors will depend upon the contractual arrangements he has made with his artists and dealers.

The best time to approach a publisher for a discount is usually just prior to the release of a new print or portfolio, when he is probably anxious to recover a substantial amount of the capital he has invested. Publishers frequently promote forthcoming editions with announcements in art magazines. Often some sort of "pre-publication" discount is offered if you purchase an impression from a local dealer before a certain date. Pre-publication discounts are typically between 10 and 20 percent off the regular retail price; however, larger discounts may be in order if you approach the publisher or distributor with a cash offer.

Some collectors improve their bargaining position by purchasing a complete portfolio of perhaps six to ten prints, with the intention of selling the images they do not want. Since the price of a complete portfolio is usually much less than the total retail value of all the individual prints, it is often possible to recoup the full purchase price by selling all but two or three of the impressions. Shrewd collectors may be able to acquire the images they want at no cost by this method, even if they are unsuccessful in obtaining a full trade discount on the portfolio. Chapter 7 gives tips on how to sell unwanted prints.

MAIL-ORDER COMPANIES AND PRINT "CLUBS": Mail-order merchandising companies which disguise themselves as "print clubs" are perhaps the worst sources of original prints, and should be avoided for the

same reason that collectors should stay away from the schlock dealers — the art they sell is for the most part overpriced junk.

Print clubs typically operate the same way as mail-order book and record clubs. A few require their customers to pay an annual membership fee, while others specify that members must make a minimum number of purchases in a year. In both cases, the merchandise offered is generally either decorative art by relatively unknown artists, or afters, restrikes, and "limited" edition photoreproductions of paintings.

Invariably, print club magazine ads, brochures, and other sales literature stress the investment potential of their low-grade art merchandise. Like schlock dealers, mail-order firms try to dupe customers into thinking the over-priced afters and reproductions they sell will appreciate at the same rate as legitimate prints and paintings by "name" artists. (In a recent promotional mailing, one company went so far as to announce that Miró's work annually appreciates by 45 percent while Calder's work was "up" 36 percent over the previous year!) The prints that most of these organizations offer have virtually no investment potential whatsoever. In fact, they are typically of such poor quality that no auction firm or reputable dealer would even consider reselling them for a client.

PUBLIC GALLERIES AND MUSEUMS: Most public art galleries have a bookstore on the premises, which sells posters and art reproductions. Some of these shops, such as the one operated by the Metropolitan Museum in New York, also sell original prints. Art museum stores can be an excellent source of prints, since the public institutions that run them usually set fairly high standards for the work they sell. Although most of them charge full retail prices, discounts are often available to gallery members.

Many public galleries also operate a lending service, which rents and sometimes sells art that is loaned to them from local dealers and artists. Lending services offer the added benefit of allowing collectors to live with the prints they select for several months before making a commitment to purchase. A nominal monthly rental fee is charged while the prints are on loan, and often the payments may be applied to the purchase price if a renter decides to buy the impressions he borrows. At the buying stage, art rental personnel will usually assist collectors in getting in touch with the dealer or owner of a print to obtain more information, provenance documentation, or a certificate of authenticity.

BUYING PRINTS FROM ARTISTS, COLLECTORS, AND OTHER SOURCES: Artists who are not represented by commercial galleries often sell their prints directly to collectors. Artists may be contacted

through local public galleries, art schools, printmaking ateliers, or the telephone directory. It is not uncommon for printmaking workshops to sell the prints that are made by their artists and, in effect, perform all the functions of a commercial gallery. They may be located by contacting print dealers or the print curator at a local art museum, or by checking the telephone directory. (Some ateliers offer classes in printmaking and may be found in the Yellow Pages under "Art Schools.")

Print collectors who wish to sell all or part of their collection may advertise in the classified section of a newspaper. Although the classified ads may turn up the odd bargain, few first-rate impressions by well-known artists are sold privately. Most serious collectors prefer to dispose of unwanted prints anonymously and expeditiously through one of the major auction firms. Prints offered in the classifieds are usually there because their owner has found that no auction house would accept them as consignments.

Finally, some excellent print bargains may sometimes be found in antique stores and galleries which normally do not sell prints, but which may have acquired several along with the purchase of a collection of paintings or sculpture. If a dealer does not have a regular clientele of print collectors visiting his store or gallery, he may be willing to sell whatever prints he has in stock at less-than-retail prices to get rid of them. It is wrong to assume, however, that such dealers will know nothing about graphic art and that you will pick up master prints for a few dollars. The day of the ignorant antique dealer seems to be over; in most shops the owner will probably know more about the prints he sells than you will. Always do your homework thoroughly before purchasing a print that appears to be a great bargain. Remember that more often than not, the dealer has probably done his homework, too, and has discovered that the print is only worth the measly sum he is asking.

WHAT TO COLLECT

After you have reviewed the selections of prints on display in local galleries, purchased several dealer and auction catalogs, and perhaps attended a print auction or two, the next step is to actually buy something. You could start by simply purchasing several prints that appeal to you for any reason. Or a better approach is to specialize in the work of a particular artist, a "school" of artists, or a style of art that you particularly like. Virtually every significant art movement in this century is represented in prints, and most of the major

FIGURE 43
PHILIP PEARLSTEIN (b. 1924), *Sphinx*, 1979. Aquatint,
28¹/₂ x 40¹/₄ in. (72.4 x 102.2 cm).
(Courtesy Brooke Alexander, Inc., New York)

FIGURE 44
KEN DANBY (b. 1940), *Aquarius*, 1979. Transfer
lithograph, 23 x 18 in. (58.4 x 45.7 cm).
(Courtesy Gallery Moos, Toronto)

artists have taken a serious interest in printmaking as a form of artistic expression. With such a wealth of material to choose from, it is often necessary to concentrate on one or two artists or styles of art and develop a certain amount of expertise on them. Specialization makes it easier to stay on top of prices, spot bargains, and assemble a quality collection.

No doubt you will find that your tastes change over a period of months or years, and while some prints will retain a certain amount of lasting appeal, others may cease to give any pleasure whatsoever after you have lived with them for a short period of time. You may decide to trade up to something better, and because "better" usually means more expensive, you will probably be faced with the problem of where and how to sell some of your prints for the best possible price. Also, when considering more expensive print purchases, you may want to give some thought to the investment potential of the impressions you wish to acquire. Few people are willing to tie up thousands of dollars in prints unless they are reasonably certain their collection will appreciate in value.

Chapter 7 outlines how to identify prints with investment potential, and gives suggestions on how to go about selling prints for maximum prices.

BUYING AND SELLING PRINTS FOR PROFIT

OVER THE PAST TWO DECADES the art boom has captured the attention of a great number of investment-conscious people who are disenchanted with the performance of conventional growth investments such as stocks, bonds, and real estate. Original prints have attracted a large share of this interest, because they are one of the few fields of art that investors can enter with a modest budget and still have a reasonable chance of making handsome profits. Fine paintings and sculpture by master artists have become far too expensive for buyers outside of museums, public galleries, and the very wealthy, so smaller investors have turned to prints.

Although some purists claim they are appalled at the very thought of buying art for its investment potential, most people who spend money on expensive art objects hope their purchases will at least retain whatever market value they had when acquired. More often than not, prints that are purchased solely for their outstanding aesthetic appeal turn out to be the best investments in the long run.

ADVANTAGES AND DISADVANTAGES OF INVESTING IN PRINTS

All the attractions of investing in paintings — portability, a hedge against inflation, and aesthetic enjoyment — apply to prints as well. In fact, prints offer investors several advantages over other types of art. Since original prints are produced in multiple and are relatively inexpensive, they trade more frequently in galleries and auctions, making them a more "liquid" investment. Prints can also be priced

more accurately than paintings and other unique objects; it is usually possible to check the price charged for a print against dealer and auction catalogs and directories, such as *Gordon's Print Price Annual,* which document price histories for other impressions of the identical image. Prints are usually smaller and lighter than paintings, sculpture, and most other art objects and may command higher prices in uncertain times when investors are willing to pay for portability.

In terms of price appreciation, first-rate prints by major artists are as attractive an investment as master paintings. Popular images by recognized master artists and printmakers often increase in value by 10 percent or more annually. Rare or exceptional prints have much better potential. Certain images and portfolios of prints by artists such as Picasso, Hockney, Johns, Matisse, Chagall, Miró, and many others have gone up anywhere from 400 to 1,000 percent in the past decade alone.

Prints are also free of the economic cycle risks affecting most other investments. They are an excellent hedge against inflation — prices for good-quality original prints generally increase each year and keep ahead of the dollar's declining value. They can perform well as an investment during good times as well as in recessions and depressions. When the economy is buoyant, people often spend more on luxury items which give prestige and status. And in periods of economic hardship, investors look to the safety of tangible assets, such as art and gold, which have a worldwide market value. The art market usually displays a remarkable resistance to economic downturns, and on rare occasions when prices do slump, they typically bounce back quickly as the economy improves. Prices for many important prints by established international masters remained stable even through the Great Depression.

Because many prints are traded internationally, they are also an excellent form of protection against currency devaluation. Collectors who live in countries with weakening currencies may realize enormous profits by selling prints in countries with stronger currencies. Foreign exchange fluctuations can yield profits even when prints are sold at a loss on foreign markets. If, for example, an American bought an internationally traded print in Switzerland in 1973 for 10,000 Swiss francs (about $3,300 U.S. dollars at that time), and sold it there six years later for just 10,000 stronger francs, he would have made a profit in dollars of about $2,300. The devaluation of the U.S. dollar combined with the strengthening of the Swiss franc against the dollar over the six-year period would have earned the owner a sizable profit, even though his print did not appreciate in terms of market value in Switzerland.

Prints that are traded on the international art market tend to be priced

by dealers the world over to reflect the current value for similar impressions in nations with the strongest currencies. Therefore, as foreign currencies such as the Swiss franc strengthen against the dollar, art held by North Americans that is marketable in countries with stronger currencies is also increasing in value.

In short, the print market offers investors many of the benefits of investing in gold, foreign exchange, and other similar commodities, with the added advantage of being a much quieter and less volatile refuge for investment capital. Unfortunately, however, there is no such thing as a perfect investment, and art buyers should also be aware of the disadvantages of tying up their investment capital in a print collection. First, prints are easily damaged and may discolor and deteriorate in time. Even small tears, stains, or signs of fading can drastically reduce a print's monetary value. Second, it is often difficult to select art that will be of lasting importance. Changing fashions and tastes could make prints by many of today's most popular artists nearly valueless tomorrow. Third, although billions of dollars are spent on art every year, the art market is highly specialized. A small amount of buying or selling activity within individual markets can have a drastic effect on prices. News that a major collector or public gallery is buying an artist's work, for example, may temporarily push his prices up. Conversely, if several well-known collectors happen to unload a number of works by a certain artist at the same time, his prices may plummet. So each specialized market is subject to price manipulation. Last, prints and other art objects can be extremely difficult to sell at a profit. Usually, sales can only be made to dealers, who will seldom pay more than wholesale prices, or through auctions, which may not obtain full market value. Prints are normally long-term investments; collectors must often hold onto prints for several years before they can realize a substantial profit after paying sales commissions to a dealer or auction firm.

Buying prints for profit requires a thorough knowledge of the type of art that you plan to collect and an understanding of certain economic factors which can affect print prices. It is also crucial to be able to identify the best examples of an artist's work before forging ahead and investing large sums of money.

CHOOSING WINNERS: FACTORS DETERMINING A PRINT'S INVESTMENT POTENTIAL

There are a number of factors that determine a print's current value and the likelihood of price appreciation in the future. They include:

THE ARTIST'S REPUTATION: An artist's reputation and the historical importance of his work are the two most important factors influencing the long-term investment potential of a print. There is usually a steady demand for prints by artists with an established place in history, particularly those who produce a distinguished body of graphic work in addition to paintings and sculpture. Many of the prints created by artists such as Toulouse-Lautrec, Picasso, Miró, Matisse, Chagall, Dufy, Rouault, Léger, and numerous others are considered "blue chip" investments, since each of these artists made important contributions to the history of art in this century, and each of them approached printmaking with the same interest, commitment, and attention that they gave to other media. The market for prints by artists who consider printmaking a serious artistic pursuit will normally closely follow the market for their paintings and sculpture.

Unfortunately, there are a number of artists with well-established international reputations as painters or sculptors who simply knock out prints for money. Artists who are not interested in printmaking seldom produce good prints, and their graphic work is typically of little investment value.

The extent to which an artist's work is accepted by the international art community is another important determinant of its investment potential. Obviously there is a much larger market, and hence a greater demand, for prints by artists who enjoy a worldwide following than by those whose popularity is limited to one country or locality. Moreover, a major benefit of investing in art — the protection internationally traded objects offer against currency devaluations — is lost if you buy prints by artists whose work is unsalable in foreign markets because they have only achieved local recognition.

Nevertheless, prints by some artists who are very popular in their native country may become excellent investments without the benefit

FIGURE 45
JOAN MIRÓ (b. 1893), *Equinox*, 1967. Etching and
aquatint, $41^1/_{16}$ x 29 in. (104.3 x 73.7 cm). When
the Museum of Modern Art in New York held a
major exhibition of Miró's prints in 1969, *Equinox*
was reproduced on the cover of the exhibition
catalog and an impression was acquired for the
Museum's collection. The attention given to this
print by a major museum increased the demand for
it, and pushed its value up to more than double
the price of similar Miró prints.
© ADAGP, Paris 1981. (Private Collection)

of international exposure. For example, in spite of the fact that the Canadian art market lacks the cash, the number of collectors and investors, and the volume of business of the European or American art markets, prices for prints by a number of Canadian artists have increased dramatically in recent years. The resale values of several prints by Ken Danby, W. J. Phillips, and numerous Indian artists, such as Daphne Odjig and Norval Morrisseau, increased in the 1970s by as much as ten times the original published prices, as certain editions sold out or popular images became scarce. As a rule, however, prints by artists with a local following are generally more difficult to sell due to the smaller market demand for them.

Another indication of the investment value of an artist's work is the number of major private galleries and print dealers who stock his prints and the number of public and private collections he is in. A fairly small number of important dealers have an enormous influence on the art market, and it is a badge of recognition for an artist to be represented by one or more of them. Similarly, if a major public institution such as the Museum of Modern Art in New York or the Bibliothèque Nationale in Paris purchases an artist's prints, it is a further indication that he has arrived and that his prices may be due to increase.

Dealer prices for prints will also rise when a respected museum or private gallery stages a major exhibition of an artist's work. If a show is well publicized in newspapers and the art press, and if the critics are kind, print publishers and dealers will usually increase the prices for the artist's prints to reflect his new-found stature within the art community.

However, the acceptance of an artist's work by the major auction firms is a far more important consideration for investors than the critical acclaim he receives in the art press or the number of collections he is in, since auctions often provide the best means to dispose of prints. Auction companies usually refuse to sell the work of relatively unknown artists and the prints of artists who have a reputation for churning out purely decorative graphics. Most of the better auction firms also refuse to handle afters and photomechanically made copies of paintings and drawings, whether they are manually signed or not. Some companies discriminate against these types of prints because the price collectors will pay for them is too low to generate a profitable commission, while other firms refuse to accept them as consignments because their print experts disapprove of the artist's style, the quality of his work, or his reputation for not taking an active role in the creation of his prints.

The lack of an auction market for an artist's prints severely limits investment potential, because there are few other outlets for profitable sales. (If you try to sell a print to a dealer, he will seldom pay you more

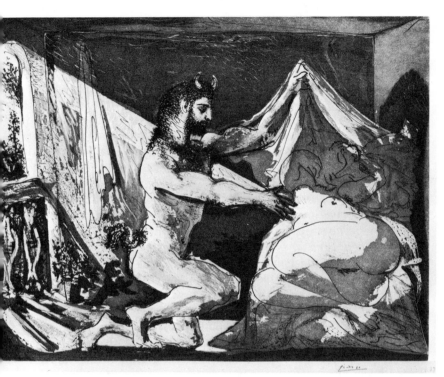

FIGURE 46
PABLO PICASSO (1881-1973), *Faune dévoilant une femme, (Faun Unveiling a Sleeping Woman)*, 1936. Etching and aquatint, 12^1/$_2$ x 16^3/$_8$ in. (31.8 x 41.6 cm). Plate 27 from the *Vollard Suite*.
© SPADEM, Paris/VAGA, New York, 1981. (Courtesy National Gallery of Canada, Ottawa)

than about 50 percent of the print's current retail value so that he may obtain his regular markup when he resells it.) Moreover, the acceptance of an artist's prints by a major auction house not only gives collectors a readily accessible resale market, but also increases the artist's stature in the art market, in the same way that the listing of a stock on an important stock exchange makes it a more visible, credible, and saleable investment. Before investing a large sum of money in a print, it is a good idea to check back through several print auction catalogs to see if the artist's work is generally accepted by the major auction houses and if his prices at auction are holding reasonably close to retail price levels.

PRINT QUALITY, CONDITION, AND SUBJECT MATTER: Contrary to what many of the mail-order print clubs and other prints-for-investment

hucksters would lead you to believe, not all prints bearing the signature of a famous artist have the same investment potential. Even master print-makers produce mediocre work from time to time, which in turn usually proves to be a poor investment.

Run-of-the-mill etchings from Picasso's *Vollard Suite*, for example, typically sell for between $2,000 and $3,500, and overall, prices have increased very slightly in recent years. However, the really superb images from the *Vollard Suite*, such as *Faune dévoilant une femme* (*Faun Unveiling a Sleeping Woman*) (Figure 46), command steadily increasing prices at auction ranging anywhere from $12,000 to $15,000. This print and a half-dozen or so others in the *Vollard Suite* stand out from the rest as being particularly fine examples of Picasso's graphic oeuvre. The exceptional images, which demonstrate brilliant use of technique combined with strong image content, are the ones that are most sought after by collectors. They are also the first ones to disappear from the market forever through museum purchases. The steady market demand, combined with a diminishing supply, causes prices to keep rising.

In the long-term selection process of art history, generally only the best work is remembered and will, in turn, offer the best investment potential. In the short term, medium-quality work usually brings less than medium prices. If you cannot afford to buy the best work of the best printmakers, a first-rate print by a lesser artist may often prove to be a better investment than a poor image by a big name.

The physical condition of a print can have a significant effect on a print's price and investment potential. Because prints are created in multiples, collectors are often reluctant to invest a substantial sum in badly faded, stained, torn, or heavily restored prints, on the theory that another impression in better condition may become available one day. As indicated in Chapter 5, if you are only buying prints for aesthetic satisfaction, minor flaws may be overlooked, but if you plan to sell your collection someday, it is important to remember that physical damage of any kind will have a critical effect on resale values.

Collectors are often willing to pay premium prices for prints depicting subjects or themes that are commonly identified with the artist. Chagall collectors, for example, prefer images with bouquets of flowers, musi-cians, clowns, or representations of events described in the Bible, since many of the artist's best-known paintings and prints depict these sub-jects. Similarly, collectors of Jim Dine's prints often prize his images of hearts, tools, false teeth, items of clothing, and other objects over his later figurative work, because Dine is more famous for his early images, which typify the 1960s Pop art movement.

Prints that are products of some offbeat stylistic excursion or short-lived experimentation by an artist may be interesting curiosities to own, but will usually prove to be poor investments. A print's resale value will normally correspond closely to the number of people who have a taste for it.

FASHION: Because fashions in art can change as quickly as fashions in clothing styles or furniture designs, it is often difficult for investors to predict which artists and art movements will have lasting appeal. Some artists develop a widespread following among knowledgeable dealers and collectors and then quickly fall into disfavor, either because a new perspective in the art world makes their work seem unimportant, or because they failed to progress in their careers and to develop new imagery.

A classic example of a popular artist who "went out of fashion" as quickly as he came in is the French painter and printmaker, Bernard Buffet. In the late 1950s and early 1960s, Buffet's distinctive images of clowns, still lifes, stark landscapes, and cityscapes became immensely popular with art buyers, dealers, and some museum curators. Buffet's work was shown all over the world, books and articles were written about him, dozens of his paintings were reproduced, and tens of thousands of copies were printed and sold worldwide. Of course, the publicity and acclaim stimulated greater demand for Buffet's work, and prices skyrocketed. But then, within a very short period of time, the novelty of Buffet's imagery began to wear thin with collectors. No new concepts or approaches to visual problems were forthcoming from him — just endless repetitions of old themes and ideas. Art critics began to re-evaluate Buffet's work and question its lasting significance. What was once considered distinctive, unusual, and fashionable, had quickly become trite and monotonous. By the mid-1960s Buffet had lost his status as the art world's favorite trendsetter, and prices for his work plummeted.

Art investors should always avoid the work of heavily promoted "overnight sensations," and should only buy prints by artists whose reputations are solidly established, or whose work represents a style or school of art that is likely to be of lasting historical importance.

However, choosing the long-term winners from the thousands of printmakers working today is often next to impossible, so some investors simply avoid contemporary work and concentrate on older prints which have withstood the test of time. New York print dealer Martin Gordon, for example, rarely handles prints made after 1950, because he believes

that the contemporary market is too easily manipulated by promoters, and that rapidly changing fashions make expensive prints by today's superstars a risky investment.

RARITY: In the print market, the demand for an image often determines rarity to a much greater extent than simple considerations such as the size of the edition or the number of impressions of a print that are known to exist. This is a quirk peculiar to the market for original prints and photographs.

Much of the appeal of collecting images made in multiple is that they enable many people to own famous works which are identical in every way to the images exhibited in museums and reproduced in books and magazines. Collectors are usually willing to pay premium prices for an artist's most popular and sought-after prints, regardless of the number of impressions in circulation. Print investors, in turn, tend to feel more secure buying well-known images for which there is a regular, predictable market. Conversely, rare images seldom attract the attention and achieve the prices they may otherwise deserve, simply because they are unfamiliar to many collectors.

Perhaps the best example of the influence strong market demand can have on the price of a print from a large edition is Friedrich Hundertwasser's *Good Morning City*, a serigraph which was published in an extraordinarily large edition of 10,000 impressions. In 1970, this print sold for just $45, but worldwide demand for it pushed the price up to $800 or more by 1980, as impressions became increasingly scarce.

It is not uncommon for extremely popular or famous prints to sell for more than an artist's unique works. In 1973 one of the early impressions of Picasso's *Le repas frugal*, for example, sold at auction for 465,000 Swiss francs (then about $144,000 U.S.), a price which at that time would have been hard to top with an important Picasso drawing or gouache.

When choosing prints with investment potential, the trick is to select images that have had just the right amount of exposure in public exhibitions, books, art magazines, and dealer and auction catalogs. With too little exposure, a print will fail to attract enough attention to maintain constant demand for it and encourage steadily increasing prices at auction. On the other hand, too much public exposure can reduce an image to banality. If an image is reproduced and thousands of copies of it are sold in some other form, whatever artistic merit the original prints may have will be undermined in the public's eye through overexposure to the facsimiles. For example, when Robert Indiana's *LOVE* image became the symbol for the hippie generation and was reproduced on

posters, made into sculptures, and issued as an official United States postage stamp in 1973, the prices for Indiana's limited edition serigraphs of the image (which were issued several times in various colors) failed to reflect the popularity of the image. With so many copies of the design around, presumably few print collectors were willing to pay more than a token amount for the dubious snob appeal of owning a signed original copy.

Other factors influencing the art buying public's perception of a print's rarity and investment potential include the presence or lack of a signature on an impression, and the age and health of the artist, particularly if it is generally thought his impending death will cause prices for his work to increase.

Art investors always prize signed impressions more than unsigned ones, and are usually prepared to pay premium prices for prints bearing the artist's signature in pencil, ink, or crayon. Signed impressions of an image are often worth at least twice as much as unsigned ones, assuming quality and condition are about the same. Clearly, unsigned modern and contemporary prints are bargains for those who collect purely for aesthetic satisfaction. However, they seldom appreciate as quickly as signed prints and should, therefore, be avoided by anyone who buys for investment. As long as collectors and investors continue to be preoccupied with signatures on prints (often under the mistaken assumption that there must be something wrong with a print if the artist did not sign it), signed impressions will continue to be the superior investment.

It is worth noting, however, that the lack of a signature on a rare print will seldom detract from its value. Unsigned state or trial proofs, for example, are usually worth much more than signed prints from a regular edition, because they are unique documents which command a price that reflects their rarity and historical value.

Contrary to popular belief, there is little evidence to suggest that prices for an artist's work will necessarily skyrocket when he dies. Some investors speculate in prints by aged or ailing artists in the hope that the death of an artist will cause the value of his prints to increase dramatically. Since the artist won't be producing more prints, they reason, all of his existing works will quickly become recognized as great rarities and prices will soar. Unfortunately, this theory does not always hold true and is particularly suspect if the artist's production of prints dwindles or ceases altogether in his later years. If no new prints are forthcoming from an elderly artist, and it is rumored that his health is declining, prices will usually begin to reflect the fixed supply of prints on the market many months or even several years prior to his death. When an artist's death is anticipated for some time in the marketplace, the actual

event will generally have a minimal effect on prices for his prints.

However, other forces at work in the market may cause prices to rise substantially when an artist dies. Print dealers, for example, will often capitalize on an artist's untimely demise by arbitrarily raising prices for his prints immediately after the announcement of his death. The price hike and subsequent upward price spiral for the work of some heavily promoted artists simply becomes a self-fulfilling prophecy for dealers who preach the investment value of the prints they sell.

Art speculators can also cause prices to rise artificially. Speculators have been known to rush in and indiscriminately buy up a famous artist's prints immediately after his death, on the assumption that prices will take off as his work becomes scarce. When Picasso died in 1973, for example, speculators snapped up every print they could get their hands on, and prices began to skyrocket. The 347 etchings and aquatints in the *347 Series*, created by Picasso in 1968, were supposedly traded over the telephone from dealer to dealer like commodity futures for as much as $1 million for the complete set.

But speculating in prints can be risky, particularly when buying is done on a grand scale with little regard for the quality of the work being purchased. The economic downturn of 1974 sent the print market into a slump and caused prices for many Picassos to plummet, as investors tried to dump prints when the first cracks appeared in the wall of confidence. Impressions that had been pushed up to extraordinary price levels by undiscriminating speculators became virtually unsalable. At a Sotheby's print auction in November 1975, a complete set of the "million-dollar" *347 Series* was bought in after only one bid was offered for $325,000. The Picasso market did not show signs of recovery from the 1973 flurry of speculative buying until late in the decade.

PRICE: In the art market, rising prices do not drive investors away, they attract them. As a print increases in price, demand for it also tends to increase. This phenomenon is known as the Veblen Effect, after Thorstein Veblen, a Norwegian-American economist who first observed that steadily rising prices have a positive effect on an artist's reputation. As prices for an artist's work are increased, Veblen claimed, he becomes important; when his prices rise above the going rate for the work of his peers, he is revered by dealers, critics, curators, and collectors, and especially investors.

Because a high price equals quality in the minds of most art buyers, prices for the work of many young contemporary artists are set with little consideration for the market influences of supply and demand. Art marketers often reason that more people will covet a painting or a

FIGURE 47

KENOJUAK (b. 1927), *The Enchanted Owl* (Red Tail),
1960. Stonecut, 15¹/₄ x 23¹/₄ in. (38.7 x 59.1 cm).
The stonecut is a type of relief print made by Inuit
artists. The non-image areas are carved out of the
surface of a flat piece of stone, rather than wood or
linoleum.
Used by permission of the West Baffin Eskimo Co-operative Limited,
Copyright 1960. (Courtesy Waddington, McLean & Co. Ltd., Toronto).

print if it is perceived to be worth thousands of dollars than if it is priced in the hundreds.

With prices for many contemporary prints being set in such an arbitrary fashion, it is obviously wise to avoid investing huge sums of money in newly published works by up-and-coming contemporary artists. New prints by relatively unknown artists should only be purchased for aesthetic enjoyment; if the test of time proves them to be a good investment, future profits should merely be considered as an added bonus.

The best rule of thumb to follow when buying prints by artists who do not have an established track record of steadily rising prices is to only pay what you think the enjoyment of owning their work is worth to you.

Prices for prints by master artists or artists with established reputations tend to be much more predictable, because they generally follow the direction of prices for their paintings and drawings. The traditional relationship between prices for works in the various art media is loosely based on an old European system, which suggests that an artist's prints are worth 20 to 25 percent of the price of his drawings and that his drawings are worth 10 percent of the value of his paintings.

Prices for prints by many modern and contemporary masters still more or less conform to this rule. However, the value of rare or exceptional prints which are highly prized by many collectors is more likely to be determined by the simple laws of supply and demand. Prices for some impressions may even exceed the price charged for many of the artist's drawings and paintings.

The market for international master graphics is probably the most rational of art markets, since prices for multiply-produced objects can be determined much more accurately than prices for unique objects. Popular prints by well-known artists frequently appear at auction, and price histories of identical or similar impressions to the one an investor is considering can be traced through publications such as *The Print Collector's Newsletter, International Auction Records*, or *Gordon's Print Price Annual*, which record print prices at major auctions in New York, London, Paris, Bern, Vienna, Munich, Berlin, Hamburg, Cologne, and Zurich. (Complete information on these publications is given in the Resource List.)

It is very important for print investors to keep up to date on price movements and trends. Normally, print prices do not move upwards in a straight line; there is generally a dramatic rise and then a plateau, followed by another rise and a new plateau. By keeping informed and following the market closely, you may be able to catch a turn in prices and buy before they leap to new levels. Also, investors who follow the

FIGURE 48
ALEX KATZ (b. 1927), *The Orange Band*, 1979.
Serigraph, 40 x 28¹/₄ in. (101.6 x 71.8 cm).
(Courtesy Brooke Alexander, Inc., New York)

trends and changing fashions will often be able to predict when prices have peaked and it is time to sell.

INVESTMENT STRATEGIES

Selecting prints with investment potential is a much more difficult and time-consuming task than buying prints for pleasure. In addition to searching for prints that they like and can live with, investors must only consider impressions that more or less conform to the investment guidelines outlined above.

The best approach to avoid indiscriminate, random buying is to plan an investment strategy and stick with it. When buying for investment, it is important to start out with the intention of building a superb collection of quality pieces. As suggested in Chapter 6, specialization is the key to assembling a quality collection in a short period of time. For the investor, specialization in a certain style or "school" of art or the work of a few artists simplifies the task of keeping up to date on price trends. Also, by selecting and limiting your primary areas of interest, you can quickly acquire some degree of expertise and familiarity with the market for your specialty.

There are basically two practical investment strategies to follow: (1) collect prints by relatively unknown artists in the hope that they will become famous someday and your collection will increase in value as their work is recognized; (2) only invest in "blue chip" works — prints by internationally recognized master artists such as Picasso, Chagall, Lautrec, Matisse, Miró, or Hockney — which will probably continue to appreciate steadily due to their immense popularity and probable lasting historical importance.

When investing in prints by lesser-known artists, buyers must always be concerned about the quality of the printmaker's work and his personal commitment to his art. Obviously investors should avoid the thousands of inexpensive decorative prints that are constantly being released onto the market. They should concentrate on the work of artists who have a visual message to communicate and who have demonstrated a technical ability to convey ideas through the various print media. It is also important to look for artists who have produced a substantial body of work over several years and who are likely to continue making prints. If an artist is not seriously committed to his art and suddenly gives it up one day to pursue another career, the chances of his prints subsequently increasing in value are exceedingly slim.

Investors in prints by "name" artists may choose either to collect several particularly fine examples of works by international masters or to concentrate on building a collection of prints by popular American or Canadian artists. Prints by American artists such as Robert Motherwell, Jasper Johns, Alex Katz, Richard Estes, James Rosenquist, and Canadians such as David Blackwood, Toni Onley, David Milne, W. J. Phillips and many, many others, all represent excellent investment opportunities, since they each have consistently produced superb work and have a large following in their own countries. Some collectors even place standing orders with dealers for every new print that is published by their favorite artists.

Regardless of what type of prints you choose to collect, always buy the best you can afford, and if possible, diversify your collection among three or four artists within the guidelines given above. You can greatly reduce the risks of making a bad art investment by only buying prints you like and can live with. If you always place aesthetic considerations ahead of monetary concerns when making print purchases, at least you can be assured of receiving a guaranteed dividend every time you look at them.

SELLING PRINTS

While prints may pay their owners aesthetic dividends every day, monetary profits can only be realized by selling. It is easy to fool yourself into thinking that a print you own has increased in value, but until someone is willing to pay you close to the current retail price for it, your profit is imaginary.

There are basically four ways private collectors can profitably dispose of their prints:

PRIVATE SALES TO OTHER COLLECTORS: It is sometimes possible to locate a buyer for a print by running classified ads in a daily newspaper or art magazine. If a sale can be made privately, you won't have to pay a commission to a dealer or an auction firm, and you will receive your money without delay — providing, of course, that a buyer can be found with the cash in hand for your print. However, private sellers must be prepared to do this work and provide many of the services that dealers offer. Before you can sell a print, you must first research its current market value by checking recent auction and dealer catalogs or the various auction price directories listed in the Resource List. If you are

unable to find a recent price for the print in question, you may get an idea of its price range by looking up a similar print by the same artist. You could also ask a dealer who specializes in the type of print you are selling to give you a written appraisal; normally a fee equal to about $1\frac{1}{2}$ percent of the print's value will be charged for this service.

With a fair price established, you simply place your advertisements in one or two publications and sit back and wait for replies. But do not expect an overwhelming response. Unless you are selling a popular print that is in great demand, or are offering a selection of prints by "name" artists at bargain prices, few collectors will take the time and trouble to respond. If they are not familiar with the image you are selling, and if your price is close to the going retail value for the artist's prints, most collectors will find it easy to pass up your offer. You should also expect those who do respond to haggle over the price, and perhaps request to take the print home "on approval."

Because most private sellers are unwilling or unable to provide the services professional dealers offer, it is often difficult to make sales to other collectors. You may be successful in selling or trading a few inexpensive prints through ads in the classifieds, but more valuable, investment-caliber pieces should be consigned to a reputable dealer or auction firm, where they have a much better chance of being sold to serious collectors who are willing to pay a full price.

SELLING TO DEALERS: Specialist print dealers are often best equipped to sell a print quickly and to obtain a top retail price for it. Unfortunately, however, the collector who sells a print to a dealer must be prepared either to accept whatever *wholesale* price the dealer offers for an outright purchase, or to pay a hefty sales commission to him if the print is sold on consignment.

Dealers normally expect to sell a print for roughly double the price they paid for it. Print dealers are able to achieve this markup with some consistency since the "trade discount" they receive from most print publishers, artists, and other wholesale print distributors is 50 percent off the suggested retail price. Because most dealers want to maintain a standard markup on every item they sell, they are unwilling to pay more than about one-half the retail value for prints they purchase outright from collectors. Unless the print you are offering is a great rarity, or unless the dealer knows he has a ready customer for it and is reasonably certain he can turn a quick profit, few dealers will pay you more than 50 percent of the retail value of a print when making an outright purchase. In most cases, any profit you hoped to make on a print will be wiped out if you insist that the dealer pays cash on the spot.

A more profitable deal for the collector can usually be made by offering to leave a print with the dealer on consignment. Since the dealer does not have to risk tying up his own money, he may be willing to take a smaller markup or commission for selling it. Normally a commission of between 20 percent and 40 percent of the retail selling price can be negotiated.

Before entering into a consignment arrangement with a dealer, you should do your homework and know exactly how much the print is worth on the current market. The first question most dealers will ask you is, "How much do you want for it?" If you obviously do not know the value, some dealers may take advantage of your ignorance and give a low estimate of a print's worth to establish a lower net price to you after he deducts his commission. Of course, the dealer would then attempt to sell the print at its full retail value and keep a larger share of the proceeds for himself.

Often consignment deals work to both the seller's and the dealer's advantages when no set commission rate or markup is established. The dealer is left to sell the print for whatever price he can get over a fixed sum that is agreed upon as the owner's share of the proceeds. This arrangement benefits the seller by guaranteeing him a certain price for his print; any reduction in the retail price that the dealer gives to a customer will not affect the net proceeds paid to the owner. Dealers often prefer this arrangement because it gives them an opportunity to try for a higher price and perhaps make a larger profit from the sale, while giving them the flexibility to reduce their price, if necessary, to clinch a sale.

Obviously, it is important for a seller to know the exact value of his print before entering into such an agreement, since he must name a price that will not only allow him to make a profit on the sale, but also allow the dealer to make a reasonable markup. It is a good idea to arm yourself with facts and figures, including recent auction prices, dealer prices, or an independent written appraisal before negotiating your share of the proceeds from a consignment sale.

Never leave a print on consignment with a dealer without obtaining a receipt for it, which clearly spells out the terms of your agreement with him. A simple handwritten note signed by the dealer will normally be sufficient, as long as the information in the example given on the following page is included.

Of course, if an agreement is made to set a firm selling price and commission arrangement, the exact amounts and percentages should be spelled out on the receipt.

Finally, be sure that expensive prints will be insured against damage

and theft before agreeing to leave them on consignment with a dealer. Your own household insurance may not cover a loss when a print is taken outside of your home. Make certain your print will be covered by the dealer's insurance while it is in his possession, and when in doubt, insist that he acknowledge his responsibility for insuring it on the receipt.

SELLING PRINTS AT AUCTION: Generally, the most profitable method of selling prints and other art objects is to consign them for sale with a major auction firm. Auctions provide sellers with a chance to net a higher price for their prints than they might receive from dealers, since it is not uncommon for prints to be bid up far above retail price levels on the auction floor. Also, the commission charged to sellers by most auction firms is usually less than the amount dealers charge to sell prints on consignment.

There is an extremely active auction market for prints. The larger New York firms, such as Sotheby's and Christie's, usually schedule several sales of modern and contemporary prints every spring and fall, and the half-dozen or so larger European auction companies each hold at least one major sale per year, which provide additional, specialized markets for international graphics.

A print will usually have a better chance of fetching a top price at auction if the auction company you consign it to has an established reputation in the print field and regularly holds well-attended print auctions. Serious print collectors throughout the world know which firms have a reputation for consistently attracting top-quality consignments, and often place standing orders with them for all their print sale catalogs. The combination of a well-attended sale and the international

exposure in the catalog of a respected auction firm maximizes the chances of obtaining a high price for a print.

Although the national and international distribution of an auction catalog may produce order bids from all over the world, most of the bidding action on a print usually originates from the auction floor. For this reason, prints should always be consigned to firms which are located in the most appropriate market for the artist's work. Prints by Canadian artists, for example, should be sent to auctions in Toronto or Vancouver; American prints will generally fetch the highest prices in New York or Los Angeles; French prints will achieve the best results at auctions in France or Switzerland. (Most of the major European firms maintain offices in New York and send English-speaking representatives around to the major North American cities in search of suitable material for upcoming auctions. It is often no more difficult to sell a print in a major European sale than it is to consign it to a local firm.)

To sell a print at auction, simply telephone or write an appropriate firm and describe your print in detail. A print expert from the company should be able to advise you whether or not your print would be suitable for inclusion in their next sale, and perhaps quote you a rough estimate of its value. If the firm is interested in your print, they will probably ask you to send it to them for a detailed examination before giving you a firm estimate. Of course, the print would be immediately returned if it were judged to be unacceptable for any reason.

When your print is accepted by an auction firm, you will be asked to sign a contract, which outlines the terms of your agreement, and spells out the responsibilities and liabilities of both parties. A typical contract specifies the terms of payment, the cost of illustrating the print in the catalog, responsibility for insurance costs, penalties charged if the owner changes his mind before the sale and decides to keep his print, and the reserve price agreed upon with the seller. It also includes the commission percentage charged by the auction firm. In North American auctions the standard rate is 15 percent on items selling for less than $500 and 10 percent on items selling for over $500; European auction firms charge anywhere from 10 to 20 percent of the selling price.

Most of the terms of agreement are negotiable with the auction firm; however, their willingness to grant favorable terms to a seller usually depends on how salable they perceive your prints to be. If you are offering a large collection of valuable prints by popular artists that the company's experts feel will enhance the prestige of the sale, or if you have one or two superb images that the auction house may wish to reproduce in advertisements or on the catalog cover, the firm may be more than willing to negotiate a reduced commission and perhaps

offer to pay catalog illustration costs and insurance fees as well. (Collectors must always make certain their prints are insured against loss or theft while in transit to and from an auction firm, and while on the premises.)

When offering highly desirable prints to an auction house, some collectors take the opportunity to unload any poor-quality prints they want to dispose of by including them in an "all or nothing" proposition. Most of the better auction firms set fairly high standards on the quality and monetary value of prints they accept as consignments, but few of them will refuse to sell one or two substandard items for you if they are offered along with a rare or popular print.

The reserve, or minimum price the auction firm agrees to sell a print for, is normally set by the owner. Because the auction firm's commission is severely reduced when a print is bought in (usually to about 5 percent of the reserve amount), their experts will always encourage you to establish your reserve as low as possible to facilitate a sure and easy sale. Under no circumstances will they allow you to set a reserve higher than the top end of the price range they estimate for the print and publish in their catalog. Normally, reserves are set at an amount equal to about 75 percent of the auction company's price range estimate.

Reserves are the only legal protection you have against your prints being sold at auction for a small fraction of their value. Laws in most American states and Canadian provinces prohibit sellers from bidding up their own consignments. (Nevertheless, some dealers have been known to bid their own prints up to retail levels when they fear that poor auction results will severely depress the value of their remaining inventory.) Always put a reasonable, but adequate, reserve on every print you consign for sale at auction.

It is often a good idea to frame modern and contemporary prints before sending them to an auction firm. Loose prints are easily damaged while on display at previews and when being transported. A suitable, good-quality frame also makes a print look more attractive and may add $100 or so to the price, since bidders are often willing to pay extra for the convenience of obtaining a print that is ready to hang.

Finally, it is important to keep in mind the length of time it will take to complete the transaction and receive cash in hand. Prints must be delivered to an auction firm at least two to three months in advance of a sale to give the company time to catalog each item, print and mail the sale catalogs, and exhibit the consignments for several days in the auction preview. You may then have to wait anywhere from thirty to sixty days after the sale before you receive payment from the auction company. A sale at auction will, therefore, normally take from three to

six months to complete, but at least you can be reasonably certain that your print will be sold and that you will be paid a fair market price for it. You could run classified ads in art magazines for your print or leave it hanging on a dealer's wall for a much longer period, and never attract a single prospective buyer. Auctions clearly offer the best opportunity for investors to sell their prints at a profit.

SELLING OR DONATING PRINTS TO PUBLIC INSTITUTIONS: Under certain circumstances, collectors may actually profit more by giving their prints to a museum or some other public institution than they would by selling them privately or at auction. This is because art objects that are sold at a profit on the open market are generally subject to capital gains tax (normally 50 percent of your profit from the sale of a print worth over $1,000 is taxable), while art that is sold or donated to a public institution may escape capital gains tax and perhaps even qualify as an allowable tax deduction for the collector as well. Collectors in high income brackets often find the tax saving that results from giving a print to a museum is far greater than the net profit that would be realized from an outright sale.

It is beyond the scope of this book to delve into the various ways art investors can benefit from selling or donating prints to public institutions for the purpose of avoiding capital gains taxes or obtaining a tax deduction. However, it is important to consider the tax implications of every sale you make, and perhaps seek the advice of a knowledgeable tax accountant before attempting to sell a major print or a large collection.

COLLECTING PHOTOGRAPHS

FINE ART PHOTOGRAPHY experienced an unprecedented boom in popularity as a collectible in the early 1970s. Suddenly the art world became aware of the wealth of exceptionally beautiful and in some cases historically important photographs that, until then, had seldom been considered as serious art by collectors, dealers, and museum curators.

Today, photographs are taking the place of lithographs, serigraphs, and etchings for some print collectors. Soaring prices for the very best works by major printmakers have pushed many people out of the traditional print market. One of the big attractions of collecting photographs is the accessibility of historically important works by master photographers at prices the average collector can afford.

However, to buy photographs wisely, a certain amount of specialized knowledge is necessary. Although the precautions, disciplines, and procedures followed when collecting photographs are quite similar to those followed when purchasing original prints, there are a number of major differences and problem areas that collectors should be aware of before plunging in and making their initial photo purchases. But first, it is important to become familiar with the various types of photographs that are available.

FIGURE 49

(a) Daguerreotype c. 1850s
(b) Carte de visite c. 1860s
(c) Stereograph card c. 1890s
((a) Courtesy Phillips Ward-Price Ltd., Toronto; (b) and (c) Courtesy Baldwin Photography, Toronto)

a

b

c

TYPES OF PHOTOGRAPHS AVAILABLE TO COLLECTORS

In the early days of photography, there were two types of photographs: "unique" photographic images made on small pieces of metal or glass; and photographic prints on paper, produced in multiple from negative images made on light-sensitized sheets of glass or paper. The processes for producing unique images enjoyed worldwide popularity from 1839 to about 1890 and were mostly used to make inexpensive portraits. Several negative and paper print systems, which were the forerunners of most of today's photographic methods, were also perfected during this period.

UNIQUE PHOTOGRAPHS: The earliest and most popular type of unique photograph was the *daguerreotype*, named after the inventor, a Frenchman named Louis Jacques Mandé Daguerre. Daguerreotypes were made on tiny silver-coated copper plates, which were sensitized with fumes of iodine and developed by exposing the image to mercury fumes. The daguerreotype process was introduced in 1839 and remained popular until about 1860.

Collectors can easily identify daguerreotypes by their mirrorlike silver coating on the picture's surface. To see the image, the picture must be viewed on an angle. Most daguerreotypes were sold in fancy leather cases or elaborate frames, and today the photos which remain in their original cases or frames will usually be worth much more than those which are unframed.

Another photographic process that enjoyed a period of great popularity for portraiture in the last century was the *ambrotype*, invented in the early 1850s. Ambrotypes were made by developing a negative image on a small piece of glass. The glass was backed with a coating of black varnish, which made the image appear to be positive.

As with daguerreotypes, ambrotype portraits were sold in decorative cases, and today the case can greatly increase the market value of an ambrotype photograph. However, a good ambrotype is seldom worth as much as a comparable daguerreotype.

The *tintype* or *ferrotype* process was another popular photographic method that was used for inexpensive portraiture from about 1860 to 1890.

Tintypes were made on thin light-sensitized iron plates, which were coated with a special black or brown varnish. They were often sold in cardboard frames. Tintypes were generally of inferior quality to daguerreotypes and ambrotypes, and many of the surviving ones are in extremely poor condition. They are therefore worth far less than comparable daguerreotypes and ambrotypes, and are of little interest to most photography collectors.

Today, daguerreotypes, ambrotypes, and tintypes sell in flea markets, auctions, antique shops, and photographic art galleries for between $20 and $50 for portraits of unidentified people. However, rare daguerreotype and ambrotype photographs of landscapes, nudes, still lifes, or portraits of famous people are priced well up into the thousands of dollars.

NINETEENTH-CENTURY PRINTS: The first practical negative and paper print process was invented in 1839 by a British mathematician named William Henry Fox Talbot. His prints, called *calotypes* (sometimes referred to as "salt" prints or Talbotypes), were made by treating ordinary sheets of writing paper with solutions of silver nitrate, potassium iodide, and various other chemicals to make them light-sensitive. When exposed to light inside a camera, a negative image was recorded on the sheet of paper. Bright areas of the subject appeared dark on the paper; low light or dark areas produced light tones on it. Paper prints could be produced by exposing the negative image on sheets of paper, which were made sensitive to light by the same chemical process. Exposure to the negative under bright daylight produced positive images on the paper. Dark areas on the negative came out light on the print, and light negative areas produced dark tones that were approximately the same as those of the original subject.

A calotype may be recognized by its dull surface and general faded appearance. The prints have a tendency to become particularly faded or washed out around the perimeter of the image.

Calotype prints were popular in the 1840s and early 1850s with photographers in Great Britain and France. Today, collectors particularly favor calotypes by two Scottish portrait photographers, David Octavius Hill and Robert Adamson, and the experimental prints made by William Fox Talbot himself.

In addition to Talbot's calotypes, a *wet plate* process of making negatives on glass plates was invented in 1851, which produced clearer and sharper images. This method of making negatives, combined with a commercially manufactured photographic paper called *albumen paper*

which was introduced at about the same time, quickly became the most popular process for printing positive paper prints.

Albumen prints were made on paper that was coated with a solution of chemically treated egg whites. They may be distinguished from calotypes by their thick, shiny surface coating and their tendency to discolor. Albumen prints typically turn an orange-brown color with age and exposure to light. They also have a tendency to fade, particularly around the outer edges.

The wet plate/albumen print process remained in use until the 1890s and many of the most important photographers of the last century employed this technique to make some of their most outstanding images. Today, photography collectors particularly prize albumen prints made by outstanding photographers of the last century such as: Julia Margaret Cameron, who photographed many of the great writers and artists of Victorian England; Gaspard Felix Tournachon (whose professional name was Nadar), a French photographer who photographed famous French writers and artists; Mathew Brady, who is best known for his photographs of the American Civil War; and William Notman, a Canadian landscape and portrait photographer.

CARTES DE VISITE: Collectors with a small budget and an interest in nineteenth-century history and culture may find pocket-sized cartes de visite or "visiting card" photographs of interest. Cartes de visite, invented by a French photographer named André Disdéri, became fashionable in France after Napoleon III halted his troops at Disdéri's studio in 1859 and had a set of carte portraits taken of himself. (Carte photographers used a special multi-lens camera, which enabled them to inexpensively photograph their subject in eight to twelve poses.)

Cartes de visite quickly became popular in England and North America, where it became fashionable to collect carte portraits of family, friends, and famous people in special albums. Complete albums filled with carte de visite photographs frequently are offered for sale on today's photography market.

Carte de visite photos measure just 3½ by 2¼ inches and are mounted on 4 by 2½-inch cards. (A larger size with a photograph measuring 5¼ by 4 inches mounted on a 6½ by 4¼-inch card was introduced in the 1860s. This size is known as a *cabinet card*.) The photographer's name is normally printed below the image or on the reverse side.

Today, cartes de visite are priced from under $5 each up to several hundred dollars. The highest prices are paid for those taken by well-

FIGURE 50
JULIA MARGARET CAMERON (1815-1879), *Portrait of Alfred Lord Tennyson*, 1867.
Albumen print, 12^1/$_2$ x 9^1/$_2$ in. (31.8 x 24.1 cm).
(Courtesy Phillips Ward-Price Ltd., Toronto)

FIGURE 51
WILLIAM NOTMAN (1826-1891), *Yonge Street
Looking North,* Toronto, 1890.
Albumen print, 9¹/₄ x 7¹/₄ in. (23.5 x 18.4 cm).
(Courtesy Jane Corkin Gallery, Toronto)

known photographers and those which depict subjects of historical importance.

STEREOGRAPH CARDS: Stereographs are another interesting area of the photographic art market for collectors on a tight budget. Stereograph cards hold two photographs of the same subject taken from slightly different angles. They produce a three-dimensional effect when viewed through a special viewer called a *stereoscope*. They were fashionable from the 1850s to the 1870s, and again from the late 1880s to the mid-1930s. The subject matter includes battle scenes, portraits of politicians and royalty, landscapes, street scenes, and still lifes.

Stereographs provide a permanent historical and sociological record of life in the nineteenth and early twentieth centuries. Like cartes de visite, many are purchased today solely for their historical value. And since millions of stereograph cards were manufactured in the last half of the nineteenth century (in 1858 the London Stereoscopic Company advertised that it had a selection of 100,000 different cards for buyers to choose from!) they are usually quite inexpensive to purchase today.

Most stereograph cards in good condition sell for between $5 and $50, although exceptional or unusual cards will often sell for several hundred dollars each.

TWENTIETH-CENTURY PRINTS: Toward the end of the nineteenth century, a number of technological advances in photographic processes had a profound effect on twentieth-century art photography. Commercially-made *dry plate* negatives, introduced in 1880, eventually replaced the wet plate process, which required the photographer to sensitize his negatives by hand just before each picture was taken. Although a method of making negatives on celluloid was invented as early as 1889, glass dry plate negatives remained in use until the 1930s.

Several new types of photographic print papers were invented during this period as well. Introduced in 1880, *platinum prints* (sometimes called *platinotypes*) produced superior-quality, fade-resistant images. The process was first used by photographers such as Peter Henry Emerson, who in 1886 published *Life and Landscape on the Norfolk Broads*, a book containing 40 platinum prints. Later it was used by twentieth-century photographers such as Alfred Stieglitz, Edward Steichen, and Edward Weston.

Around the turn of the century, *silver prints* (a generic term for all prints made with paper photo-sensitized with silver) gradually replaced albumen prints and quickly became the most common type of photograph available. Most original photographs made since then

are described in auction and dealer catalogs simply as "silver prints," although a number of different types of papers have been manufactured over the years which fall into this broad category.

Another nineteenth-century invention that ultimately played an important role in twentieth-century photography was the *photogravure* process for reproducing photographs in books and magazines. Invented in 1879, photogravures (sometimes called *gravures*) are high-quality reproductions printed in ink from photographically-etched copper plates.

Although gravures are not original photographs, they are actively collected and traded on today's photography market. This is because prints by popular late nineteenth- and early twentieth-century photographers are often scarce and the cost is prohibitive for many collectors. Most of the gravures collected today have been removed from photographically illustrated books or from magazines such as: *Camera Notes*, published from 1897 to 1903; *Camera Work*, published from 1903 to 1917; and *291*, published from 1915 to 1916.

Platinum prints, silver prints, and photogravures by the so-called "master" photographers of this century (photographers who are generally recognized as having made a lasting contribution to photographic aesthetics are usually referred to as "masters") are the most sought-after pictures in the photography market.

Some of the most important photographs in this category were made by members of an avant-garde movement called the Photo-Secession, which was active in New York from about 1902 to 1917. The group's founder was a photographer named Alfred Stieglitz, who was also the editor of *Camera Work* and *291*.

Stieglitz is best known for his photographs depicting everyday scenes and events in New York. (See Figure 52.) In addition to Stieglitz, two other leading members of the Photo-Secessionist movement were Edward Steichen, famous for his dark, soft-focus portraits and landscapes; and Paul Strand, who became famous for his direct, clear focus or "straight" photography.

Original platinum prints and silver prints made by these photographers are rare, and when they do appear on the market, it is not uncommon for them to sell for between $5,000 and $15,000 each. However, photogravures from *Camera Work* and *291* are readily available and typically sell for between $100 and $1,000 each.

After the demise of *Camera Work* in 1917, few photographers published their photographs using the photogravure method of reproduction. Master photographers working since the 1920s, such as Edward Weston, Imogen Cunningham, Ansel Adams, André Kertész, Henri Cartier-Bresson, and dozens of others whose work is popular with

FIGURE 52
ALFRED STIEGLITZ (1864-1946), *The Steerage*, 1907.
Photogravure, 7³/₄ x 6¹/₄ in. (19.7 x 15.9 cm).
From the October 1911 issue of *Camera Work*.
(Courtesy Yarlow/Salzman Gallery, Toronto)

collectors today, have made black and white silver prints, and in a few instances, platinum prints.

Most contemporary photographers also work in black and white. (In the photography market, "contemporary" usually refers to photographs by the less-established photographers working from the 1950s to the present day, rather than masters such as André Kertész or Edward Weston, who were still active during this period but who are generally associated with an earlier photographic art movement.) Until recently, very few photographers have produced substantial bodies of work in color, although several processes for making excellent quality color prints have been on the market for several years, including: *type-C* prints (the same kind of print you receive when you send your films away for processing); *Cibachrome* prints (the trade name of a process for making prints from color transparencies); and *dye-transfer* prints (made with special fade-resistant dyes).

Color has been slow to catch on for three reasons: photographers often have difficulty controlling color hues on their finished print, because they normally must rely on technicians to make their prints for them; color prints fade relatively quickly; and the processes for making fade-resistant prints are often prohibitively expensive.

Nevertheless, a small but growing number of photographers — Harry Callahan, William Eggleston, and Ansel Adams to name a few, have produced some excellent work in color in recent years. As technical improvements are made to the medium, it will no doubt become increasingly popular with both photographers and photography collectors.

LIMITED AND
UNLIMITED EDITIONS

VINTAGE VERSUS NONVINTAGE PRINTS:
Photographs are seldom made in numbered, limited editions as is the customary practice in modern and contemporary printmaking. Photographers have traditionally made prints in response to the market demand for their work, and until very recently the demand for art photography was so small that photographers would typically only make two or three prints from any one negative. As a result, many *vintage prints* — those prints which are made within a year or two of the date the picture was taken — are great rarities. Some photographs (particularly certain nineteenth-century prints) exist today as unique images, and in many cases the

FIGURE 53
Paul Caponigro (b. 1932), *Sunflower Vase,* 1970.
Silver print, 8³/₄ x 7¹/₄ in. (22.2 x 18.4 cm).
(Courtesy Déjà Vue Gallery, Toronto)

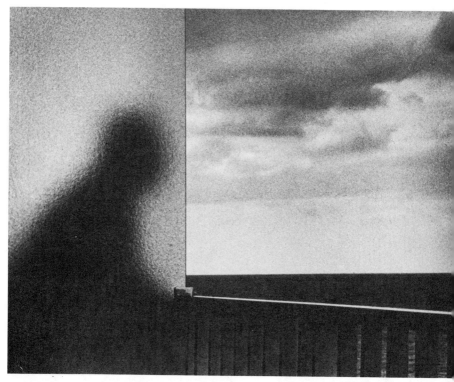

FIGURE 54
ANDRÉ KERTÉSZ (b. 1894), *Martinique,* 1972. Silver
print, printed later, $7^1/_4$ x $9^5/_8$ in. (18.5 x 24.5 cm).
(© André Kertész, 1972. Courtesy Jane Corkin Gallery, Toronto)

photographer's negatives are known to have been lost or destroyed,
making it impossible for additional copies to be printed.

However, many twentieth-century photographers have from time to
time gone back into the darkroom and reprinted their old negatives, or
have allowed a technician to make additional prints for them to meet
the recent collector demand for their work. Photographic prints that are
made a number of years after the picture was taken are usually called
modern prints or *reprints.* In photography auction catalogs they are
usually described simply as "printed later." Prints made by a techni-
cian after a photographer's death are called *posthumous prints.*

In the jargon of the print world, nonvintage photographs are the
"restrikes" of the photography market, and like reprints from old litho-
graphic stones or etching plates, they are normally worth considerably

less than the photographer's vintage prints of an identical image.

How much less depends upon a number of factors, including: the quality of the later printing; the photographer's involvement in the reprinting of his negative (a reprint made by a technician is normally worth somewhat less than one made by the photographer himself); and the presence or absence of the photographer's signature or stamp on the print, certifying that he inspected it and approved the quality. In general, reprints which are signed by the photographer are worth between 40 and 80 percent of the market value of a signed vintage print of the same image, and posthumous prints made by a technician are typically only worth between 5 and 20 percent of the value of the photographer's vintage works. But this is only a rough rule of thumb that does not apply to every photographer.

Collectors usually have little difficulty in distinguishing vintage photographs from nonvintage prints. Most photographs are identified on the back by signatures, stamps, dates, and other markings as vintage prints, modern prints, or posthumous prints. For example, posthumous Edward Weston prints made by his son Cole (who is the only person Weston authorized to reprint his work after his death) are stamped on the back "NEGATIVE BY EDWARD WESTON, PRINT BY COLE WESTON."

There are often some obvious visual differences between vintage and nonvintage photos as well. In fact, the aesthetic appeal and desirability of each category of print is the subject of many heated debates by photography collectors, dealers, and other experts.

Some collectors will only buy vintage photographs, claiming that aging often enhances an image and that vintage works also have a richness, mystique, surface quality, and historical value which is unequalled by modern prints. Many collectors of vintage works also insist that the prints made by the photographer shortly after the picture was taken are the ones that most closely relate to his original conception. In addition, vintage collectors maintain that early photographs are more appealing because they were often printed on special papers selected by the photographer to enhance the image quality.

On the other hand, many collectors who are content to buy later prints of outstanding images maintain that later printings of negatives often produce better-quality prints than the photographer's initial attempts. Ansel Adams and a few other photographers support this theory. Adams generally prefers the look of his later prints to the original prints of pictures he took in the '30s and '40s. He likes to compare a photographer's negative to a musical score and his prints to repeat performances. The artist who reprints his work, he claims, is like a performer who reworks and improves his arrangement of a musical

score — with more knowledge and practice, the later interpretations may be more inspired.

Ultimately, however, for most people the decision to collect vintage or nonvintage prints is a financial one. Although vintage prints are normally a superior investment to modern or posthumous prints (due to their greater rarity, the enormous collector demand for them, and generally superior print quality), the cost of acquiring them is becoming increasingly prohibitive for most collectors. Modern prints, therefore, have become very popular in recent years, because they may be acquired at a fraction of the cost of vintage works.

Other factors may also account for the increase in popularity of nonvintage prints. These include the exceptional visual appeal of certain later printings of a photographer's images and the availability of certain images. Modern prints are readily available from photography dealers, auctions, and from the photographers themselves, while vintage photos are often extremely scarce.

CONTEMPORARY EDITIONING PRACTICES: Collectors of contemporary photographs often worry that some living photographers may decide to cash in on the popularity of their best-known images by producing enormous quantities of prints. If a photographer suddenly flooded the market with his work, the collectors reason, it would cause the value of his prints that are already in the hands of collectors to plummet. But in reality, this is only a theoretical problem for the following reasons.

First, there is insufficient market demand for the work of most photographers to justify the mass-production of their prints. In fact, most photographers working today consider themselves lucky if they can sell four or five prints of any one image. They will often only make one or two prints of each photograph they offer to galleries.

Secondly, most photographers hate to go back into the darkroom and reprint old negatives. Darkroom work is very time-consuming; some meticulous printers will often spend a day or more making a single print to their exacting standards. Most photographers would prefer to spend their time creating new imagery rather than churning out huge volumes of prints.

Finally, photography collectors, like collectors of original prints, should not be overly concerned about the number of prints of an image in circulation. The demand for an image normally has a greater effect on prices than the number of copies that are known to exist.

Although rarity is often an important factor in the determination of prices for nineteenth-century works (when only one or two copies of

certain images are known to exist), the number of prints in circulation seldom has much to do with the prices charged for photographs. For example, Ansel Adams estimates that over the years he has made between 800 and 1,000 prints of his most popular photograph, *Moonrise, Hernandez, New Mexico*. But in spite of the large number of prints of this image in circulation, prices for *Moonrise* have continued to climb rapidly since Adams announced in 1975 that he had decided to stop printing his old negatives and would not accept any new orders for his prints. Today, Adams's less famous photographs, which were printed in much smaller quantities, sell for between $1,500 and $3,000, but strong collector demand has pushed the price for prints of *Moonrise* up to the $15,000 to $20,000 range.

Some contemporary photographers do in fact make their prints in limited editions of three or more signed and numbered copies, following the traditional practice of modern and contemporary printmakers. A few photographers with established reputations such as Harry Callahan, Paul Caponigro, Lee Friedlander, and many others have also issued collections of their prints in boxed, limited edition portfolios, again following a practice that was originally established in the print market.

However, in the photography market the limited edition concept offers even fewer guarantees of rarity than it does in the print market. Very few photographers destroy or cancel their negatives after issuing an edition or portfolio, as printmakers deface their matrixes after an edition is printed. The edition size indicated in the margin or on the back of a photograph typically only applies to that particular printing, and some photographers will continue to make more prints from the same negatives in addition to the ones made for their numbered editions. At present, each photographer has developed his own policy regarding edition sizes and reprintings of negatives, and there are no consistent numbering or editioning procedures being followed in the contemporary market.

In most cases, the practice of printing photographs in numbered editions, like the practice of making original prints in limited editions, is merely a marketing device designed to give the illusion of rarity to each print and to satisfy collector concerns regarding the number of copies that were made. The numbering and editioning practices of many photographers offer collectors few guarantees of rarity.

PHOTO FORGERIES

Because photographs are easily copied and duplicated in quantity, many collectors fear that skilled technicians could reproduce popular images and flood the market with their fakes.

Surprisingly, the photography market is almost entirely free of fakes and forgeries, although there have been a few cases of signatures being forged on unsigned prints, and pictures being misrepresented or wrongly attributed as the work of famous photographers. Moreover, photo forgery is not likely to become a big problem for collectors in the forseeable future. Would-be photo fakers have found it is nearly impossible to duplicate the look, feel, and surface tone of authentic vintage prints, and prices for contemporary photography, as well as for most modern prints made from old negatives, are presently too low to warrant anyone going to the trouble and risk of faking them.

Unfortunately, there is a very limited amount of documentation available to assist photography collectors in identifying faked or misrepresented prints and forged signatures. There are no catalogues raisonnés listing all the works of individual photographers as there are for most important printmakers.

However, one book, *The Photograph Collector's Guide* by Lee D. Witkin and Barbara Morgan, offers basic information of the work of 234 major nineteenth- and twentieth-century photographers whose prints are of interest to many collectors. Each listing gives biographical information on the photographer, a description of his work, the type of photographs made, typical sizes of his prints, availability, a list of the major collections the photographer is represented in, a reproduction of the photographer's signature or stamp, and a bibliography. In addition to the 234 individual listings, information on numerous other photographers is given in group entries, which describe the major photographic themes and movements.

There are also numerous other books available on or by famous photographers which may be helpful in authenticating prints.

BUYING PHOTOGRAPHS FROM DEALERS AND AUCTIONS

There are well over 200 galleries and art dealers in the United States and Canada which are devoted primarily, and often exclusively, to selling photographs. Many specialize in one or more periods or types of photography, such as nineteenth-century prints or the work of twentieth-century masters. A few specialize in color photography, and others concentrate on the experimental work of contemporary artists and show photographs along with paintings, prints and sculpture.

Most of the important photography dealers are clustered in the major art centers such as New York, Toronto, and Los Angeles, however, there are a number of galleries in many smaller North American cities which sell photographs along with other types of art.

Personal taste and familiarity with the marketplace can best be developed by browsing in several photography galleries. Most have well-informed staffs who are eager to help new collectors. The trick is to find a dealer whose tastes are compatible with yours.

Normally photography dealers have a good deal more stock on hand than they are able to show on their walls at any one time. Therefore, when visiting a dealer for the first time it is often a good idea to ask to see a selection of other works the gallery handles in addition to what is on display, in order to get a feel for the dealer's range of tastes or areas of specialization.

Some photography dealers, like print dealers, publish annual catalogs of their current offerings, and collectors who are unable to visit dealers in person may wish to send for catalogs or stock lists. A listing of over sixty American, Canadian, and European dealers is available from The Association of International Photography Art Dealers, Inc. (see the Resource List for the address). This is a non-profit association which promotes high ethical standards in the sale of photographic art.

Photography collectors, like print collectors, should insist that dealers guarantee the authenticity of the photographs they sell in writing on the bill of sale. Most photography dealers will offer their customers the same refund and exchange privileges, guarantees, and discounts that are offered by print dealers.

Auctions have also become excellent sources of photographs for collectors. Numerous photography auctions are held every spring and

fall by the major New York auction companies such as Sotheby Parke Bernet, Christie's, and Phillips, Son & Neale Inc. In addition, Sotheby's has regular photography auctions at its Los Angeles branch, and Phillips Ward-Price Ltd. holds one photography auction every year in Toronto. Christie's and Sotheby's in London, England, hold numerous auctions of photographs each year as well. Collectors may subscribe to the photography auction catalogs that are published by these firms by writing to them at the addresses given in the Resource List.

The Print Collector's Newsletter, Photo Communiqué and *printletter* (again, see the Resource List for details) also keep collectors up to date on market developments, prices, trends, photo aesthetics, and important shows and auctions. In addition, there are several excellent books available on photography collecting and the history of the art. A sampling of some of the more comprehensive texts will be found in the Bibliography.

THE CARE AND FRAMING OF ORIGINAL PRINTS

ORIGINAL PRINTS, PHOTOGRAPHS, and other works of art on paper are fragile and require special care to protect them from being damaged by atmospheric pollution, insufficient or excessive humidity, overexposure to light, mold, insects, and contact with poor-quality framing materials. If prints are properly framed and displayed, their lifespan can be greatly increased. Frames and mats not only enhance the appearance of your prints, but also play an extremely important role in the long-term preservation of your collection.

Most inexpensive papers, mat boards, and cardboards manufactured today are made from wood pulp and other materials which are high in acid content. Acids within papers and boards eventually cause them to discolor and ultimately decompose. As a result, the lifespan of some cheap paper products is exceedingly short; newsprint, for example, decomposes within a decade or so.

Because cheap papers will self-destruct in a relatively short period of time, most modern and contemporary artists make their prints on expensive acid-free papers, which are manufactured by specialty paper companies and a few craftspeople who still painstakingly make art papers by hand. Through careful selection of materials (acid-free rags are normally substituted for wood pulp; such papers are referred to as having "all-rag" content) and precise quality control, manufacturers are able to make papers that will last indefinitely with proper care.

However, all prints, even those made on all-rag, acid-free papers, are highly vulnerable to damage through prolonged contact with certain types of acidic mat boards, cardboards, and adhesives used by many picture framers. Acids within low-quality mat boards, and other materials made largely from wood pulp, "migrate" to the print and begin to acidify the paper within a few years. Also, excessive moisture can cause dyes in poor-quality colored boards to be released, staining the print.

The migration of acidity from framing materials to a print can be prevented by instructing your framer to only use acid-free mat board, sometimes referred to as museum board. It is crucial for print collectors to find a framer who is aware of the damage that can be caused by using improper materials. Unfortunately, some framers will agree to work with the acid-free materials you specify and will then cut mats from whatever boards they have in stock. Skeptical or dishonest framers will ignore your instructions and assume that you will never open the frame to inspect the materials they have used. (Acid-free mat boards are easily identified by their characteristic white edges. Cheap mat boards are normally a light gray or brown color on the edges.)

To find a framer you can trust, it may be necessary to ask a local print dealer or museum curator to recommend someone. Then insist he follows the procedures and uses the materials specified below.

INSIDE THE FRAME: MATTING AND MOUNTING

MATTING: Prints and other works of art on paper should be properly matted whether you plan to hang them on the wall or keep them in storage. A *mat* consists of two pieces of acid-free board: the *backboard* (also called the back sheet) and the *overthrow* (also called the "window" mat or the overthrow mat). These two pieces of board are joined together along one edge. The print is attached to the backboard and when framed it is viewed through the "window" or hole cut in the overthrow. (See Diagram 1.)

Instructing your framer to make both the overthrow and the backboard from acid-free materials is very important. To prevent the work of art from touching the cheap mat board they are accustomed to using, some framers cut costs by simply attaching strips of acid-free paper around the inside of the window and a sheet of acid-free material behind the print on the backboard. But a shield of rag paper between the mat and the artwork only offers temporary protection; in time, the acids in the mat board will migrate to the rag paper and eventually stain the print. Again, insist that your prints are only matted with 100 percent acid-free, all-rag boards.

The brown corrugated cardboard which many framers use as an *outside backing sheet* will stain the acid-free backboard, and over

several years, the acids will eventually migrate through to the print. The board used to close the back of the frame should therefore be made from an acid-free material such as all-rag board or specially made plastic backing sheets such as fluted Mylar.

The mat board's thickness should be in proper relation to the size of the print. Large prints tend to sag in the middle and may be damaged if they stick to the inside surface of the glass. (High relative humidity may periodically cause the glass to become damp with condensation.) Prints must be set back from the glass by a sufficiently thick overthrow. A single board of 4-ply thickness will often do the job; however, very large prints on heavy paper may require a double overthrow to keep the print away from the glass.

To enhance the appearance of the print, framers will often suggest that two overthrows be made. The inner one, the one next to the print, is made of colored mat board. The window of the outer overthrow is cut larger than the window of the inner one to expose a thin line of color around the perimeter of the print when the two overthrows are attached together. Unfortunately, acid-free board is only available in two or three light colors, and both overthrows must be made from acid-free material. Never allow a framer to use a dark-colored, acidic mat board in a double overthrow mat.

The overthrow should be attached to the backboard with a continuous strip of acid-free linen tape along the top edge or down the left side of the backboard. This allows you to examine the margins and the back of an unframed print by simply lifting the overthrow or opening it like a book. (See Diagram 1.) The best material for attaching the overthrow to the backboard is acid-free linen tape. Masking tape and other "sticky" tapes should never be used due to their acid content and their tendency to irreversibly stain the mat boards.

Framers usually place the window in the optical center of the mat rather than in its measured center. The bottom of the overthrow is normally made slightly wider than the top and sides, which is more pleasing to the eye than having all four sides of the mat of equal width. It is also desirable to allow for a space of an aesthetically appropriate width between the inner edge of the window mat and the print's image. When matting a signed and numbered print, a wider space than usual should be left at the bottom so that the artist's signature and other written notations are visible.

Prints should be *hinged* to the backboard of the mat (never to the overthrow) with small pieces of acid-free linen tape. It is very important for your framer to ensure that the tape in direct contact with the print is made from 100 percent acid-free materials. Other commercial

DIAGRAM 1

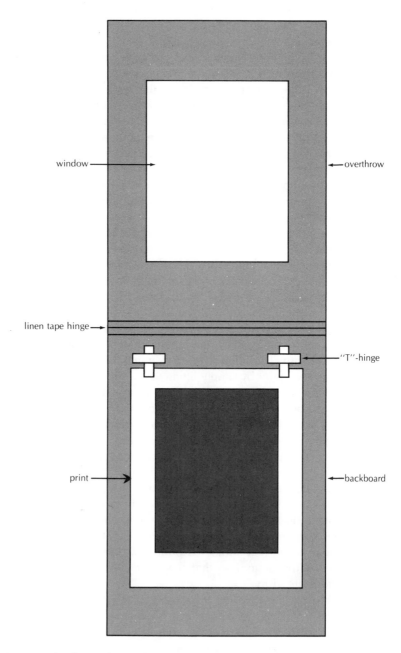

window → ← overthrow

linen tape hinge →

"T"-hinge →

print → ← backboard

Open mat showing a print attached to the backboard with "T"-hinges.

DIAGRAM 2

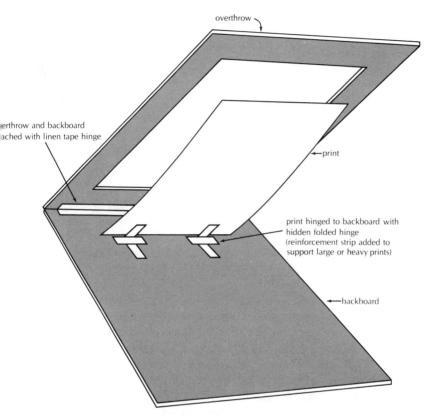

overthrow

overthrow and backboard attached with linen tape hinge

print

print hinged to backboard with hidden folded hinge (reinforcement strip added to support large or heavy prints)

backboard

Open mat showing how a print without margins is attached to the backboard with hidden folded hinges. Reinforcement strips of acid-free tape are added to support large or heavy prints. The window is normally cut slightly larger than the print, leaving a narrow line of the backboard exposed around the perimeter of the image.

DIAGRAM 3

Cross-section of a frame made for a print matted without an overthrow. Note how spacer material hidden behind the frame creates an airspace which prevents the print from touching the glass.

adhesives and tapes have a high acid content and will in time damage works of art on paper. "Sticky" tapes, pressure sensitive tapes, rubber cement, mucilage, and other household tapes and glues will stain a print and sharply depreciate its value. Gummed linen tape does become somewhat acidic with age, but it is the most acceptable commercially made product available today.

Hinges should only be attached along the top edge of the print, never on the sides or bottom, where they cause the print to buckle and warp with changes in humidity. Very large or heavy prints may require several "T"-hinges (sometimes called reinforced pendant hinges) to support their weight (see Diagram 1). Hinges must be set in from the corners of the print (the weakest points) to avoid tearing the paper under stress.

Small prints and photographs may be attached to the backboard with four mulberry or rag paper envelope corners similar to (but somewhat larger than) the "picture corners" made for photograph albums. By this method, no adhesive need be applied directly onto the artwork. If the print has wide margins, the corners will be hidden behind the mat. (This method is often used to mat photogravures, which were printed on thin tissue paper for publications such as Camera Work.)

Prints without margins are often "floated" in an oversize mat with a narrow line of the backboard exposed around the print. The art is attached to the backboard by a hidden folded hinge as shown in Diagram 2.

Conversely, some contemporary artists leave very wide margins on their prints as part of the visual effect they are trying to achieve. A window mat would spoil the print's impact, so often wide-margined prints are simply mounted with hidden folded hinges onto a sheet of acid-free board, leaving an inch or two of the board exposed around the edges of the print. When framing art in this way, a framer must be sure

that an airspace separates the art from the glass in the picture frame, in order to prevent the print from sticking to the glass with changes in temperature and humidity. A spacer made of non-acidic material should be placed around the frame between the back of the glass and backboard (see Diagram 3) to separate the print from the surface of the glass.

Finally, instruct your framer *not* to cut a print's margins to fit a mat. Trimmed margins will often reduce a print's value to the same degree as one which has been permanently mounted on a backboard. Ask your framer to leave prints in the same condition in which he received them. You should also instruct him not to make any repairs, not to remove old hinges, and not to attempt to flatten a warped print by dry mounting, taping, or gluing it permanently to a piece of stiff board.

GLAZING: For protection against dirt and pollutants, all works of art on paper must be framed under glass or a rigid plastic such as Plexiglas. Although regular glass has its faults, it is without question the best material and has the added advantages of being cheap and durable. Non-reflective glass is not satisfactory because of its poor light-transmitting qualities and its tendency to make prints and photographs look dull and lifeless.

Plexiglas or plastic sheets are sometimes used as substitutes for glass. Specially treated Plexiglas UF1 and UF3 sheets protect works of art on paper by filtering out most of the ultraviolet rays emitted from sunlight and fluorescent lighting. These rays cause ink colors to fade and paper to discolor. Plexiglas, however, is quite expensive and is only practical for small, valuable prints. It has a tendency to twist out of shape with changes in temperature, and may damage large prints, which warp, sag and touch the plastic under humid conditions.

SEALING: Paper conservators and expert framers disagree on whether picture frames should be sealed against dust, or be allowed to "breathe." But in areas with a highly polluted atmosphere, as in most North American cities, it is probably desirable to have the glass sealed into the frame. The air in industrial areas contains harmful concentrations of sulfur dioxide fumes, which will eventually cause the paper to decompose.

A continous strip of transparent self-adhering tape may be wrapped around the edges of the glass and the backboard, sandwiching the print and its mat together before it is placed in the frame. Or, the framer may apply the tape along the cracks between the outside backing sheet and the back of the frame. Either method should effectively seal out dirty air, which can streak and discolor your print.

AFTER FRAMING:
WHERE TO HANG
YOUR PRINTS

Once a print has been matted and framed, precautions must be taken to protect it from environmental conditions that will, in time, cause serious damage to works of art on paper. They include:

EXCESSIVE EXPOSURE TO LIGHT: Framed prints exhibited in rooms that are brightly lit with daylight or fluorescent tube lighting are exposed to the deteriorating effects of ultraviolet rays. Excessive exposure to direct sunlight or unfiltered fluorescent lighting will cause paper to decompose and become discolored. The amount of deterioration and discoloration depends upon the composition of the paper; cheaper papers will turn a yellow-brown color after only a few weeks' exposure to bright light. More importantly, light also causes the inks in an image to fade or darken.

Rooms where works of art on paper are to be hung should only be exposed to indirect daylight and should be illuminated with incandescent lighting (light bulbs), which is fairly harmless since it is relatively free of ultraviolet rays. The amount of damage light will do to paper depends upon the intensity of the illumination and the length of time the artwork is exposed to the light source. Paper conservators recommend that not more than five foot-candles of light be used to illuminate prints. This is equal to the output of a 150-watt light bulb placed four feet away from the work of art. Prints should never be spotlit with lightbulbs.

If you want to hang valuable prints in your office or another room that is illuminated with fluorescent lighting, Plexiglass UF1 sleeves may be purchased. These slip over the fluorescent tubes and absorb the damaging rays. They have a short lifespan, however, and must be replaced every few years. If your office is exposed to direct sunlight, special UV filtering film may be purchased to cover the inside of the windows to keep out the sun's harmful rays.

RELATIVE HUMIDITY AND TEMPERATURE: The atmospheric fluctuations in the North American climate cause paper fibers to expand and contract as the temperature and relative humidity keep changing. Dryness causes paper to become brittle, while humidity makes it expand with moisture and eventually warp and buckle. This expansion and

contraction with changing humidity has a debilitating effect on paper fibers.

Excessive humidity also makes paper subject to microbiological attack by bacteria and fungi, which stimulate the growth of mold. In addition to acidifying paper, mold discolors it with brown spots called *foxing*. These spots and stains are produced by the chemical reaction between acids in the mold and impurities within the paper itself.

Mold growth flourishes in an environment with a relative humidity in excess of 70 percent. If the humidity in your area exceeds 70 percent for several months of the year, dehumidify or air-condition rooms where prints are hanging. A relative humidity of between 45 and 55 percent is ideal for works of art on paper. (Very dry conditions below 30 percent relative humidity will eventually cause paper to become brittle.)

Never store prints in damp closets, unventilated rooms, attics, or basements, and avoid hanging them near radiators, on damp walls, or walls subject to frequent changes in temperature, such as those covering chimneys and heating ducts.

Whenever possible, framed works of art on paper should be hung in well-ventilated rooms maintained at a temperature of between 65° and 70° F. If prints must be hung in poorly ventilated areas, have your framer affix small felt or cork "bumpers" on the bottom corners of the frame to keep it away from the wall. This will allow air to circulate behind the frame and prevent dust from settling on the back.

Be sure to regularly inspect both framed and unframed prints for signs of foxing.

INSECTS: Silverfish, cockroaches, woodworms, and other insects can do serious damage to works of art on paper. Most paper-destroying insects flourish in damp, dark environments where there is a ready supply of paper to consume. Never store prints next to old books, magazines, or cardboard cartons which may be infested. And never attempt to exterminate insects by spraying insecticides on a print's surface. Infested works should only be treated by a competent museum-trained paper restorer.

As a final precaution, every three or four years you should give your prints a thorough examination. Open the frames and check prints for damage from light, mold, and insects.

FIGURE 55
Print showing the effects of foxing (the dark spots).
This photoreproduction of the *The Goldsmith* by
Rembrandt Van Rijn was stored in a damp basement
for several years.

HANDLING AND STORAGE

HANDLING UNFRAMED PRINTS: Unframed prints should be handled as infrequently as possible and with extreme care, particularly if they are unmatted as well. Unmatted prints should always be lifted with two hands and carried flat between two sheets of acid-free board. When carrying prints this way, each one should be covered with a thin sheet of acid-free tissue paper, in order to protect the images' delicate surfaces. Unmatted prints should be kept in folders or envelopes made of acid-free paper until they are matted.

Valuable prints that are to be stored unframed for any length of time should be matted as soon as possible. To protect images against scratches and dust while in storage, sheets of acid-free tissue paper should be laid between each impression and its overthrow mat.

Always open a hinged mat by handling the outside edges. The practice of opening a mat by putting fingers through the window can often damage the print's surface.

If you wish to examine the verso of a print after opening a mat, do not bend the corner as you would when turning a page of a book; instead, slip a small piece of paper under a corner of the print and carefully lift it with the slip of paper.

If you accidentally tear a print, the damaged area should not be touched, and no attempt should be made to repair it. The print should be carefully placed between two sheets of acid-free board and taken to an expert paper restorer recommended by your local art museum.

STORING UNFRAMED PRINTS: To protect matted but unframed prints from contact with dust, dirt, polluted air, and acidic materials, store them in dust-proof drawers or in Solander boxes. A Solander box is simply a flat box with a hinged lid and a lining of acid-free paper. A single box may hold twenty or more matted prints, depending upon the thickness of the mats. If Solander boxes are not available at local art supply stores, ask print dealers or a museum print curator for the name and address of a nearby supplier.

If you have more prints than a single Solander box will hold, you will need some wide shelves where several boxes can be stored flat, or you may purchase storage drawers instead. The most readily available products for this purpose are map drawers or architect's blueprint filing cabinets, which can be purchased from office supply companies. The

metal drawers in these cabinets are, of course "acid-free," and are wide and shallow, making them ideal for print storage.

It is often a good idea to rotate your print collection, alternating display with storage in a dark closet or Solander box every few months. Although this practice in no way "freshens up" the appearance of a print, it does increase a print's lifespan by reducing its exposure to light.

CONSERVING PHOTOGRAPHS

As with other works of art on paper, photographs should never be exposed to direct sunlight, illuminated with fluorescent light, or subjected to extreme fluctuations in relative humidity and temperature. It is also important to frame photographs with 100 percent acid-free materials in the same manner described above for unframed prints. In addition to these basic conservation measures, there are a number of special considerations to be kept in mind when buying, displaying, and storing photographs.

Photography collectors, unlike print collectors, need not be overly concerned about purchasing prints which have been permanently mounted or "laid down." Several well-known photographers make a practice of *dry mounting* all their prints on sheets of stiff board. (Dry mounting involves placing a thin sheet of tissue, which is coated on both sides with an adhesive, between the photograph and the board. When heated in a special dry mounting press, the adhesive bonds the photograph permanently to the mount.)

Some conservators, however, worry that over a long period of time impurities or chemicals within the tissue may cause staining on the photographs. Also, there are concerns that photographers who dry mount their prints may not use acid-free board, and that acids within the boards they use will eventually migrate through the tissue to the print.

For now, dry mounting remains a controversial subject with photograph conservators, since there is no conclusive evidence to prove that the process does permanent damage to photographs so long as acid-free mounting board is used. Dry-mounted photographs are not presently discounted in the photography market as "laid down" or permanently mounted impressions are in the print market.

Color photographs present special problems for collectors because they are highly susceptible to fading. The degree to which a color photo-

graph will fade depends upon the process that was used to make it, and the manner in which it is displayed or stored.

As indicated in Chapter 8, there are basically three types of color photographs available to collectors: type-C prints, Cibachrome prints, and dye-transfer prints. Type-C prints will often begin to fade within ten years. The other two processes are capable of producing prints which are considerably more fade-resistant. However, no one can be certain how permanent the colors are because neither method has been in use long enough for accurate tests to be made. Nevertheless, some photographers and galleries specializing in color photographs guarantee their dye-transfer and Cibachrome prints for a specific number of years, and offer to replace prints which show evidence of fading within the guarantee period.

Collectors of color photographs must be sure to display their works under low light conditions, and away from direct sunlight and fluorescent lighting. Experts in photograph conservation also recommend that color prints should be displayed or stored at a constant relative humidity of between 30 and 50 percent, at temperatures below 70°F.

Black and white prints will last for decades with little or no signs of fading, staining, or discoloring if they are properly processed by the photographer and cared for by the collectors. Most contemporary photographers follow correct darkroom procedures to ensure their prints meet "archival standards" (the standards for print conservation recommended for photos stored in public archives).

However, some nineteenth-century black and white prints will fade if left exposed to light for long periods of time. Albumen prints and calotypes, for example, should be stored in the dark whenever possible, and only displayed under low level, indirect lighting.

In addition, a few twentieth-century photographers whose works are popular with collectors are known to have ignored the procedures to chemically "fix" (make permanent) their black and white photographs. (They may not have been aware of the proper techniques, or perhaps they simply were not concerned about preserving their prints for a long period of time.) As a result, some vintage prints by the masters of this century have a tendency to become oxidized (a chemical reaction with air which causes a print's surface to deteriorate and lose its texture). Competent photograph restorers (there are very few of them) can normally treat this condition and repair other damage as well. Photography dealers and curators at museums with large photograph collections may be able to recommend a qualified photo restorer.

To be able to spot defects and avoid photographs which may require expensive restoration, collectors should learn about the characteristics

of the various types of photographs available, and also find out as much as possible about the working habits of the photographers whose work they collect. This information may be acquired by looking at photographs, reading, and talking to dealers, curators, and other experts.

CONSERVATION AND RESTORATION

It is important not to confuse print *conservation* with print *restoration*. Print conservation involves maintaining an impression in its present condition, through proper framing, handling, and storage. Print restoration, on the other hand, involves rejuvenating damaged works, returning them as closely as possible to their original condition.

It is advisable, whenever possible, to purchase prints unframed and to take them to a competent framer whom you can trust to use only acid-free materials. Proper matting, mounting, and framing, and display or storage away from bright light and dampness, are the best assurances that your new prints will be conserved in their original condition.

Old prints, particularly those which have been acquired already framed, however, may require some degree of restoration. Late nineteenth-century prints, for example (particularly French posters from the 1890s), were often made on low-grade, acidic papers, and survive in poor condition today. Similarly, many Inuit prints created in the 1960s were printed on poor-quality papers and inexpensively framed with highly acidic materials. These prints, and several other types of modern and contemporary graphic art are often in need of extensive restoration work and should be thoroughly examined before being purchased. As indicated in Chapter 6, before purchasing an expensive print it is a good idea to insist that the dealer or auction house open the frame for you to inspect the condition of the print and the materials that were used to frame it. Obviously a print in poor condition — torn, stained, "laid down," or mounted with masking tape — will be worth much less than a print that is in pristine condition. Often, prints in poor condition may be purchased for a fraction of their undamaged value, and in the hands of an expert restorer, may be rejuvenated to like-new condition.

The services offered by skilled restorers include: unmounting prints which have been glued down to a backboard; removal of glue deposits or framing hinges and tape; stain removal; treating damage caused by mold and insects; and the repair of tears and creases. Some restorers can

even reconstruct holes and torn areas in a print by weaving fibers from another piece of paper into the damaged areas.

The execution of these treatments and repairs requires the expertise of someone who specializes in restoring works of art on paper. Repairs to expensive prints should never be attempted by restorers who are not museum trained, picture framers, or even expert oil painting restorers — unless they also happen to be paper specialists. The American Institute for the Conservation of Historic and Artistic Works publishes a directory of members in the United States and Canada, which lists restoration experts by specialty. A copy of the directory may be obtained by writing to the Institute at the address given in the Resource List.

After examining a print, a restorer will recommend an appropriate method of treatment and give you an estimate of the cost of repairing the damage. Some restorers work on an hourly rate, while others base their fees on the treatment required.

TRANSPORTING PRINTS

Prints can be seriously damaged through careless handling. The risk of damage is greatly increased when prints are mailed or transported to a restorer or to an auction firm.

Large prints framed behind glass should never be shipped in their frames, whether traveling by airfreight or through the mails. (If the glass is removed, there is less chance that a framed print will be damaged in transit; however, prints shipped in large frames will often require a special wooden crate to be made for each picture.)

Large prints should be shipped mounted in mats, and protected by sheets of acid-free tissue paper placed under the overthrow to cover the image. The matted prints should be placed between two pieces of stiff cardboard and sealed around the edges with tape or paper.

Small prints and photographs may be shipped in their frames, provided strips of masking tape are placed over the glass in a grid pattern. If the glass is accidentally broken, the tape will hold the pieces in place without damaging the print. The strips should be spaced not more than one inch apart, both horizontally and vertically.

Unframed prints should never be shipped rolled up in cardboard mailing tubes. It is next to impossible to roll a print without creasing it, and the tubes may be crushed, bent, or broken open in the mail. What's more, it is often difficult for the recipient to remove a print from a tube without creasing and wrinkling it.

Original prints may be sent duty-free to and from Canada, the United States, and Western European countries. Most manually signed and numbered prints that are described on customs forms and on a dealer's or auction company's invoice as "original art" may be shipped from country to country without charge. However, in some countries certain types of "mechanically made" prints such as photographs and photo-offset lithographs are not recognized as original art by customs authorities and may be subject to duty.

Canada Customs, for example, presently does not recognize photographs less than fifty years old as art objects, regardless of signatures, numbering, or documentation which may accompany them. Canadian collectors must pay 18.9 percent duty and 9 percent federal sales tax (plus provincial sales taxes in some provinces) on photographs purchased abroad. Photographs over fifty years old, however, are classed as "antiquities," and enter Canada duty-free.

When shipping prints long distances or overseas, air express is generally more dependable than the postal service, and is better equipped to accommodate large, flat packages.

RESOURCE LIST

THERE ARE NUMEROUS catalogs, newsletters, and other publications that are of special interest to collectors of original prints and photographs. Here is a listing of some of the more useful publications and the companies or organizations which publish them. Further information may be obtained by writing to each publisher.

PERIODICALS

In addition to magazines such as *Art in America, ARTnews,* and *artmagazine,* which regularly publish articles on prints and print collecting, there are a number of specialist publications that are of particular interest to collectors of original prints and photographs. They include:

Art/Antiques Investment Report
Wall Street Reports Publishing Co.
120 Wall Street
New York, N.Y. 10005
A biweekly newsletter giving tips on investing in all types of art and antiques.

Photo Communiqué
Fine Art Photography Publications
P.O. Box 129, Station M
Toronto, Ontario, Canada M6S 4T2
A quarterly magazine devoted to photography with an emphasis on the Canadian market.

printletter
Postfach 250
Ch — 8046
Zurich, Switzerland
A bimonthly newsletter devoted to collecting photographs.

Print Collector
Salamone Agustoni editori
srl via Montenapoleone 3-20121
Milan, Italy
A newsletter covering the international print market with an emphasis on old master works. Published five times per year.

The Print Collector's Newsletter
16 East 82nd Street
New York, N.Y. 10028
A bimonthly newsletter covering both the print market and photography market.

Camera Arts
Ziff-Davis Publishing Co.
1 Park Avenue
New York, N.Y. 10016
A magazine for collectors of photographs.

AUCTION CATALOGS

Auction catalogs are available individually or by annual subscription. Catalog prices and information on upcoming sales may be obtained by writing to the catalog subscription departments of each company. An increasing number of companies hold print and photograph auctions every year. The following list gives the names and addresses of the major firms which publish comprehensive catalogs for each of their sales.

Christie's
(Christie, Manson & Wood Ltd.)
8 King Street
St. James's, London
SW1Y 6QT, England

Christie's New York
502 Park Avenue
New York, N.Y. 10022

Hauswedell & Nolte
Pösseldorfer Weg 1
Hamburg 13, West Germany

Karl & Faber
Amiraplatz 3
Munich 2, West Germany

Kornfeld & Company
Laupenstrasse 41
3008 Bern, Switzerland

Phillips, Blenstock House
7 Blenheim Street
New Bond Street
London W1Y OAS, England

Phillips, Son & Neale Inc.
867 Madison Avenue
New York, N.Y. 10021

Phillips Ward-Price Ltd.
76 Davenport Road
Toronto, Ontario M5R 1H3

480 St. Francis Xavier
Montreal, Quebec H2Y 2T4

Sotheby Parke Bernet & Co.
34-35 New Bond Street
London W1A 2AA, England

Sotheby Parke Bernet Inc.
980 Madison Avenue
New York, N.Y. 10021

Sotheby Parke Bernet Los Angeles
7660 Beverly Boulevard
Los Angeles, California 90036

Sotheby Parke Bernet (Canada) Inc.
156 Front Street W.
Toronto, Ontario M5J 2L6

AUCTION PRICE INDEXES

Several annual directories of auction prices are available to collectors in most reference libraries or by subscription from the publishers. The directories enable print collectors to keep up to date on current prices and check price trends over several years by comparing back issues. The following publications are particularly useful:

Art Price Annual
Art and Technology Press
8 Lipowskystrasse
8000 Munich 70
West Germany

Gordon's Print Price Annual
Martin Gordon Inc.
25 East 83rd Street
New York, N.Y. 10028

International Auction Records
Editions Mayer
224 Avenue du Maine
Paris 14e France

North American address:
Editions Publisol
P.O. Box 339, Gracie Station
New York, N.Y. 10028

ART DEALER ASSOCIATIONS

Lists of professional and responsible dealers and galleries with good reputations for fair and honest dealings with collectors may be obtained by writing to the appropriate dealer's association:

Art Dealers Association of America Inc.
575 Madison Avenue
New York, N.Y. 10022

Professional Art Dealers Association of Canada
65 Queen Street W., Suite 1800,
Toronto, Ontario M5H 2M5

The Association of International Photography Art Dealers Inc.
Box 1119 F.D.R. Station
New York, N.Y. 10022

A list of expert paper restorers may be obtained by writing to:

The American Institute for the Conservation of Historic and Artistic Works
1522 K Street N.W., Suite 804
Washington, D.C. 20005

GLOSSARY

THERE ARE MANY "terms of the trade" which frequently appear in publications written for print collectors and in auction catalogs and catalogues raisonnés. This list includes most of the common terms pertaining to modern and contemporary prints.

Acid-free paper Paper made from non-acidic materials.

After A print copied by hand by a craftsman from another work of art. The French term is *après*. The completed work may be called a *gravure d'interprétation*.

Albumen print A type of photographic print made with albumen paper that was popular in the last half of the nineteenth century. May be identified by its characteristic orange-brown color.

All-rag paper Paper made of 100 percent acid-free rag fiber materials.

Ambrotype An early type of photograph which was made on glass; popular for portraiture in the 1850s.

Après *See* After.

Aquatint An intaglio method for creating uniform tones on a matrix.

Arches The trade name of a French paper manufacturer.

Artist's proof (A.P.) Prints made outside of a regular edition for an artist's own use and excluded from the numbering of a printed edition. Also called *épreuve d'artiste (E.A.)*.

Atelier A studio or printmaker's workshop.

Auction ring A conspiracy among bidders who agree not to bid against one another on items offered at an auction, in order to allow members of the ring to acquire certain lots at a lower price.

Backboard *See* Mat.

Bid A price offered by a buyer for an item being auctioned.

Bid sheet A form for submitting written bids prior to an auction.

Bite The penetration of acid into a metal plate in the etching process.

Blindstamp A tiny symbol or mark printed or embossed onto sheets of paper used for creating an edition of prints, usually to identify the artist, publisher, or printer. Also called *chop mark*.

Bon à tirer (B.A.T.) "Good to pull" or "good to be printed." A printer's working proof, which serves as the standard of quality by which other prints will be judged as they are being printed.

Burin A sharp tool used in the etching, engraving, and drypoint techniques. Also called a *graver*.

Burr A curl of metal raised above the surface of the matrix when a line is incised into a metal plate. The burr produces highly desirable velvety blacks on drypoint prints.

Buy bid An order given by a bidder to an auction firm to buy a certain item at any price. Most auction houses refuse to accept buy bids.

Buyer's premium A commission charged by auction firms to buyers; normally set at 10 percent of the final selling price.

Buy-in An item which is bid up to its reserve price by an auctioneer when legitimate bidding stops. Buy-ins or "bought-in" items are normally returned to their owners.

Calotype A type of photographic print that was popular in the 1840s. Also called a *Talbotype* or a *salt print*.

Canceling Defacing or destroying a matrix to prevent it from being reprinted.

Cancellation proof A proof made from a matrix after it has been defaced to prove that the plate was canceled.

Carte de visite A "visiting card" photograph mounted on a small card; popular in the 1860s as an inexpensive type of portraiture.

Catalogue illustré An illustrated catalog of an artist's work. Similar to a catalogue raisonné but containing less information on specific works.

Catalogue raisonné A definitive catalog of an artist's work giving information about states, edition sizes, etcetera.

Chiaroscuro A woodcut technique that requires one wood block to be printed in dark ink and one or more other blocks carved to print the light tones and highlights.

Chop mark *See* Blindstamp.

Chromiste *See* Copyist.

Cibachrome The trade name of a photographic process for making color prints from color transparencies.

Collagraph A method of printmaking using an assembly of materials in varying layers (in the form of a collage) to create a raised image. Also spelled "collograph."

Collector's mark An identifying stamp placed on a print by a collector to identify it as his property. Collector's marks are often useful in researching the provenance of a print.

Collotype A photomechanical method of printing pictures in books that was popular in the late nineteenth century.

Contemporary In the art market, the period from approximately 1945 to the present day.

Copyist A craftsman who copies original works of art, "translating" them into a printmaker's medium for the purpose of making an edition of prints. Prints made by copyists or *chromistes*, are called *afters*.

Cross-hatching A method artists use to create tone or shading by drawing a series of parallel lines crossing over one another at varying angles.

Daguerreotype A type of photograph made on a silver-coated metal plate. The daguerreotype process was often used for portraiture in the mid-nineteenth century.

Deckle edge The torn uneven edge on many handmade and some commercially made art papers.

Discretionary bid An order bid that allows an auctioneer to make one extra bid on behalf of a client, if the order bidder's maximum price is matched by a bid from the floor.

Dryplate A photographer's negative made on glass by a process that was popular in the late nineteenth century.

Drypoint An intaglio technique in which a sharp needle is used to scratch an image into a copper or zinc plate. *See also* Burr.

Dye-transfer print Color photographic print made with special fade-resistant dyes.

Edition The total number of prints made of an image.

Embossing A printing technique which raises all or part of an image from the paper.

Engraving An intaglio printmaking method in which a pointed tool is employed to incise the lines of an image into a matrix.

Epreuve d'artiste (E.A.) *See* Artist's proof.

Estate stamp An official stamp or mark placed on the work of a deceased artist to certify its authenticity.

Etching An intaglio printmaking process in which images are scratched with a sharp tool onto a metal plate covered with an acid-resistant waxy material, the *ground*. Acid is then applied to "bite" the scratched image areas into the plate.

Ex coll of Means "formerly in the collection of." A term used in documenting a print's provenance.

Facsimile signature A copy of an artist's signature reproduced photographically and printed on an impression, or added by means of a rubber stamp.

Fecit (fec.) Means "made it."

Ferrotype *See* Tintype.

Foxing Brownish spots on paper produced by the chemical reaction between acids in molds and impurities within the paper itself.

Frontispiece First page of an illustrated book or portfolio of prints.

Graver *See* Burin.

Gravure d'interprétation *See* After.

Ground A waxy, acid-resistant coating placed on a metal plate used for an etching. *See also* Etching.

Halftone A method of reproducing images photographically by means of a special screen, which translates tonal values into tiny dot patterns.

Heliogravure A method of making art reproductions by photographically etching an image into a metal plate, which is then used to print copies on sheets of paper.

Hinge A strip of linen tape used by picture framers to attach a print to the backboard of the mat.

Hors de commerce (H.C.) A designation often made on a number of prints which are not intended for sale.

Impression A single print made from a matrix.

Impressit (imp.) Means "printed it."

Inkless intaglio A printmaking technique in which part of an image is raised on the paper and printed without ink.

Intaglio A term used to describe printing methods in which images are incised or "bitten" into the matrix with tools or acid.

Japan paper A high-quality, acid-free art paper made from mulberry fibers. Also called *Japon paper*.

Japon paper *See* Japan paper.

Laid down A term used to describe a print which is glued or taped directly onto a piece of board or paper.

Laid paper Paper made on screens which produce a grid pattern on the surface of each sheet.

Late impression *See* Restrike.

Lift-ground etching An etching technique which enables an artist to "paint" areas of the image with a brush. The image is painted directly onto the plate with a special solution. A coating of ground is then applied on top of the image. The plate is immersed in warm water which causes the ground to "lift" in the image areas, exposing the plate surface. The exposed image is later bitten into the metal by immersing the plate in an acid bath. Also called *sugar-lift etching*.

Limited edition The practice of artificially limiting the number of prints that are made of an image by canceling or destroying the matrix.

Linocut A relief printing method in which the image is cut into a sheet of linoleum. The design to be inked and printed is formed by cutting away areas on both sides of the image lines, leaving the outline intact on the surface of the linoleum block. Also called *linoleum cut*.

Lithographic stones Limestone slabs on which images are drawn for the purpose of making lithographs.

Lithography A planographic printing process based on the principle that grease and water do not mix.

Lot An item (or items) offered for sale at auction.

Mat A protective support for works of art on paper. Consists of two pieces of acid-free board: the *backboard* (also called the back sheet) and the "overthrow" (also called the "window" mat or the overthrow mat). The print is attached to the backboard and when framed, it is viewed through the "window" in the overthrow.

Matrix A printing surface on which an image is drawn or incised. May be made of wood, stone, metal, linoleum, or any other substance that will print images on paper.

Mat stain A stain on a print caused by contact with an acidic mat board.

Mezzotint An intaglio process in which the entire surface of a metal plate is textured with a special tool called a *rocker*. The plate would print solid black if inked at this stage. The artist makes his drawing by scraping away certain areas to produce white and gray tones in the image.

Minimum price guarantee The minimum price an auction firm agrees to pay a seller for a consignment, regardless of whether the item reaches the guaranteed price on the auction floor. The seller pays an extra commission for this guarantee, and if the item fails to sell, the auction company takes possession of it and must pay the owner the guaranteed price.

Mixed media A print made with two or more printmaking techniques or by incorporating other art media into the creation of a print.

Modern In the art market, the period from the turn of the twentieth century up to approximately 1945.

Modern print A photograph made a number of years after the picture was taken.

Monoprint An image made using a printmaking medium and materials but only one print is produced. Also called *monotype*.

Monotype *See* Monoprint.

Mordant The acid solution used in the etching process.

Mulberry paper An acid-free paper.

Museum board An acid-free board used by picture framers for matting and backing works of art on paper.

Mylar Trade name for a type of plastic. A stiff "fluted" Mylar material is used by picture framers as a filler material or backing in frames.

Oeuvre The works of an artist taken as a whole.

Offset printing *See* Photo-offset printing.

Order bid A bid submitted to an auction firm in writing or by telephone on one or more lots being offered in a specific sale. Normally order bids are mailed in prior to a sale when the bidder is unable to attend in person. Also called a *sealed bid*.

Overthrow *See* Mat.

Photogravure A high-quality photographic reproduction made from a copper printing plate. Also called *gravure*.

Photomechanical process Any method of transferring an image to printing plate by means of photography.

Photo-offset printing A commercial printing method in which the image is photographically copied and transferred or "offset" from one roller to another on a printing press before it is printed on paper.

Pinxit (pinx) Means "painted it."

Plate *See* Matrix.

Plate mark The indentation in the paper around the perimeter of an image made by one of the intaglio processes. Plate marks are caused by the edge of a plate being pressed into the paper under the pressure exerted by the printing press.

Plate tone An overall tone produced on a print by a thin film of ink left on a printing plate.

Platinum print A photographic print made with a superior-quality paper that was popular from the 1880s to the 1930s. Also called *platinotype*.

Pochoir A French term for prints made by the stencil process. Also a term used to describe reproductions which are hand-colored by painting inks through stencils.

Portfolio A collection of original prints by one or more artists. When the prints are related in theme or subject matter they are often referred to as a *suite*.

Posthumous print A print made by a technician after the death of a printmaker or a photographer.

Preview Items for sale at an auction are "previewed" for two or three days prior to the auction to allow potential buyers to examine lots.

Pristine condition A term used to describe a print which is in perfect condition.

Proof An impression of a print made at any stage of its creation.

Provenance The "pedigree" of a work of art; its history of ownership.

Pull To print a single impression.

Rabbet The recess in a frame which holds the glass and matted print.

Recto The front side of the paper on which an image is printed.

Register The alignment of colors so that they will print without overlapping. When colors print in perfect alignment they are said to be "in register."

Relief printing Any printing method where the non-image areas are gouged out of the surface of the matrix leaving the raised portions to form the image.

Remarque A sketch or notation in the margin of a print. Also spelled *remark*.

Reproduction A copy of an original work of art.

Reserve A minimum price agreed upon between a seller and an auction firm. Items which fail to meet their reserve are "bought in." *See also* Buy-in.

Restrike A later impression made from an original matrix sometime after the artist's first edition was printed. Also called a *late impression*.

Rice paper A high-quality acid-free artist's paper made in the Far East.

Rives Trade name for a type of French art paper.

Rocker A tool used to prepare the surface of a mezzotint plate. *See also* Mezzotint.

Salt print *See* Calotype.

Sealed bid *See* Order bid.

Serigraph A stencil print created by forcing ink or paint through a cut stencil or the open mesh of a screen onto sheets of paper. Also called a *silkscreen*.

Signed in the plate A term used to describe a signature which is drawn or incised into a matrix and printed along with the image.

Silkscreen *See* Serigraph.

Silver print The most common type of photographic print. Called a "silver" print because the photographic paper is made with light-sensitive silver salts.

Soft-ground etching An etching technique which produces coarse, heavy lines on the finished prints.

Solander box A flat box lined with acid-free paper, designed to store works of art for long periods of time.

State Each significant change an artist makes to the appearance of an image constitutes a new state. Artists normally make several *state proofs* or *trial proofs* when creating an image to check how their work is progressing.

State proof *See* State.

Steelfacing A thin coating of steel placed on the surface of a copper plate to make the engraved or etched lines hold up longer when the image is printed.

Stencil process *See* Serigraph.

Stereograph card A small card holding two photographs of a subject taken from slightly different angles. When viewed through a special viewer called a *stereoscope*, the double pictures combine and give the illusion of depth.

Stopping out A method of covering or protecting certain areas of an etched image from being further bitten in subsequent immersions in the acid bath.

Sugar-lift etching *See* Lift-ground etching.

Suite *See* Portfolio.

Talbotype *See* Calotype.

Tintype A type of photograph made on small iron plates. The tintype process was used for making inexpensive portraits in the last half of the nineteenth century. Also called *ferrotype*.

Transfer lithograph The image for this type of print is drawn by an artist on special transfer paper rather than directly onto a lithographic stone. The image is later transferred to a stone for printing.

Trial proof *See* State.

Tusche A greasy ink used for drawing on lithographic stones.

Type-C print The most common type of color photographic print.

Verso The back of a print.

Vintage print A photographic print made at approximately the same time as the negative. Prints made within a year or so from when the photograph was taken are generally classed as vintage prints.

Watermark A name or a design impressed into the paper during manufacture to identify the paper manufacturer, the artist, his printer or his publisher.

Wet plate An early type of photographer's negative that was in use in the mid-nineteenth century.

Woodcut A relief printing method in which an image is incised into the side of a block of wood.

Wood engraving Similar to a woodcut, except the image is cut out of the end grain of a block of wood rather than the side.

Wove paper An even-textured paper without the surface lines or irregularities found in most laid papers. *See also* Laid paper.

BIBLIOGRAPHY

Adhémar, Jean. *Twentieth Century Graphics*. New York: Praeger Publishers, 1971.

Antreasian, Garo Z. *Tamarind Book of Lithography*. New York: Abrams, 1971.

Beaton, Cecil, and Buckland, Gail. *The Magic Image*. Boston: Little Brown, 1975.

Bloch, George. *Picasso: Catalogue of the Printed Graphic Work*. Berne: Kornfeld and Klipstein, 1971.

Blodgett, Richard. *How to Make Money in the Art Market*. New York: Peter H. Wyden, 1975.

_____. *Photographs: A Collector's Guide*. New York: Ballantine Books, 1979.

Bolliger, Hans. *Picasso's Vollard Suite*. London: Thames & Hudson, 1956.

Buchsbaum, Ann. *Practical Guide to Print Collecting*. New York: Van Nostrand Reinhold, 1975.

Castle, Peter. *Collecting and Valuing Old Photographs*. London: The Garnstone Press, 1973.

Castleman, Riva. *Contemporary Prints*. New York: Viking, 1973.

_____. *Prints of the Twentieth Century: A History*. New York: The Museum of Modern Art, 1976.

Chieffo, C. T. *Silk Screen as a Fine Art*. New York: Van Nostrand Reinhold, 1972.

Crommelynck, Aldo. *Picasso 347*. New York: Random House, 1969.

Darrah, William C. *The World of Stereographs*. Gettysburg, Pa: W. C. Darrah, 1977.

Dennis, Landt, and Lisl, Dennis. *Collecting Photographs: A Guide to the New Art Boom*. New York: E. P. Dutton, 1977.

Dolloff, Francis W., and Perkinson, Roy. *How to Care for Works of Art on Paper*. Boston: Boston Museum of Fine Arts, 1979.

Donson, Theodore B. *Prints and the Print Market*. New York: Thomas Y. Crowell, 1977.

Doty, Robert. *Photo-Secession: Photography as a Fine Art*. Rochester: George Eastman House, 1960.

Edmondson, Leonard. *Etching*. New York: Van Nostrand Reinhold, 1973.

Eichenberg, Fritz. *The Art of the Print*. New York: Abrams, 1976.

Gombrich, Ernst. *The Story of Art*. 11th. ed. New York: Phaidon, 1967.

Green, Jonathan. *Camera Work: A Critical Anthology*. Millerton, New York: Aperture, 1973.

Heller, Jules. *Printmaking Today*. New York: Holt, Rinehart and Winston, 1972.

Hunter, Dard. *Papermaking, The History and Technique of an Ancient Craft*. New York: Dover, 1978.

Ivins, William M. *How Prints Look*. Boston: Beacon Press, 1960.

Knigin, Michael, and Zimiles, Murray. *The Technique of Fine Art Lithography*. New York: Van Nostrand Reinhold, 1970.

Leymarie, Jean. *Picasso, Artist of the Century*. New York: Viking, 1971.

Milrad, Aaron and Agnew, Ella. *The Art World — Law, Business & Practice in Canada*. Toronto: Merritt Publishing, 1980.

Mourlot, Fernand. *Art in Posters*. New York: Braziller, 1959.

——————. *Bernard Buffet, Lithographs, 1952-1966*. Paris: A. C. Mazo, 1967.

——————. *Picasso Lithographs*. Monte Carlo: A. Sauret, 1949-64.

Newhall, Beaumont. *The History of Photography*. New York: Museum of Modern Art, 1964.

Passeron, Roger. *French Prints of the Twentieth Century*. New York: Praeger Publishers, 1970.

Pollack, Peter. *The Picture History of Photography*. New York: Abrams, 1969.

Reitlinger, Gerald. *The Economics of Taste*. London: Barrie Books, 1961.

Restoration and Conservation Laboratory, National Gallery of Canada, *The Care of Prints and Drawings with Notes on Matting, Framing and Storage*. Ottawa: National Gallery of Canada, 1977.

Shapiro, Cecile, and Mason, Lauris. *Fine Prints: Collecting, Buying & Selling*. New York: Harper & Row, 1976.

Sontag, Susan. *On Photography*. New York: Farrar, Straus and Giroux, 1978.

Sorlier, Charles, and Mourlot, Fernand. *The Lithographs of Chagall 1969-1973*. New York: Crown Publishing, 1973.

Sotriffer, Kristian. *Modern Graphics, Expressionism to Fauvism*. New York: McGraw-Hill, 1972.

Szarkowski, John. *Looking at Photographs*. New York: Museum of Modern Art, 1973.

Time-Life Books. *Caring for Photographs*. New York: Time-Life Books, 1972.

Wechsler, Herman J. *Great Prints and Printmakers*. New York: Leon Amiel, n.d.

Welling, William. *Collector's Guide to Nineteenth-Century Photographs*. New York: Macmillan Publishing, 1976.

Witkin, Lee D., and London, Barbara, *The Photograph Collector's Guide*. New York: New York Graphic Society, 1979.

Zigrosser, Carl. *Guide to Collecting and Care of Original Prints*. New York: Crown Publishing, 1965.

INDEX

Illustrations are denoted by numerals in **bold face italic.**